SO-ALN-950

MARGARET FULLER

THE BARNARD BIOGRAPHY SERIES

Margaret had so many aspects to her soul that she might furnish material for a hundred biographers; not all could be said even then.[1]
—James Freeman Clarke

She demanded our best, and she gave us her best.[2]
—Sarah Freeman Clarke

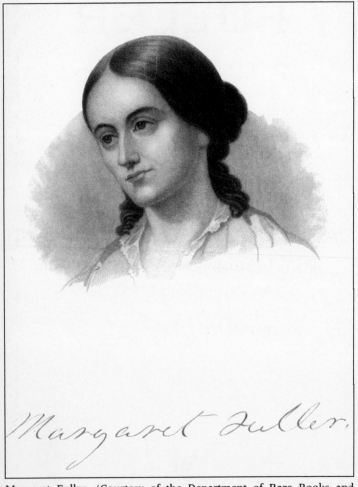

Margaret Fuller. (Courtesy of the Department of Rare Books and Special Collections, University of Michigan Library.)

MARGARET FULLER

A Life of Passion and Defiance

CAROLYN FELEPPA BALDUCCI
WITH AN INTRODUCTION BY
ANNA QUINDLEN

BANTAM BOOKS
NEW YORK · TORONTO · LONDON · SYDNEY · AUCKLAND

MARGARET FULLER

A BANTAM BOOK / DECEMBER 1991

LIBRARY OF CONGRESS CATALOGING-IN-PUBLICATION DATA

BALDUCCI, CAROLYN.
MARGARET FULLER : A LIFE OF PASSION AND DEFIANCE / CAROLYN FELEPPA
BALDUCCI ; INTRODUCTION BY ANNA QUINDLEN.
P. CM. — (THE BARNARD BIOGRAPHY SERIES)
INCLUDES BIBLIOGRAPHICAL REFERENCES AND INDEX.
ISBN 0-553-08123-3 (HC). — ISBN 0-553-35148-6 (TP)
1. FULLER, MARGARET, 1810–1850—BIOGRAPHY. 2. AUTHORS,
AMERICAN—19TH CENTURY—BIOGRAPHY. 3.FEMINISTS—UNITED STATES—
BIOGRAPHY. I. TITLE. II. SERIES.
PS2506.B34 1991
818'.309—DC20
[B] 91-26347
CIP

PUBLISHED SIMULTANEOUSLY IN THE UNITED STATES AND CANADA

PRINTED IN THE UNITED STATES OF AMERICA

FFG 0 9 8 7 6 5 4 3 2 1

THE BARNARD BIOGRAPHY SERIES

The Barnard Biography Series expands the universe of heroic women with these profiles. The details of each woman's life may vary, but each was led by a bold spirit and an active intellect to engage her particular world. All have left inspiring legacies that are captured in these biographies.

Barnard College is a selective, independent liberal arts college for women affiliated with Columbia University and located in New York City. Founded in 1889, it was among the pioneers in the crusade to make higher education available to young women. Over the years, its alumnae have become leaders in the fields of public affairs, the arts, literature, and science. Its distinguished faculty of scholar-teachers is committed to the fundamental values of a liberal arts and sciences curriculum. Barnard's enduring mission is to provide an environment conducive to inquiry, learning, and expression while also fostering women's abilities, interests, and concerns.

To my daughters, Sirad and Victoria

Acknowledgments:

To Joseph Jay Deiss, Bell Gale Chevigny, Paula Blanchard, and Joel Myerson for their scholarship.

To my esteemed colleague, Professor Ralph A. Loomis, for his meticulous editorial help, generosity, and wisdom.

To Margaret Davis for her insight and support.

To United States Representative Dale Kildee for his enthusiasm and help.

To the University of Michigan Libraries for their assistance.

To the Ohio Program in the Humanities, for funding my film adaptation of Margaret Fuller's *Summer on the Lakes, in 1843*.

To my colleagues and students at the Residential College of the University of Michigan.

To my husband, Gioacchino, for being Transcendental.

Contents

Introduction

I FELT my first connection to Margaret Fuller when I was a girl yearning to grow into a newspaperwoman. At a time when a woman could exhibit neither her ankles nor her brains, Margaret Fuller was America's first female foreign correspondent, a reporter for the *New York Tribune* who covered England, France, and Italy during the middle part of the nineteenth century.

If the society of great American thinkers of that time sounded a little like a boys club, then Margaret Fuller was a woman who was one of the boys, smart, aggressive, adventurous, and taken seriously by men like Emerson and Thoreau because of her intellect and education. "I now know all the people worth knowing in America," she once said, "and I find no intellect comparable to my own." That sentence is always used to demonstrate her arrogance, but the first time I read it I was struck by what I thought must be the fear and insecurity at the bottom of a declaration so conceited. Maybe I was

just too intent on imagining that America's first great newspaperwoman must be someone very much like myself.

In some ways it turned out she was, more than I understood until I grew older and learned something more of the kind of life she had lived. Like me, she was an oldest child whose father pushed her to study and excel and armed her with a direction and an education that was at once a blessing and a curse, that sometimes made her feel peculiar and different, particularly from the kind of girls who were most interested in clothes and boys.

Like me, she turned to the written word as a way to express emotions that sometimes seemed to choke her, and to the newspaper business as a way to explore and understand the world.

All of that makes her sound like a very modern woman. And in many ways the most memorable and significant thing for us today about the life of Margaret Fuller is that it was a very twentieth-century life—lived in the midst of the nineteenth.

I think it's often hard for us to imagine the lives of the women who lived a century or two ago because the strange trappings, the clothes and rules and customs, seem so entirely different from our own. And it's also hard to imagine that many of the things happening to us have happened thousands of times before, to other girls and other women. But when I read about Margaret Fuller's life, I felt a strong connection to her long-ago world. And I had a profound sense of how many of my own life experiences had been lived before.

She was always fighting against the conventions of her time, in her life and her work. For five years she held "conversations" for well-to-do Boston women, courses

on subjects ranging from literature to classical mythology to art, a kind of continuing education program that she envisioned as filling the vacuum left in the schooling of many women. She edited the transcendentalists' magazine, the *Dial*—without pay—and became the literary critic for Horace Greeley's *Tribune*. Wherever she went, she was the first woman and almost always the only one. To be admitted to these circles must have taken great courage and determination; to succeed must have taken great talent.

It's interesting to find that despite all that, some historians tend to mention prominently the fact that she was awkward, peculiarly dressed, even ugly. Margaret Fuller herself would have found it ironic that, no matter how accomplished the woman, someone was bound to focus on her looks!

Horace Greeley became enraged when she abandoned her reporting from Italy in 1848; he did not know that she was not only the nation's first female foreign correspondent, but also its first pregnant one. She had fallen in love with an Italian nobleman and gave birth to his son when she was almost forty.

"I am determined on distinction," she once told a teacher when she was still a teenager. It is another quote that is used to illustrate her arrogance, but I have always thought it illustrates the strength one young girl must have needed to live a life so different from that of everyone else around her.

—Anna Quindlen

One day, when she was alone with me . . . she said, "Is life rich to you?" and I replied, "It is since I have known you." Such was the response of many a youthful heart to her, and herein was her wonderful influence. She did not make us her disciples, her blind followers. She opened the book of life to us and helped us to read it for ourselves. . . .

To this day, I am astonished to find how large a part of "what I am when I am most myself" I have derived from her.[1]

—Ednah Dow Cheney

CHAPTER ONE

Childhood and Adolescence

At first her school-mates were captivated with her ways; her love of wild dances and sudden song, her freaks of passion and of wit. She was always new, always surprising, and, for a time, charming.[1]
—Margaret Fuller from "Mariana," a short story in *Summer on the Lakes, in 1843*

Farewel my dear Father I am
your affectionate daughter Margaret Fuller
PS I do not like Sarah, call me Margaret alone, pray do![2]
—Margaret Fuller
letter to her father, January 16, 1820

ALL the girls at Miss Prescott's Academy in Groton, Massachusetts, agreed that Margaret Fuller was the smartest person any of them had ever met. As soon as Margaret

arrived at boarding school in the spring of 1824, she had made herself the center of attention by reciting poetry, performing scenes from Shakespeare's plays, putting on funny skits, and talking nonstop. She knew exactly how to attract an audience and keep it. She was so persuasive that she'd convinced her father, Congressman Timothy Fuller, to let her shorten her name from Sarah Margaret to just plain Margaret. She promised to change it back to Sarah when she was an old maid of sixty; until then, she argued, her gracious mother's name, Margaret, would be her inspiration to become more gentle and kind. Hoping to see some improvement in his head-strong daughter's behavior, Congressman Fuller relented.

Had he asked the girls at Miss Prescott's, however, they would have advised him to say no—first, because nothing would ever turn Margaret Fuller into a *proper* young lady; and second, because no one as energetic, stubborn, and bold as Margaret Fuller could hope to live past her *fortieth*, let alone her *sixtieth* birthday.

With her thick honey-blonde hair, swanlike neck, and lovely hands, Margaret would have been considered attractive if she didn't squint and curl her lips so much, if her cheeks were not so flushed, and if she didn't slouch. The eldest in a household full of children, she was the protector, the ringleader, and the spokesperson for her younger brothers and sister. If she talked like a boy, thought like a boy, and walked like a boy, it was her father's fault: until he went to Washington to serve in Congress, he had been her only teacher. Margaret had not attended school with children her own age until she was twelve; consequently, she did not know how to fit in. At Miss Prescott's school, the other girls thought she was just a show-off. When called on in class, she would quote passages of classical literature; preachy and opin-

ionated, she hardly ever let anyone else talk; and when she wasn't talking, she would tap her feet or drum her fingers. Restless and busy all day, she even walked in her sleep at night.

As the school "brain," Margaret got special treatment from the teachers and the headmistress. The other girls resented her for getting away with things, like skipping meals and coming late to dinner. Three weeks after having taken part in a school play, she was still wearing rouge, and no one had made her scrub it off. So the girls decided to teach Margaret Fuller a lesson.

One evening, arriving late to dinner, Margaret scurried to her place and sat down. The girl beside her passed a platter of food and invited her to serve herself. Turning, Margaret noticed that there were bright red blotches of color on the other girl's cheeks. Across the table sat another schoolmate whose cheeks were also rouged. Margaret looked around the room: another and another, and indeed, every single girl in the school dining hall was wearing rouge! The women who served the meals and cleared the tables began to titter. Even the teachers had to struggle to keep from smiling at the practical joke. Choking down her dinner and pretending to ignore what was going on, Margaret was humiliated.

The next morning, Margaret was nowhere to be seen. She failed to appear at lunch or attend afternoon classes, and by evening the teachers were worried. Finally, they broke down her bedroom door and found her sprawled on the floor unconscious. Margaret had suffered an epileptic seizure triggered by the emotional shock of the girls' practical joke. Knowing that everyone in the school was against her, Margaret was deeply hurt. When she recovered, she decided to behave herself. Gradually, the girls sought her out again. Having been cut down to

size, she seemed friendly and likable, for she was a good listener and a loving and affectionate big sister at heart. Eventually, the girls confided their secrets to her.

Unfortunately, Margaret was careless about secrets. She would tell one girl what another had said about her, or her thoughtless jokes would reveal something that would cause rifts between friends. It was not long before every girl in the school was miserable. When the source of the gossip was traced back to Margaret, eight girls complained to Miss Prescott.

After prayers one day, Miss Prescott summoned Margaret to the front of the room where all the girls in the school were gathered. The headmistress repeated the accusations the other students had made against Margaret. Though she denied everything, the sight of all those faces glaring at her made her weak and nauseous. Her head started to ache. No matter what she did, it seemed to turn out wrong. Once again, no one stood up for her. Making things worse was Margaret's realization that she had betrayed her own belief that loyalty and truth are the highest virtues. Disgusted with herself, Margaret blacked out and fell, hitting her head against an iron railing around the fireplace. She sank to the floor as if dead. The school went into an uproar. Everyone turned against the tattle-tales, chiding them for being cruel to a girl who had already suffered one seizure that year. Suppose Margaret Fuller, the daughter of a congressman, were to die?

Eventually, Margaret's eyes fluttered open, but she made no other response. She was taken to her room and put to bed. Deeply depressed and yearning to die, Margaret stayed in bed, neither speaking nor eating for several days. Her head hurt so much, she could not sleep. Taking a turn for the worse, she began to burn with fever. Miss Prescott prepared an herbal tea and

brought it to Margaret's bedside. She begged her to drink the tea so she could get some rest. Nothing Miss Prescott said had any effect. Margaret continued to stare at the wall. Certain that her most brilliant pupil would never recover, Miss Prescott burst into tears and confessed a secret of her own—a story about a humiliation she had once suffered for the sake of friendship. Deeply touched, Margaret finally took Miss Prescott's hand and drank the tea she offered.

Once this crisis passed, Margaret fared better at the school. She learned a great deal about making friends and about her own conflicts. Although she was glad she had gone away to boarding school, she knew she could learn more at home. In late June 1825, Margaret left boarding school by stagecoach and headed home. She had missed her parents and her adoring brothers and sister, and she had missed her father's excellent library. Though her hometown, Cambridgeport, Massachusetts, was dull, only one mile away, past some farms and marshes, was Harvard College, and the city of Boston was a short walk across the bridge over the Charles River.

The Fullers' boxy house, situated on Cherry Street at the corner of Eaton, had a splendid view of the sunset through the garden gate. Timothy Fuller had bought this house while still a bachelor, when the needs of a wife and a houseful of children had been far from his mind. Having put Harvard College and his law studies behind him, he had opened a small law office on Court Street. Active in the Republican party and dreaming of a brilliant political future, he worked hard to establish himself. He even attended dinner parties to rub elbows with influential people, although his heart was not in it. At thirty-two, he fell in love with a beautiful young schoolteacher, Margarett Crane, from Canton, Massachusetts,

a cheerful, affectionate woman, tall, blonde, and blue-eyed, like a Renaissance madonna. There were many differences between the two: Timothy was austere, protective, verbose, and public-spirited, though privately-warm and sensitive, while Margarett was sunny, dependent, tactful, and shy. His favorite pastime was reading Latin authors; hers was gardening. Nevertheless, their love remained fresh and romantic throughout their marriage. They had nine children, two of whom died in infancy. Their first, born May 23, 1810, was Sarah Margaret Fuller, named after Timothy's mother and her own mother.

From the day she was born, her father treated her like a princess. He celebrated her safe arrival in the world by planting twin elm saplings on the front lawn of the house. Recognizing her intellectual gifts, Timothy supervised Margaret's education, for his wife was often preoccupied with running the household. Margaret loved both her parents equally, and she was eager to please them. She spoke clearly and intelligently even as a baby. Unfortunately, Margaret's retentive mind also preserved the tragic events of her life in vivid and frightening detail. Her earliest memory was her saddest: the funeral of her sister Julia Adelaide, who died at the age of two.

> I see yet that beauty of death! ... Then I remember the house all still and dark,—the people in their black clothes and dreary faces,—the scent of the newly made coffin—my being set up in a chair and detained by a gentle hand to hear the clergyman,—the carriages slowly going, the procession slowly doling out their steps to the grave. But I have no remembrance of what I have since been told I

did,—insisting with loud cries, that they should not put the body in the ground.[3]

Margaret always believed that had Julia lived, her relationship with this sister would have enriched her life. Julia would have been the one true friend whose soft, graceful, and lively character would have made Margaret's own personality more gentle. That was not to be. While Margarett Crane Fuller grieved for her dead child, Timothy Fuller threw himself into the education of Sarah Margaret. He saw to it that by four and a half, she could read English. In order to read Roman history and laws as the foundation of the American Constitution, Margaret had to learn Latin. By seven, she was reading Virgil's *Aeneid* and selections from Horace and Ovid. Though intellectually precocious, Margaret was still a child, and the images from these texts frightened her. Following her evening lessons, Margaret often refused to go to bed, for in her dark room she would imagine colossal menacing faces with dilating eyes and mouths and cheeks swelling into hideous proportions. Her shrieks would chase these phantoms away, but once asleep, she could do nothing about her nightmares of horses trampling her body, of trees dripping with blood, or of pools of blood into which she seemed to sink.

Margaret's recurring nightmares and images of death linked the death of Julia Adelaide with the spiritual death of her mother. In many dreams, Margaret saw herself following her mother's coffin to Julia's grave, and she would awaken to find her pillow drenched in tears. She often walked in her sleep, moaning, until someone shook her awake. When she would describe this terrifying, recurrent dream to her father, he would scold her. Twice she was found in convulsions, and she suffered

excruciating migraine headaches which, unlike the night-
mares and sleepwalking, she never outgrew.

By the time she was thirteen, thanks to her father,
Margaret had read all of Shakespeare, Cervantes, and
Molière, as well as Timothy's favorite Latin and Greek
authors. Her classical education guaranteed that she
would be able to mingle with politicians, diplomats, rev-
olutionaries, and literary figures alike. Had she been a
boy, she could have entered Harvard College. However,
the education of a daughter had no purpose, for women
could neither practice a profession, nor hold property,
nor vote. They were expected to live private lives and
let men speak and act on their behalf. Timothy Fuller
believed the condition of American women would im-
prove. He never thought it fair that he and his brothers
had been able to earn money to pay their expenses at
Harvard, while their sisters could not. As a result, Timo-
thy vowed that his own daughters would receive as good
an education as possible.

Descended from Thomas Fuller, who had left Middle-
ton, Essex County, England, in 1638 to settle in the Mas-
sachusetts Bay Colony at Salem, the Fullers were noted
for their nonconformity. Timothy's own father, also
named Timothy, was a 1760 Harvard graduate. A Uni-
tarian minister, he had been driven from his pulpit in
Princeton, Massachusetts, in 1775 for failing to endorse
the cause of the Revolution. In the 1780s, having
returned to Princeton, he was elected delegate to the
Constitutional Convention. When he learned that the
new American Constitution did not outlaw slavery, he
refused to vote for it.

Timothy Fuller, Jr., born July 11, 1778, in Chilmark,
Massachusetts, was a nonconformist like his father. A
brilliant scholar, he was first in Harvard's class of 1801
until he was demoted to second place as punishment for

having participated in a student rebellion. He taught at Leicester Academy, studied law, and was admitted to the Bar in 1804. Timothy Fuller served in the Massachusetts State Senate from 1813 to 1817. Later, he was elected U.S. Congressman from 1817 to 1823, serving as Chairman of the Committee on Naval Affairs. He returned to the Massachusetts State House of Representatives from 1825 to 1828; served as State Councilor in 1828; and was elected again to the State House of Representatives in 1831. Opposed to slavery like his father before him, Timothy Fuller spoke against the Missouri Compromise of 1820. This series of laws attempted to maintain the balance between slave and nonslave states. He served as President John Quincy Adams's campaign manager, hoping to become an ambassador, with his daughter by his side.

Between her lessons and her household chores, Margaret had little time for anything but reading. When she was eight, she made her first friend, Ellen Kilshaw, an elegant young English woman who was in Cambridge visiting her married sister. Over the next few months, the Fullers and Ellen and her relatives exchanged many visits. Margaret adored Ellen and tagged along after her, watching her paint, listening to her play the harp, and pouring out her young soul to her. Ellen found the girl's devotion endearing. As great a listener as Margaret was a talker, Ellen was the first to recognize that this shy and sometimes stuffy little girl was an authentic genius.

Ellen Kilshaw's own destiny impressed upon Margaret the fact that women were not equal in status to men. During her American visit, Ellen learned that her father had lost his vast fortune in the depression of 1819. Upon her return home, Ellen was so desperate for money that though she was a Unitarian, she was about to accept a proposal of marriage from a wealthy Catholic, until the

man's mother objected vehemently to their religious differences and put an end to it. The Fullers were shocked to learn that the formerly affluent and stylish Ellen had only one choice and that was to attempt to earn her own living by working as a governess.

Three weeks after Ellen Kilshaw left Cambridge, her father, now an elected member of Congress, went to Washington. Cut off from the two most beloved people in her life, Margaret became withdrawn, sullen, and resentful. At Christmastime, she refused to welcome her father home, and Timothy finally realized that books were no substitute for companionship. He fretted over his daughter's appearance and manners, quarreled with her about her wish to change her name, and scolded her that at ten, she could not write him a simple letter without sounding like a dowager empress. Hoping to make her more socially acceptable, Timothy enrolled Margaret in Mr. Dickinson's school in Cambridge, while his brother Elisha tutored her in classical Greek. Other instructors were found for music and penmanship. Margaret's only joy was music: she also took dancing lessons to improve her social graces as well as for physical exercise. None of these efforts worked, for Margaret was still sullen and awkward, and her haughty attitude offended everyone.

When Timothy Fuller finally persuaded his wife to accompany him to Washington, Margaret lived in Boston with her aunt and uncle in order to attend Dr. Park's school with her cousin, Susan Williams. It was a very difficult period in her life. Her manners, her posture, her weight, and her complexion were all wrong. She felt she was expected to blend in somehow and be like other girls—less competitive and less outspoken—directly opposite her father's training. When she took top honors away from Susan Channing, the most popular girl at Dr.

Park's school, she was ostracized. Finally, Timothy Fuller withdrew Margaret from Dr. Park's. For the next year and a half Margaret studied at home, though she was invited to parties in Cambridge, where she made friends with a lively group of Harvard students who enjoyed talking with her about literature and politics.

Still, Margaret's aunt and uncle fretted that Margaret seemed to be drawing too much attention to herself when she was around boys. They knew that when it came time for marriage, these same young men who found her witty would seek out girls who made them feel intellectually superior. Fearing that Margaret's outspoken ways would prevent her from finding a husband, they convinced Timothy to put Margaret in boarding school. In 1824, ignoring Margaret's protests that Groton was too far from home, Timothy chose Miss Prescott's school. Once there, Margaret complained bitterly about the rules, her roommate, and the curriculum. She felt that she had been demoted back to the first grade, for the girls were not encouraged to study hard or to respond in class. At Timothy's insistence, Miss Prescott created a more challenging academic program for Margaret. After undergoing a difficult period of adjustment, Margaret had learned how to get along with others and to accept herself.

After leaving at Miss Prescott's school, Margaret enrolled at Mr. Perkins's private school where her independent spirit was finally allowed to flourish. This time, neither her father nor her teachers controlled her studies or limited her exercise. Writing in July 1825 to Miss Prescott, Margaret described her new routine:

> You keep me to my promise of giving you some sketch of my pursuits, I rise a little before five, walk an hour then practise on the piano

till seven, when we breakfast. Next, I read
French,—Sismondi's Literature of the South of
Europe,—till eight, then two or three lectures
in Brown's Philosophy. About half-past nine I
go to Mr. Perkins's school and study Greek
till twelve, when, the school being dismissed, I
recite, go home and practise again till dinner,
at two. Sometimes, if the conversation is very
agreeable, I lounge for half an hour over the
dessert, though rarely so lavish of time. Then,
when I can, I read two hours of Italian, but I
am often interrupted. At six, I walk or take a
drive. Before going to bed, I play or sing, for
half an hour or so, to make all sleepy, and
about eleven, retire to write a little while in
my journal, exercises on what I have read, or
a series of characteristics which I am filling
up according to advice. Thus, you see I am
learning Greek, and making acquaintance
with metaphysics, and French and Italian
literature.[4]

By studying Greek at Mr. Perkins's coeducational
school, Margaret made friends with a number of young
people who would play significant roles in her future.
Many were members of prominent Boston families like
the Fullers, whose ancestors had helped found the
nation and who themselves would one day help shape
American policy and culture. Among them were Oliver
Wendell Holmes and Richard Henry Dana, both of
whom later became distinguished public figures and
writers. These classmates appreciated Margaret's intel-
ligence and enthusiasm as well as her great sense of
humor and vivacious spirit. Feeling more at ease among
these young Bostonians, Margaret's popularity grew. Her

flushed cheeks, her fine, frizzy hair, her embarrassingly large bosom, and her unbecoming homemade clothes seemed unimportant to these bright students. The girls even copied her posture and the casual way she filled the hood of her cloak with books and flung it over her shoulder. Well treated and admired, Margaret continued to understand and appreciate what set her apart from others. "Very well," she told herself, "I will be ugly and bright."

In 1825, the Fullers bought the spacious home known as Dana Hall in Cambridge, signifying Timothy Fuller's continued optimism about his political future. Having served as President John Quincy Adams's campaign manager, Timothy hoped to be named American ambassador to England, France, or one of the Italian states. Though his wife was too shy for a life of public service, he had groomed his daughter to function as his official hostess. To impress those in political power that he and his family were ready for this distinction, Timothy planned a lavish early July dinner-dance to honor his friend John Quincy Adams, the President of the United States. A sort of debutant party for Timothy—now a member of the Massachusetts State Legislature—as well as for sixteen-year-old Margaret, this gala event was to be one of a number of celebrations of the fiftieth anniversary of the signing of the Declaration of Independence. Starting July 1, 1826, church bells rang out and fireworks brightened the sky over Boston Harbor and the Charles River. As Americans began celebrating the birth of their nation, however, no one realized that the second and third presidents—John Adams, ninety, and Thomas Jefferson, eighty-three—had died early on July 4. Boston learned the news on the fifth and, like the rest of the nation, went into mourning.

President Adams left Washington and hurried to

Braintree, Massachusetts, to look after his late father's affairs. Having already accepted Timothy Fuller's invitation to the dinner-dance, he was now uncertain about the propriety of attending a party. In the end, Adams decided to attend, since he felt so connected to Timothy Fuller through religion, friendship, education, and political philosophy. The Fullers breathed a sigh of relief—their plans had not been ruined. Moreover, the president's gesture under such circumstances would magnify Timothy's political importance. Only a few people had been invited to dine with the president, but many guests were expected to attend the ball. Dana Hall was gleaming; extra servants had been hired and trained; punch and an oyster soup were ready for a midnight supper. Having invited twenty-five of her own young friends, Margaret trembled with excitement as she and her mother put the last stitches in her new pink-silk-and-white-muslin ball gown.

The entire Fuller family lined up at the entrance to Dana Hall to greet President John Quincy Adams upon his arrival. After Timothy introduced his children to the president, the younger children—Eugene, William Henry, pretty little Ellen, Arthur, and the toddler, Richard—were sent back to the nursery. Margaret, however, joined the adults in the dining room. Since Mrs. Adams was too ill to attend the banquet, the seating arrangements had to be changed, and Margaret sat beside the quiet, dignified president. She hardly knew what to do or what to say to him. She didn't want to make her usual mistake of talking too much, so she tried her best to restrain herself, without seeming to be rude. It was quite an ordeal. Not knowing exactly what to do, Margaret prayed for the music and dancing to begin. To everyone's surprise, however, at the end of the meal President Adams stood up, thanked his hosts and the

handful of guests for the excellent dinner, and excused himself, saying he had to return to the bedside of his ailing wife.

Adams's early departure embarrassed the Fullers, who had to make excuses all evening to the stream of guests who began arriving a little later for the ball. Lacking the presidential guest of honor, the party centered upon Margaret. Happy, talkative, spirited, with cheeks flushed pinker than her dress, she chatted with every guest and danced exuberantly with all the gentlemen, from the president of Harvard to her shy schoolmates. Though Margaret throughly enjoyed herself that night, President Adams's early exit seemed an omen of the sudden evaporation of the political power of his fellow Jeffersonians over the issue of slavery which Democratic-Republicans like Fuller opposed.

CHAPTER TWO

Bohemian

In an environment like mine what may have seemed too lofty or ambitious in my character was absolutely needed to keep the heart from breaking and enthusiasm from extinction.[1]

—Margaret Fuller

[If] Margaret's life *had an aim* ... If she was ever ambitious of knowledge and talent, as a means of gaining fame, position, admiration,—this vanity had passed before I knew her, and was replaced by the profound desire for a full development of her whole nature by means of a full experience of life.[2]

—James Freeman Clarke

DESPITE Timothy Fuller's hopes for gifted women like his daughter, in the first part of the nineteenth century no American college accepted female students. Too old to attend an academy, Margaret continued to study at

home. Luckily, some of her friends from Mr. Perkins's
school were now attending Harvard Divinity School, and
two of them, Frederick Henry Hedge, who had studied at
Göttingen, in Germany, and Margaret's cousin, James
Freeman Clarke, joined her in translating and discussing
contemporary German texts. The discovery of new Ger-
man authors was due to the lectures of a Harvard profes-
sor, Dr. Charles Follen, a German scholar who had fled
Germany in 1825 seeking political freedom. He lectured
on German literature and philosophy, and he was an
influential spokesperson for liberal causes, such as the
abolition of slavery.

The German texts he discussed, however, had not
yet been translated into English, though commentaries
about these books and plays had been published in Brit-
ish literary journals. The praise of Scottish writer Thomas
Carlyle greatly enhanced the reputation of Johann Wolf-
gang von Goethe (1749–1832). Unlike the classical
authors Margaret and the others had studied, Goethe
broke new ground by revealing his own passions, his
failings, and some of his experiences, especially with his
semiautobiographical romantic novel *The Sorrows of
Young Werther* and the sublime drama *Faust*. In showing
that no one can be happy if he does not follow his own
code, Goethe not only questioned the existence of God,
but claimed that nature provides each individual with
an intuitive sense of good and evil. That one would act—
or not act—because of social convention, and not inner
conviction, was to Goethe the source of tragedy. This
message captivated Margaret and forced her to question
every rule and restriction she encountered. For a
woman, particularly in the nineteenth century, it
required both introspection and courage to live a life of
her own. Goethe's work made a radical impact on Mar-
garet Fuller that lasted her whole lifetime.

Goethe's message was radical and timely. Indeed, Europe was undergoing tremendous social and economic changes. To consolidate power after the collapse of Napoleon's empire, ultraconservative governments, aided by the aristocracy and established religions used repressive measures to try to retain control over the masses and the emerging middle class. While the American democratic system seemed more enlightened, two classes of people in the United States lacked the right to vote, to own property, or to receive an education: women and slaves. This contradicted Goethe's message of individual freedom. When this agnostic notion crossed the Atlantic by way of the English Romantic poets Coleridge, Byron, Shelley, and Keats, it took root among young Harvard intellectuals who borrowed Immanuel Kant's term *transcendental* to describe their own philosophy. In time, the American Transcendentalists' idealization of the beauty of nature and platonic love established the dominant themes of American literature.

On a personal level, their meetings, held every evening at Dana Hall, transformed the young scholars into activists: eventually, the brilliant but often indecisive James Freeman Clarke would find the courage to speak out against slavery, Henry Hedge would draw together the members of the Transcendentalist Circle, and Margaret Fuller would evolve into a self-supporting public figure, educator of women, journalist, and radical.

MARGARET worked well with Henry Hedge and James Clarke, for her friendships with men were intellectually rewarding, even though her blunt, sarcastic jokes sometimes made them uncomfortable. Feeling less stimulated but more relaxed around women, her most emotionally fulfilling relationships were with her close female friends.

Eliza Farrar, the wife of a Harvard professor and mother of one of Margaret's schoolmates, took the stout, self-conscious twenty-year-old Margaret under her wing and introduced her to her circle of women friends in Cambridge. She convinced Margaret to lose weight, tone down her gestures, and simplify her hair style, and by degrees turned Margaret into someone to be listened to rather than someone to be gawked at.

Eliza also introduced Margaret to her young cousin from New Orleans, Anna Barker, a soft-spoken, magnetic southern beauty who had all the mysterious feminine attributes that the cerebral, restless Margaret lacked. Loving Anna as if she embodied the soul of her "gentler half," her deceased sister Julia, Margaret discovered how her emotions refused to follow the rules. As a Transcendentalist she acknowledged feeling divided between her intellectual, creative, "masculine" self and her loving, receptive, and richly "feminine" self. Through her relationship with Anna Barker, Margaret learned how complex and powerful love could be, and that it might be impossible to find someone both idealistic enough and stable enough to unify these two opposing forces within her.

When Goethe died in 1832, the twenty-two-year-old Margaret decided to write his biography, for she was convinced that no one could understand the value of his literary work otherwise. She planned to become more fluent in German, and then after researching his life for a few years, she intended to travel to Germany to finish her project. Unfortunately, President Adams lost the election in 1828, and Timothy Fuller's career began to suffer. The Fullers left Dana Hall and moved to the lovely old mansion called Brattle Hill. In 1833 Timothy decided to retire to a farm in Groton, though there were no schools for the younger children and no servants avail-

able to help run the household. Margaret, now twenty-five, was expected to take charge of the family's domestic situation. Not only would she be isolated from friends her own age, she would also be limited in her intellectual pursuits. Even if she could find time to study, books would be no substitute for stimulating conversation.

Following their graduation from Harvard Divinity School, Margaret's friends began to leave Cambridge. George Davis, a cousin whom she loved dearly, was engaged to be married and moved to another part of Massachusetts; William Henry Channing, nephew of the great William Ellery Channing and now a minister, founded a Unitarian church in Cincinnati, Ohio; Hedge would soon have his own Unitarian congregation in Bangor, Maine; and James Clarke, after some hesitation, was about to depart for a frontier ministry in Kentucky.

Having gone to boarding school in Groton, Margaret knew it was isolated and she did not want to return. Indeed, tragedy struck just after the Fullers moved there. While working with farm implements for the first time, ten-year-old Arthur Fuller suffered a near-fatal head injury that left him blind in one eye. At about the same time, following weeks of illness, baby Edward died in Margaret's arms. Lloyd Fuller, now three years old, frequently wandered off the property, and the family suddenly realized that his intelligence was below normal.

Horrible as these crises were, the ordinary, monotonous routine of the farm affected Margaret more. Her day was spent teaching the children, doing housework and needlepoint, and preparing or cleaning up after meals. She studied when she could after dinner in dim light. Nevertheless, with effort, she finished reading all of Goethe's works, as well as books by other German and Italian writers. She studied European history, architecture, and to Timothy Fuller's delight, the life and let-

ters of Thomas Jefferson, which she and her father
discussed at length. It was a harsh, isolated existence,
one which taught Margaret endurance and patience, and
made her more self-reliant. Yet by depriving her of social
contacts, it intensified her craving for public recognition.

In the fall of 1834, the historian George Bancroft pub-
lished an article in the *North American Review* on Brutus,
one of the ancient Romans who had assassinated Julius
Caesar. After a lively debate with her father, Margaret
submitted a reply to *The Daily Advertiser* and signed her
letter "J." Not only did she see her words in print for
the first time but she also the published response it pro-
voked. Margaret wrote quickly to her friend Hedge:

> It was responded to (I flatter myself by some
> big-wig) from Salem. He detected some igno-
> rance in me. Nevertheless, as he remarked that
> I wrote with "ability" and seemed to *consider
> me* as an elderly gentleman, *I considered* the
> affair as highly flattering and beg you will keep
> it in mind and furnish it for my memoirs as
> such after I am dead.[3]

Like many new authors, Margaret was inspired by her
first taste of fame. She quickly submitted four essays to
a Boston periodical. All were rejected; the only encour-
agement came from some correspondence concerning
the possibility of publishing her translation of Goethe's
play *Torquato Tasso*. Margaret craved recognition, but
apart from becoming an author, only one other mode of
self-expression was permitted to women at that time:
teaching. She asked James Freeman Clarke to find her
a teaching post near him in Louisville, but he discour-
aged her, writing back, "You would find teaching in
Kentucky intolerable, on account of the utter disrespect

and lawlessness of the children here. . . . There is an indifference here which would shock New Englanders as regards human life."[4] Clarke suspected Margaret would get so involved with some new project that she would lose interest in the idea of moving to Louisville.

The winter of 1835 was especially harsh. Margaret's mother and grandmother were both ill, and while taking care of them, Margaret worried that she might never become anything but her parents' housekeeper. Nature, which had once represented solace and freedom to her, closed around her like a prison: furthermore, it was cold and dirty and showed no remorse for the sickness and death it caused. Watching her younger brothers and sister at play, Margaret realized that she had had no childhood. Having learned about life from books, she feared she had lost the capacity to experience it for herself. Recognizing how hard she had worked, her father let her visit Anna Barker and the Farrars in Newport, Rhode Island, that summer, but this brief taste of freedom only plunged Margaret into a deeper depression when she returned to Groton. Her glorification of Goethe's life seemed a sham: *he* had lived a man's life. *She* was a woman.

DURING the 1830s, religious revival and reform created great controversies and debates in the United States, the most dynamic of which occurred in Boston among the Unitarians. Margaret was never religious in the conventional sense, though in 1831, while out for a walk, she had felt herself mystically "taken up into God." Sustained by this memory and trying to save herself from despair, Margaret began to study the Bible in 1835, corresponding heavily with James Clarke and Henry Hedge, both of whom had completed their studies at Harvard Divinity

School and were Unitarian ministers. Margaret found it difficult to follow Goethe's motto, *"Accept the universe"* when she couldn't accept the vice, suffering, and injustice the universe contained. Hoping to achieve spiritual balance, Margaret decided to seek out the most outstanding religious figure of the day, Ralph Waldo Emerson (1803–1882), whom Henry Hedge knew through the Unitarian ministry. As a means of introduction, Hedge sent Margaret's translation of Goethe's *Tasso* to Emerson.

A Harvard-educated minister like his father, grandfather, and other men in his family before him, Emerson had resigned his pastorship of the Second Congregational Church of Boston in 1832. As a visiting lecturer at various liberal churches in New England, he encouraged people to find themselves spiritually and morally in terms of their own practical spheres. While he was mourning the death of his first wife, Ellen Louise Tucker, in 1831, Emerson had gone to Europe. There he had met a number of British intellectuals and began a lifelong friendship with Thomas Carlyle, the essayist who had introduced Goethe's life and work to the English-speaking world. By studying German philosophy and non-Western religions, Emerson began his search for what he called "the realities of the soul." In 1834, when he returned to the United States, he brought back exciting new topics for his lectures and took up residence at Concord, Massachusetts.

At thirty-two and newly married to Lydia Jackson, the once-unpopular Emerson was now a success. He had a special gift for making complex things sound simple. His resonant baritone voice made him an effective and popular speaker. Emerson's voice was so beautiful, in fact, that the poet James Russell Lowell (1819–1894) claimed it made the singing of the church choir seem coarse and discordant by contrast. Emerson timed his pauses so

carefully that his listeners imagined that they were his partners in his reasoning process, and that his witty asides were spontaneous. Emerson, one of the most influential men of the nineteenth century, was in fact a gifted essayist who wrote and rehearsed everything beforehand.

In the spring of 1835, Hedge told his friends he was thinking of publishing a new "transcendental" periodical. Though it would take a while to launch this magazine, he invited Margaret as well as Emerson to contribute. Meanwhile, James Clarke became a member of the staff of a new Unitarian journal, the *Western Messenger*, and asked Margaret to write some articles for him. With his friendly advice and careful editing, Clarke helped Margaret make her style more concise and convincing. Gratified to see her name in print again, Margaret renewed her determination to write Goethe's biography, even though little new information had been published in the three years since his death in 1832. Making her goal even more difficult to achieve was Harvard University Library's policy of excluding women. She also knew that scholars were not likely to support a woman's unladylike investigation into the scandalous private life of a foreign author. If these obstacles did not deter her, she also knew it was unlikely that she would be able to sign her name to her work, even if published, for a woman author at that time hid her identity behind a pen name.

Luckily, in June 1835, while visiting the Farrars, Margaret met Harriet Martineau, a visiting English author. Harriet and Margaret were very similar: both were middle-class liberal Unitarian women intellectuals; both had been traumatized by childhood nightmares; both had disabilities, Harriet's being partial deafness and Margaret's migraines. After the death of her father, Martineau faced such abject poverty that her mother, her sisters,

and she had had to do needlework in order to survive. Even so, she wrote a book and sent the manuscript to several publishers, only to be rejected by all of them. Determined to have her ideas debated in public nonetheless, she put aside enough funds, penny by penny, to have the book printed at her own expense. It was well worth it, for *Illustrations of Political Economy* (1832–1834) was a financial success. Best of all, as far as Margaret was concerned, Harriet Martineau had signed it with her own name.

The success of Harriet Martineau, had proven that there were some avenues open to women. Visiting the United States to observe slavery as a social and economic institution, the zealous reformer Martineau had no patience with Margaret's detached insistence that victims of injustice ought to speak out for themselves. Harriet and her fellow Abolitionists demanded new legislation to outlaw slavery overnight, ignoring the likelihood that Southern states would never give up their slaves without a violent struggle. Though offended by the Abolitionists' emotional appeal and by their Bible-thumping self-righteousness, Margaret was pleased that middle-class women were finding the courage to speak out.

Following her year-long visit, Harriet Martineau planned to sail back to Europe with Eliza Farrar, and they proposed that Margaret accompany them. She could visit England as well as Greece and Rome with ample time to go to Germany to interview Goethe's acquaintances and to consult German libraries. Justifying the trip as part of her education, Margaret begged her father to let her go. His reply, while not an outright *yes*, was a decided *maybe*.

Margaret spent the next few weeks travelling by boat up the Hudson River with the Farrars and their friends.

It was a romantic trip, so blissful that Margaret couldn't help feeling it was a preview of things to come. In addition to Eliza Farrar and Harriet Martineau, the group included a handsome young Harvard graduate, Samuel Gray Ward, who planned to study art in Italy. Like one of Goethe's rebellious young bohemians, Sam declared himself an artist, defying his father's wish that he work for the family mercantile business. Margaret encouraged Sam to become a painter, and though he was seven years younger he taught her how to look at nature as if she were an artist, through detail and color. A dreamy romance between Sam and Margaret developed that would turn into a lifelong friendship, for Sam had already met the beautiful Anna Barker, whom he was destined to love and eventually marry.

Returning from her idyllic visit with the Farrars, Anna Barker, and Sam Ward, Margaret arrived in Groton to find a personal disaster awaiting her. A recently published short story she'd written had deeply offended her cousin, George Davis, and his bride, Harriet Russell. The short story involved a romantic triangle between a recently engaged woman, her fiancé, and a young visitor to Boston. Inspired by a real episode in Harriet's engagement to George, this story not only seemed like a betrayal of trust, but had caused a rift between newlyweds. The unspoken question was whether Margaret's motivation was jealousy, for at one time she had been infatuated with George.

Mortified, Margaret felt she was once again perceived as exposing her friends' confidences to the world. Her head exploded with excruciating pain. This time, the migraines were accompanied by a high fever that lasted nine days. No cure worked, and Margaret thought she was dying. In one of the moments when she was conscious, she remembered that her father stood by her bed-

side, inconsolate with grief and worry. "My dear, I have been thinking of you in the night," he confessed, "and I cannot remember that you have any *faults*. You have defects, of course, as all mortals have, but I do not know that you have a single fault."[5] After this, Margaret rallied, her fever dropped, and those around her began to hope that she might live. Nevertheless, the fates had a new card to play: on September 30, Timothy Fuller staggered into the house, violently ill from the dreaded cholera. He began vomiting and did not stop until he had lost consciousness. On the morning of October 2, 1835, he was dead.

There would be no trip to Europe now. There would be no money. There would not, in fact, be much of anything. Timothy Fuller, lawyer, legislator, and patriarch, had left no will. His financial affairs were a disaster. Since women could not own property, and were considered "dead in the law," the courts appointed Timothy's unmarried brother Abraham as executor of the estate. Margaret was appalled. Added to her remorse, grief, and guilt, she now felt the sting of humiliation. "I have often had reason to regret being of the softer sex, and never more than now," she wrote angrily. "If I were an eldest son I could be guardian of my brothers and sister, administer the estate and really become the head of my family."[6]

No matter how she approached her uncle Abraham, there was no budging him. There was hardly any cash to take care of everyday expenses. Future prospects looked dim. The modest twenty-thousand-dollar estate was to be divided according to the law: one-third to the widow and two-thirds to the surviving children. In this case, the children's share had to be divided into seven equal parts, regardless of need or special circumstances. The two older boys were already self-supporting:

Eugene was teaching in Virginia, and William Henry worked in a store in Boston. However, the younger children—Ellen, Arthur, and Richard—needed to continue their educations and the retarded child, Lloyd, would need special care. Uncle Abraham adamantly refused to spend a penny of Ellen's share on her education, insisting that she find work as a governess; he decreed, furthermore, that one of the younger boys would have to be put up for adoption. Margaret and her mother refused to knuckle under. To survive that winter, they butchered a cow and two hogs and consumed the vegetables and fruits they had painstakingly preserved in the summer months. They barely had enough food to last the long, cold New England winter, but they were determined to defy Uncle Abraham.

Struggling against hardship and the injustice to her family, Margaret was even more determined than ever to live a full life. Refusing to submit to a destiny which threatened to lock her in a vise of family responsibility, she knew she would triumph, for she believed she'd been spared in order to do something significant: something only *she* could do. Her fine education and all her social advantages through her family and friends were not going to be wasted. In February, she wrote to her friend Almira Barlow about her near-fatal illness and how she was coping with the loss of her father:

> [M]y hard-won faith has not deserted me, and I have so far preserved a serenity which might seem heartlessness to a common observer. It was indeed sad when I went back, in some sort, into the world and felt myself fatherless. . . . [M]y prayer is that I may now act with wisdom and energy; and that since I was called

> back to this state of things, it may be to per-
> form some piece of work which another could
> not do.[7]

Despite the Fullers' miserable financial situation, the
family understood the importance of Margaret's dream
of travelling to Europe. It was something Timothy had
intended to allow her to do. Her mother, brothers, and
sister urged her to borrow money against the inheritance
due her. But Margaret now refused, believing she had a
duty to help support them. Not only would she have to
postpone her trip to Europe, but also her biography of
Goethe would have to wait. She hoped to earn a few
dollars by writing articles until she realized the enor-
mous difference between writing to please oneself and
writing to please an editor and the general public. Con-
fronted by the monumental task of keeping her large
family afloat, Margaret lost her self-confidence. "What I
can do with my pen, I know not," she wrote in her
journal. "At present I feel no confidence or hope. The
expectations so many have been led to cherish by my
conversational powers, I am disposed to deem ill-
founded. I do not think I can produce a valuable work."[8]

Margaret's only joy that sad season was the prospect
of meeting the great Ralph Waldo Emerson at last. This
meeting had been proposed a number of times by Henry
Hedge and Elizabeth Palmer Peabody, who had known
Emerson since they were teenagers. Elizabeth boarded at
the rooming house owned by James Freeman Clarke's
mother, and when young Clarke and Hedge met with
Margaret for their German seminars, she often joined
them. Emerson and Lidian, as his wife Lydia was called,
invited Margaret to visit them in Concord for two weeks.
Emerson's first impression of Margaret was not particu-
larly favorable:

She had a face and frame that would indicate fulness and tenacity of life . . . her complexion was fair, with strong fair hair. She was then, as always, carefully and becomingly dressed, and of ladylike self-possession. For the rest, her appearance had nothing prepossessing. Her extreme plainness,—a trick of incessantly opening and shutting her eyelids,—the nasal tone of her voice,—all repelled; and I said to myself, we shall never get far.[9]

However, Margaret handled herself so well on her first day that she soon had the great man laughing "more than he liked." By dinnertime, he was enchanted. "She studied my tastes, piqued and amused me, challenged frankness with frankness, and did not conceal the good opinion of me she brought with her, nor her wish to please. . . . Of course it was impossible long to hold out against such an assault. . . . She had an incredible amount of anecdotes, and the readiest wit . . . and the eyes which were so plain at first, soon swam with fun and drolleries."[10] They enjoyed each other's company so much, she extended her visit an extra week. Years later, Emerson bristled at the suggestion that Margaret was malicious. "Her satire was only the pastime and necessity of her talent, the play of superabundant animal spirits."[11] He knew that to protect her softer side, Margaret had to play the role of the intellectually competitive bluestocking, creating for the public the image of what Emerson dubbed "Margaret's mountainous ME." Emerson discerned that Margaret was, in fact, so affectionate and sympathetic that she was one of the most compassionate listeners he had ever known, comparing her to "the wedding guest to whom the long-pent story must be told."[12]

Emerson also treasured Margaret because she brought so much of the world beyond Concord into his reach. He had mourned the deaths of those closest to him: his first wife, Ellen, died in 1831; his brother Edward in 1834; and in 1835, his favorite brother, Charles. As a contemplative man who loved the solitude of his Concord home near Walden Pond, he more or less demanded that people come to him. Margaret and her expanding circle of friends revitalized his life, especially when she introduced him to Samuel Gray Ward, Anna Barker, and Caroline Sturgis. The mischievous Caroline was Margaret's best friend; nine years younger than Margaret, Caroline and her sister Ellen had been Elizabeth Peabody's pupils. Through Emerson, in turn, Margaret met Elizabeth Hoar, who had been engaged to his late brother Charles, and the innovative educator, Bronson Alcott.

Alcott's Temple School had started off well in 1834. The pupils were allowed to express their own opinions, for Alcott firmly believed that each individual can respond to the voice of an inner divinity. Through Socratic dialogue and "conversations" he encouraged children to comment on any topic. When the public heard that children were allowed to express their own interpretations of the Bible, however, Alcott was accused of going too far, for this was considered sacrilegious. Elizabeth Peabody, Margaret's friend who had been teaching at the Temple School, fully supported Alcott, yet she felt so personally threatened by the uproar that she resigned her post. Alcott offered the position to Margaret, and she accepted it.

In the fall of 1836, Margaret helped her mother put things in order: Arthur was sent to Leicester Academy where his father had once taught; Ellen lived with relatives so that she could attend school in Cambridge; Eugene returned to the Groton farm to study for his law

examinations; and Richard agreed to be responsible for the farm. There may have been a modest income from the properties Timothy Fuller had owned, including some rent from the house on Cherry Street. Margaret made decisions that benefitted her gentle mother and her younger brothers and sisters. Teaching at Alcott's school in Boston provided her with a salary, a sense of accomplishment, and a way to defy Uncle Abraham.

CHAPTER THREE

Transcendentalist and Teacher

What is popularly called Transcendentalism among us, is Idealism. . . . The materialist insists on facts, on history, on the force of circumstances and the animal wants of man; the idealist, on the power of Thought and of Will, on inspiration, on miracle, on individual culture. . . . The Transcendentalist . . . believes in miracles, in the perpetual openness of the human mind to new influx of light and power; he believes in inspiration and in ecstacy.[1]

— Ralph Waldo Emerson

Mr. Emerson . . . has a friend with him of the name of Henry Thoreau who has come to live with him and be his working man this year. H.T. is three and twenty, has been through college and kept a school, is very fond of classic studies, and an earnest thinker yet intends being a farmer. He has a great deal of practical sense, and as he has bodily strength to boot,

he may look to be a successful and happy man. He
has a boat which he made himself, and rows me out
on the pond. Last night I went out quite late and staid
til the moon was almost gone, heard the whip-poor-
will for the first time this year. There was a sweet
breeze full of apple-blossom fragrance which made the
pond swell almost into waves. I had great pleasure. I
think of you in these scenes, because I know you love
them too. By and by when the duties are done, we
may expect to pass summer days together.[2]

—Margaret Fuller
letter to Richard Fuller,
May 25, 1841

IN 1836, Margaret was glad to be living in Boston at her
uncle Henry's home again. Margaret felt comfortable at
Alcott's school, though her own eccentric education had
provided no useful example of how to run a classroom.
She had studied best alone or with a tutor, but having
taught her younger brothers and sisters she knew how
to inspire children by expressing high expectations of
their abilities. To disguise her genuine affection for her
pupils she mimicked the gruffness of her father, which
many of her students eventually realized was an act.
When she began teaching at the Temple School in
December, she realized that a number of her former
friends were shunning her. They did not approve of her
association with Amos Bronson Alcott (1799–1888). A
self-educated farmer's son, Alcott, though not ordained,
was included among the seven Unitarian ministers of the
Symposeum. The others were Emerson, Hedge, W. H.
Channing, and Clarke, as well as Oresks Brownson and
Convers Francis. Informally they dubbed themselves

"Hedge's Club" since their meetings coincided with his monthly visits from Maine.

The Unitarian conservatives regarded Alcott as "dangerous" for encouraging young children to think for themselves about sensitive issues such as the Bible. Despite the controversy, Margaret found teaching at Alcott's school to be rewarding, for she discovered that she liked the freshness of young minds and the children's sweet habit of returning her affection. (Alcott's own daughter, Louisa May, then about four years old, was one of Margaret's pupils.) The school had a pleasant atmosphere with white walls and tall windows to let in plenty of light and warm carpets on the floor. Plaster casts of sculptures filled the niches, and reproductions of paintings hung on the walls. Margaret's distant cousin, the gifted young artist Sarah Clarke, James Freeman Clarke's sister, taught drawing. Since the desks were not bolted to the floor, they could be moved to allow the children to gather in groups for discussions and readings. Apart from arithmetic and geometry, most subjects were taught in the form of lively "conversations," based on the teaching style of Socrates.

Margaret had already decided to offer private foreign-literature lessons to women students in order to earn extra money. She placed an advertisement in a Boston newspaper, announcing that her fee would be fifteen dollars for twenty-four lessons. Prospective students could choose between two programs of study that met two nights a week: one to examine the works of nineteenth-century German authors Schiller, Goethe, Lessing, Tieck, and Richter; and the other to study Italian Renaissance authors Tasso, Petrarch, Ariosto, and Dante. Margaret insisted that the ladies not only translate these texts but also express their personal interpretations of the readings.

In addition to teaching foreign-literature classes two nights per week, Margaret spent another evening a week with elderly Dr. William Ellery Channing (1780–1842). She sat beside him, translating the works of the German theologian De Wette and the philosopher Herder for him since his eyesight was failing. One reason for her devotion to Dr. Channing was the fact that though he was a skeptic, his home was the meeting place of Boston's most vociferous young radicals, such as Elizabeth Peabody, George Ripley, and Dr. Channing's nephews, the poet William Ellery Channing (1817–1901) and the Rev. William Henry Channing (1810–1884). Regarded as the founder of modern Unitarianism and a liberal thinker through and through, at these gatherings Dr. Channing often expressed the most conservative position in order to encourage debates about topics such as the personality of God, astrology, the spartan New England way of life, and other subjects that would later be regarded as typical Transcendentalist themes. For Margaret, surrounded by people she liked and talking about controversial subjects that interested her, these energetic debates may have been too stimulating. Between teaching, researching Goethe's life, and attending concerts and Emerson's lectures, she became overwhelmed and suffered another agonizing period of relentless migraines. "It is but a bad head," she joked sardonically, "as bad as if I were a great man! I am not entitled to so bad a head by anything I have done."[3]

Criticism of Bronson Alcott erupted into a furor with the publication of the second volume of Elizabeth Peabody's transcription of Alcott's *Conversations with Children on the Gospels*. This slim volume was condemned from many otherwise liberal pulpits. One conservative Unitarian minister, Andrews Norton, labelled it "one third absurd, one third blasphemous, and one third obscene."

While Orestes Brownson, Ralph Waldo Emerson, James Freeman Clarke, and Elizabeth Peabody defended Alcott, a number of Margaret's other friends attacked him, and she pleaded with her good friend Henry Hedge not to "cut up" Alcott in the press.

Margaret was scandalized to discover that Bronson Alcott had been condemned by still another of her friends, Harriet Martineau. To Martineau, as long as slavery existed, philosophy was frivolous. Basing her opinion on a single day's observation of Alcott's school, in her new book *Society in America* (1837) Martineau declared that Alcott's utopianism was repulsive and that his pupils were victims of his mischief. (Ironically, Alcott, a staunch abolitionist, would be forced to close down his school in 1839 after he accepted a child of color as his pupil.) Margaret wrote a blunt letter to Harriet, accusing her of failing to investigate her subject thoroughly and of writing a crude tirade against a sincere and innocent man. Martineau never forgave Margaret for her rebuke.

Martineau's cause was abolition; increasingly Margaret's was the rights of women. Though women would have to wait a long time for the right to vote, 1837 marked the coronation of Victoria as Queen of England. In America, Oberlin College let women students take the same courses as men; and two Southerners, Angelina and Sarah Grimké, boldly began their grassroots anti-slavery campaign, proving that women could speak out even when they themselves did not have the right to vote. Although alike in many ways, Fuller and Martineau's differences were so profound in other respects that fifty years later, Martineau's autobiography dismissed Margaret and her circle of women students, some of whom would lead the abolitionist movement in the 1850s, as "gorgeous pedants."

At the end of the school term, Margaret returned to Groton with little hope of continuing at Alcott's school because enrollment had dropped so drastically. Margaret planned to continue researching Goethe's life and translating his writings. One of her friends, George Ripley, wanted to publish a series of studies of foreign literature, and he assured Margaret that he would publish her book on Goethe when it was completed. Quite unexpectedly, Margaret received an offer from Colonel Hiram Fuller (no relation), headmaster of the Green Street School, a new school in Providence, Rhode Island, that utilized Alcott's teaching method. For the proposed salary of a thousand dollars per year, she would teach only morning classes, which would allow her time to write in the afternoons. Margaret accepted.

Unlike Boston, with its banks, its political life, shops, museums, and concert halls, the main industries of Providence were fishing and shipping. Compared with Boston, it was provincial. Even so, the establishment of a progressive school, with its neoclassical architecture and glistening white portico, indicated that the city was becoming more sophisticated. Alcott graciously declined Colonel Fuller's invitation to speak at the dedication ceremony, fearing that the new school's reputation might be tarnished by association with him. Instead, Emerson gave the dedication address on June 10, 1837. The Providence *Journal* noted that Emerson's thoughts on education were "so transcendental that they were scarcely intelligible," which shows that while the term *transcendentalism* was being used, it was only vaguely understood and little appreciated.

Once she began teaching, Margaret found that Colonel Fuller had misled her: she had twice as many students as she'd had at Alcott's school, and they were not as well prepared. Colonel Fuller himself was a difficult man

who did not approve of Margaret's participation in a Whig political caucus meeting. He was not sure what to make of her visit to the *Hercules*, a huge French frigate docked in Narragansett Bay, or her enthusiastic remarks about wanting to command such a ship one day. What was important about her experience at the Green Street School, however, was that Margaret felt increasingly confident in herself as a teacher. Even though she almost had to force the girls to express themselves, she knew they liked her and listened to her. With little social life outside the school to distract her, Margaret kept up a voluminous correspondence with her ever-widening circle of friends and acquaintances. Moreover, she was able to complete her translation of *Eckermann's Conversations with Goethe*, which would be published in Boston in 1839.

ON August 31, 1837, Ralph Waldo Emerson delivered a landmark speech to Harvard's Phi Beta Kappa society in which he called for an evaluation of American culture. Arguing that experience is equal in importance to academic studies, Emerson advocated a radical change in American education and values. His controversial remarks inspired his admirers to gather the next day at his house in Concord. The fourteen New England intellectuals who gathered there became known as "the Transcendentalists." By now "Hedge's Club" included four women: Sarah Alden Ripley, Elizabeth Hoar, Lidian Emerson, and Margaret Fuller. (Harvard professor Convers Francis and two of his former students, Cyrus Bartol and John Sullivan Dwight, were less active members and eventually were replaced by the writers Henry David Thoreau and Theodore Parker.)

The Transcendentalists belief in each person's inborn

divine quality formed the basis for their idealism, includ-
ing their love of nature and their opposition to religious
and racial bigotry, capitalism, and slavery. Their belief in
the quality of spirit strengthened the position of women
within the group. Beyond the common denominators,
however, the Transcendalists had no credo other than
agreeing to disagree. Some, like Emerson, thought that
all formal religions were outmoded, while others clung
to traditional forms of worship. Orestes Brownson, a
socialist, was, by turns, a Presbyterian, a Unitarian, and
a Roman Catholic. Theodore Parker, on the other hand,
remained a Unitarian in order to voice dissent from
within. Margaret believed in a benign but indifferent
God and in a heavenly afterlife which all but the most
determined sinners could attain. Since she had faith in
the gradual evolution of society through each individu-
al's quest for self-realization, she steadfastly refused to
believe that social problems could be solved by legisla-
tion or reform. Unlike the poetic Thoreau and the moody
Emerson, Margaret placed such importance on relation-
ships that she never believed that God could be found
only in nature.

All Transcendentalists shared an enthusiasm for what
Cicero called "the good life." This meant having only
enough money to secure the basic necessities and some
modest pleasures, including travel, good company, and
good food. Pragmatic enough to be critical, almost to a
fault, of the narrow-mindedness and mediocrity of
American society, the Transcendentalists themselves
were free of prejudice and tolerant of all points of view,
and to encourage debate, invited conservatives to join
them. Whatever their differences, the Transcendentalists
were the originators of an enduring and distinctly Ameri-
can philosophy of art and literature that stressed the rela-
tionship between man and nature.

While her Transcendentalist friends supported Margaret's belief in the education of women, her uncle Abraham most certainly did not. He kept insisting that her sister Ellen leave school and find a position as a governess, but recalling the fate of her first friend, Ellen Kilshaw, Margaret would not allow it. Tightening her own belt, she brought Ellen with her to Providence and saw to it that she attended school. Despite her sister's company, however, Margaret felt restless and lonely and so stifled by her environment that she wrote jokingly to Emerson, "And I see no divine person. I myself am more divine than any I see. I think that is enough to say about them."[4]

In June 1838, after her second academic year in Providence, Margaret brought her young, gypsy-spirited friend Caroline Sturgis to Concord to meet Emerson. They carried with them hundreds of engravings that had been loaned to Margaret by Samuel Gray Ward, who had recently returned from his year abroad. These engravings represented the work of the greatest Italian Renaissance and Baroque painters: Raphael, Michelangelo, Titian, Botticelli, and Renzi. Though only shadows of the originals, these engravings made Margaret long to go to Italy. On a second visit, Margaret brought Sam Ward to meet Emerson, and the two men Margaret loved most became good friends.

These two visits to Concord, and a third trip to visit Caroline Sturgis, made Margaret question whether she could continue teaching at the Green Street School. Feeling isolated from her beloved friends and her family, and fearing she would never accomplish anything if she did not move on, she notified Colonel Fuller of her intention to resign. At Christmas in 1838, when she bid her students a sad farewell, she asked them to forgive her if she had been too harsh on them, and she kissed each of them good-bye. She spent the cold winter months at

Groton, studying, writing, and giving private lessons while the property was put up for sale.

In the spring of 1839, a buyer for the farm was found, and Eugene Fuller helped his mother, his brother Richard, and his sisters Margaret and Ellen move to the rural village of Jamaica Plain, only five country miles from Boston. The property included land and a shed for a few farm animals, and the house was spacious enough to accommodate the family as well as two boarders and one or two servants. The younger Fullers saw to it that Margaret could devote most of her time to her writing. She was also attempting to organize her late father's papers.

Once the Fullers were settled at Willow Brook, as the lovely residence was called, Margaret paid a long-over-due visit to the Emersons and their two children, little Waldo, about three, and a newborn baby named Ellen. On July 15, 1838, just prior to Margaret's visit, Emerson had addressed the Harvard Divinity College's senior class. He created a controversy when he asked his listeners to brush aside Scripture and all other mediators of faith and to look for "the new Teacher"—the divinity within themselves—who would reveal how morality is one with science, beauty, and joy. This was considered such heresy that many of Emerson's speaking engagements were cancelled. He became apprehensive about his family's financial security, even though the publicity made Transcendentalism better known.

Responding to the Transcendentalists' interest in European literature, the scholar Elizabeth Peabody opened a lending library and bookstore in the parlor of the West Street home she shared with her two younger sisters. Her inventory included French and German novels, plays, and journals. The bookstore became a casual meeting place for the Transcendentalists, for when they

came to browse, they lingered to talk. Everyone present participated in these extended conversations, with the exception of two painfully shy young men: the future educator Horace Mann and the future novelist Nathaniel Hawthorne, who were courting Elizabeth Peabody's sisters. The banter was informed and witty, and everyone expressed his or her opinion. Typically, after letting others speak first, Margaret would sum up all comments before expressing her own thoughts. Starting off quietly and casually, her articulate manner of speaking, her rich vocabulary, and her citation of numerous literary sources eventually brought home her meaning. Though Margaret had learned much by attending Emerson's lectures, her comments were always spontaneous. She especially loved to poke fun at the faulty logic of her liberal friends and to lampoon the opinions and deeds of their conservative foes.

As Margaret gained more experience mediating these casual sessions, the idea of offering similar colloquia to women started to take shape. Elizabeth Peabody and Bronson Alcott had earned modest fees addressing small private gatherings, but Margaret wanted to spread her seminars over many weeks and to offer topics challenging enough to attract twenty women participants who were willing to pay twenty dollars for ten sessions. Half of the group that met in November 1839 for the first session, in Elizabeth Peabody's bookstore, were Margaret's friends: the three Peabody sisters, Eliza Farrar, Sophia Ripley, Sarah Clarke, Ellen Sturgis Hooper, Anna Barker, and Caroline Sturgis.

The Conversations, as these meetings were called, continued for four years. There were two sessions per year, one in late autumn and the other in early spring. Of the twenty-five to thirty-five women enrolled, some were Margaret's friends and former students, while others

were strangers; some came from the city of Boston, while others came from nearby towns. These "gorgeous pedants," as Harriet Martineau would call them, were the wives, sisters-in-law, mothers, fiancées, and daughters of some of the most prominent men of the day. Most of them opposed slavery, and two, Lydia Maria Child and Louisa Loring, later became world famous as leaders of the abolitionist movement.

Margaret's official topics for discussion were "Education," "The Fine Arts," and "Greek Mythology" but in actuality, the Conversations covered a broad spectrum of subjects, from aesthetics to health. On Saturday mornings at eleven o'clock, Margaret would stand before the semicircle of participants and introduce the morning's topic. Then each woman would write out her own definition of the day's theme which she would read aloud, starting with Margaret. Modeled on Plato's *Symposium*, everyone would question, comment, and give examples until the two hours were up.

A description, written by Edgar Allan Poe, depicts how Margaret Fuller appeared in her public lectures:

> She is of the medium height; nothing remarkable about the figure; a profusion of lustrous light hair; eyes a bluish gray, full of fire; capacious forehead; the mouth when in repose indicates profound sensibility, capacity for affection, for love—when moved by a slight smile, it becomes even beautiful in the intensity of this expression; but the upper lip, as if impelled by the action of involuntary muscles, habitually uplifts itself, conveying the impression of a sneer. Imagine now, a person of this description looking at you one moment earnestly in the face, at the next seeming to look

only within her own spirit or at the wall; moving nervously every now and then in her chair; speaking in a high key, but musically, deliberately, (not hurriedly or loudly,) with a delicious distinctness of enunciation—speaking, I say, the paragraph in question, and emphasizing [certain] words—not by impulsion of the breath, (as is usual), but by drawing them out as long as possible, nearly closing her eyes the while—imagine all this, and we have both the woman and the authoress before us.[5]

The chemistry among the women was excellent. Margaret guided the discussion with a gentle hand, delighted to discover the intellectual potential of each woman. While a few may have felt she controlled the class too much, most regarded her with deep admiration and affection. She made only one mistake: in 1841, she invited men to join the Monday-evening series, but the presence of such gifted speakers as Emerson, Alcott, Ripley, Hedge, Clarke, Jones Very, and William Wetmore Story so overwhelmed the women that they could not find the courage to speak. After this experience, Margaret not only refused to invite men to the Conversations but she also learned an important lesson: that the education of women ought to take place among women.

Margaret undertook another important venture in agreeing to be the editor of the Transcendentalist journal that Henry Hedge had originally proposed in 1839. Margaret was considered the only one patient enough and impartial enough to edit it. George Ripley promised to take care of the business end of things. He hoped to sell enough subscriptions to cover the printing costs and to provide Margaret with a two-hundred-dollar stipend. Margaret had reasonable expectations of the *Dial*, for

there were not many literary journals in America at that time and the Transcendentalists had a special message. She decided that the journal should be neither dogmatic nor bland, and that it ought to stimulate its writers and readers to think for themselves. Even if it became only a vehicle for new ideas, she would consider the *Dial* a success.

Margaret was eager to get started, but there were numerous setbacks. The contributors were so late that in March 1840, after extending the deadline, Margaret filled up the empty pages herself, though her literary style embarrassed her. The first issue of the *Dial* included fiction and nonfiction contributions from Emerson, as well as Parker, Ripley, Alcott, Sarah Clarke, and Ellen Sturgis Hooper. Margaret's "Essay on Critics" turned out to be one of the better pieces. Thanks to Margaret, the disorganized, idealistic, and highly impractical Transcendentalists had managed to launch their own journal. Though no one—least of all Margaret—was completely happy with the *Dial,* the magazine found a readership. In 1841 the printers went bankrupt and demanded a fee for the return of the *Dial's* subscription list. Heroically, Elizabeth Peabody printed one or two issues herself until publication was resumed by a full-fledged printing company. By 1843, however, the *Dial* had run out of funds, and Emerson paid for the printing of the last few numbers.

The *Dial* lasted only three years, but this was long enough to establish the reputations of a number of Transcendentalist authors. The July 1843 issue of the *Dial* (Volume Four, Number One) contained Margaret's most stirring essay, "The Great Lawsuit: Man *versus* Men, Woman *versus* Women," the first radical plea for the rights of women in America. The forty-eight page article demanded that since all souls are created equal, women

were entitled the same rights as men. "We would have every arbitrary barrier thrown down. We would have every path laid open to women as freely as to men," she wrote.[6] She asserted, furthermore, that the typical male education and the arcane and intellectually stifling manner in which it was acquired were not relevant to women. Having observed first hand how the presence of men had intimidated and silenced her women students, Margaret advocated the establishment of women's colleges with women faculty, and, in a somewhat roundabout manner, she called for civil rights and equal employment opportunities for women. Like her fellow Transcendentalists, Margaret believed that a Platonic ideal could be achieved in a relationship between a man and a woman, but not until the legal and educational status of women was greatly improved: "It is the very fault of marriage, and of the present relations between the sexes that the woman does belong to the man, instead of forming a whole with him."[7] Over the next two years, Margaret expanded her ideas into a book entitled *Woman in the Nineteenth Century*. Though the slender book received poor reviews upon publication in 1845, this controversial volume would make the name of Margaret Fuller famous throughout the United States and Europe.

CHAPTER FOUR

Socialist, Feminist

Saturday. Well, good-by, Brook Farm. . . . I have found myself here in the amusing position of a conservative. . . . There are too many young people in proportion to the others. I heard myself saying, with a grave air, "Play out the play, gentles." Thus, from generation to generation, rises and falls the wave.[1]

—Margaret Fuller

Ye cannot believe it, men; but the only reason why women ever assume what is more appropriate to you is because you prevent them from finding out what is fit for themselves. Were they free, were they wise fully to develope the strength and beauty of woman, they would never wish to be men.[2]

—Margaret Fuller

DISCOURAGED by conditions in the real world, some Transcendentalists retreated to Sophia and George Ripley's Brook Farm in Roxbury, Massachusetts, as an experiment in communal living. Charles King Newcomb, John Sullivan Dwight, Christopher Cranch, Nathaniel Hawthorne, and Almira Barlow and her son were some of the permanent residents. As a utopian community, all duties and studies were shared, but they were so eager to have Margaret join them that they were willing to make an exception in her case to let her devote all her time to writing. She turned down their invitation, however, fearing that her special privileges would put too much pressure on her to write something of great importance. Furthermore, she did not believe that retreating from social problems resolved anything. Nevertheless, Margaret was a frequent visitor to Brook Farm, and her mildly retarded youngest brother, Lloyd, lived there for a while. On those visits, she became better acquainted with Nathaniel Hawthorne, who found the Ripley's farm a convenient place to live and write, though he did not share the group's beliefs.

A shy man, Hawthorne was both intimidated and fascinated by strong, independent women like the self-supporting spinster Margaret Fuller and the married Almira Barlow, who had left her husband. Fuller and Barlow blended together in Hawthorne's creative mind and merged into a character named Zenobia in *The Blithedale Romance*, a novel by Hawthorne that was published in 1852, two years after Margaret Fuller's death. Apparently modelled after Margaret, the self-destructive, amoral Zenobia is considered to be Hawthorne's strongest fictional heroine. As if to absolve himself of malice, Hawthrone actually mentions Margaret (and provides a glimpse of her) in the novel when a character finds that someone reminds him of Fuller in the "curve of the

shoulders, and a partial closing of the eyes, which seemed to look more penetratingly . . . through the narrowed apertures, than if they had been open at full width."

As ambivalent as Hawthorne may have been about Margaret, she herself was ambivalent about Brook Farm. The Brook Farm Transcendentalists were followers of Charles Fourier (1772–1837), a French utopian socialist who advocated communal living as an alternative to the materialism and competitiveness of society. Margaret thought that instead of constructing a socialist island within a sea of capitalism it would be better to form a new nation where social equality was possible. Aware that democratic idealism would never succeed in prosperous, civilized New England, where there was an ever-widening gap between rich and poor, Margaret decided to investigate America's frontier.

Margaret's decision to travel through the Great Lakes in the summer of 1843 was inspired by her need for change and transformation. Eager to live what Goethe called an active life, Margaret had been feeling trapped in New England. Hemming her in were society's expectations of her as a middle-class spinster, as well as changes in her most intimate relationships. When Anna Barker and Samuel Gray Ward announced their plans to marry, Margaret underwent tremendous emotional conflict. Their marriage, October 3, 1840, disturbed a number of the Wards' friends, but none more than Margaret. Since she loved both Sam and Anna, she was jealous of their relationship. Furthermore, Margaret resented Anna for accepting Sam's proposal of marriage only on the condition that he work for the family firm. Margaret was even more shocked when Emerson took Anna's side.

Even Margaret's friendship with Emerson was changing. For one thing, he refused to agree with her views on

Sam's decision to become a businessman. Furthermore, Emerson's habitual self-involvement and his inability to express his emotions were beginning to infuriate her. Not even the death of his young son Waldo from scarlettina in January 1842 shook Emerson's emotional detachment. In September 1842, while Margaret and her mother were the Emersons' house guests, the still-grieving Lidian Emerson, who was taking opium to treat a fever, felt so estranged from her husband that an emotional outburst took place at dinner. Lidian was distraught by her impression that her husband was spending all his time with Margaret when, in fact, Emerson had been taking solitary walks and working alone in his library. Scrambling to make peace, Margaret tried to make sense out of the domestic muddle:

> I thought it all over a little, whether I was considerate enough [to Lidian]. As to W. I never keep him from any such duties, any more than a book would. . . . He lives in his own way, & he dont soothe the illness, or morbid feelings of a friend, because he would not wish any one to do it for him. . . . [W]hat does it signify whether he is with me or at his writing. L. knows perfectly well, that he has no regard for me or any one that would make him wish to be with me, a minute longer than I could fill up the time with thoughts. . . . He has affection for me, but it is because I quicken his intellect.[3]

The next day, Lidian insisted that Margaret had failed to pay enough attention to her. Emerson offered not one word of kindness. "He retained his sweetness of look, but never offered to do the least thing," Margaret noted

in her journal, adding sardonically, "I can never admire him enough at such times; he is so true to himself." Emerson could not supply the compassion his wife needed. He could not change because he believed the relationship between his wife and himself was perfect. Lidian, like most of Margaret's married friends, envied Margaret's independence without understanding how frustrating and difficult it was to be alone. While advising Lidian to accept Emerson for what he was, Margaret confided to her journal, "I dont know that I could have fortitude for it. . . . Yet nothing could be nobler, nor more consoling than to be his wife."[4]

During that same September visit, Margaret found herself caught in the middle of another marital conflict. Her brother-in-law, the poet Ellery Channing, arrived in Concord to look for a new home. His young wife, Ellen, Margaret's sister, was expecting their first child. Before Ellen reached Concord from Cincinnati, however, Ellery hurried to Naushon Island, off Cape Cod, to visit Margaret's friend, the free-spirited Caroline Sturgis, who had been in love with him less than two years before. Margaret knew their relationship was Platonic, but when Ellen Channing arrived early in Concord and did not find her husband there to greet her, Margaret did not know what to do. The one-year-old marriage already seemed unstable, and Margaret feared that the truth would crush her sister. Emerson himself was so alarmed that he offered to go to Boston to look for Ellery. Upon his arrival, Ellery gave his wife an honest account of where he had been. When she observed her sister's acceptance of Ellery's excuses, Margaret realized how wives had no choice but to tolerate their husbands' weaknesses.

Through these incidents, Margaret realized how self-absorbed most men were—even her liberal, well-educated, and cultured friends. Thankful she had been born

in the right place and at the right time to know Emerson,
Margaret was tired of doing all the work in their rela-
tionship. She was the one who always went to him—
seeking out *his* home, *his* lectures, *his* opinion—while he
never made a move in her direction. Like the other men
in the Transcendentalist circle, he scorned her desire to
live an active life based on Goethe's philosophy. Marga-
ret finally realized that though he stimulated her *think-
ing,* if he could, Emerson would stop her from *doing*
anything.

As a Transcendentalist, Margaret firmly believed that
American literature and art ought to reflect the American
way of life. She objected to the fact that British traditions
and tastes endured in the United States, even though
America differed from England in many other ways.
Underpopulated, fertile, and multicultural, the United
States was a democratic republic free of a monarchy,
aristocracy, or established religion. Furthermore, Ameri-
ca's vast western wilderness was still largely unexplored.
By exploring the frontier, Margaret hoped to discover
what made American culture and society unique.

Some British books—Harriet Martineau's *Society in
America* (1837) and Charles Dickens' *American Notes*
(1842), for example—had been so harshly critical of
American society and values that she was curious to
know if a native-born American could do better.
Another reason for Margaret to go to the frontier was to
observe relationships between men and women there.
And so, in the summer of 1843, leaving most of her
friends behind, Margaret embarked on an adventure on
the Great Lakes, determined to keep an open mind and
to try to evaluate what she saw by its own standards.
"What I got from the journey," Fuller later remarked,
"was the poetic impression of the country at large; it is
all that I have aimed to communicate."[5]

Her trip began on June 11, 1843. Margaret's travelling companion was her cousin Sarah Clarke, the artist and art teacher from Alcott's school. (Clarke's engravings of scenes from their trip illustrate the book Margaret later published.) Margaret's uncle William and her brother Arthur, as well as Sarah's mother and brother William, lived in Illinois. James Freeman Clarke accompanied his sister Sarah and Margaret from Boston to Niagara Falls. At Buffalo the two women boarded a Great Lakes steamship and James returned to his family and congregation in Boston.

After a brief stop at the red clay bluffs of Cleveland, they sailed slowly toward Detroit, where more passengers came aboard. While the other passengers talked about what they hoped to get out of their future homes, Margaret was busy observing everything around her. Near Detroit, Margaret caught her first glimpse of Native Americans, a group of five men on shore: two were dressed in blue with scarlet headbands and leggings, and the others were wrapped in white blankets. They vanished so swiftly and silently into the woods that Margaret hardly knew what she had seen. The ship went north through Lake St. Clair and Lake Huron, around the tip of Michigan's lower peninsula. They docked at beautiful Manitou Island, which teemed with wildlife although lumberjacks were rapidly stripping it of its valuable timber.

On June 17, 1843, the ship sailed into Chicago's harbor, and Margaret and Sarah disembarked amid a swarm of people. Margaret wrote in her journal, "They are from all parts, all complexions, all temperaments; they have come together for one purpose: Business, and nothing else."[6] Waiting for them on the dock were Mrs. Clarke, Sarah's mother, and her jovial son William. That evening, William took Margaret and Sarah out for a ride

through the prairie that stretched in one unbroken tree-
less line like a vast ocean from Chicago's back door to
the hills of the Dakotas.

> At first the prairie seemed to speak the very
> desolation of dullness. There is no motion
> except of waving grasses as the cattle move
> slowly homeward in the distance. That home!
> Where is it? It seems as if there was no home,
> and no need of one, and there is room enough
> to wander on forever. But after I had ridden
> out and seen the flowers and observed the
> sunset, I began to love because I began to
> know the scene and shrank no longer from the
> "encircling vastness." It is always thus with
> the new form of life: we must learn to look at
> it by its own standard.[7]

Judging a thing by its own standard is never easy;
even the most open-minded people have prior expecta-
tions of how things ought to be. Margaret Fuller the
Transcendentalist was outraged by the exploitation of the
land and forests, and by the sufferings of the Native
Americans, while Margaret Fuller the feminist bristled at
the discovery that pioneer women were worse off than
she and her mother had ever been at the farm in Groton.
In most cases, men had made the decision to move to
the frontier, and their wives and daughters had had no
choice but to go with them. Women exhausted them-
selves in their struggle to maintain an urban middle-
class way of life in the wilderness without gaining legal,
educational, or financial benefits.

Since the Clarke and Fuller families were distantly
related, the trip included a visit to Margaret's uncle Wil-
liam Williams Fuller and her brother Arthur, both of

whom lived in Illinois. With William Clarke as the
wagoneer, Sarah, Margaret, and Mrs. Clarke headed
west across the prairie to Geneva, Illinois, a perfect rep-
lica of a typical nineteenth-century New England river
town. Beyond Geneva, they stopped at a remarkable
house that looked like a large ship, where some English
settlers lived. Built by a former sea captain, the Stephen-
son household included two daughters and a number
of Norwegian servants and field workers. The eccentric
architecture and the combination of English elegance
and crude day-to-day workings of a farm fascinated
Margaret. One of the Stephenson girls travelled with
them, and they shared many adventures, such as spend-
ing a night sleeping on barroom tables at an inn; dis-
covering a Yankee peddler seated in the middle of open
prairie waiting for prospective customers to pass; visiting
the stately English-style Walgren estate; and skidding
down steep hills and around river bends. For Margaret,
this part of the trip was delightful, thanks to William
Clarke, "the pleasantest person one could be with in
such a way, for he has the spirit of light fun and
adventure. . . . He knows his path as a man, and follows
it with the gay spirit of a boy," she wrote in her journal,
adding, "We do not see such people at the East."[8]

Finally, they arrived at the home of Margaret's uncle
William Williams Fuller in Oregon, Illinois. But her
uncle was ill, so Margaret and her companions stayed
across the river with an Irish family, the Henshaws.
Infused with enthusiasm for the beauty of the land, Mar-
garet sensed how happy and noble the native peoples
who had once lived there had been. Seeing the translu-
cent Rock River, she sympathized with Black Hawk,
chief of the Sacs and Foxes, whose defeat in 1832 not
only had opened the way for the white settlements in the
area but had also established the reputation of Abraham

Lincoln, then a young army captain. The courageous Black Hawk's fatal mistake was to break his treaty and cross back into the tribal homeland territory east of the Mississippi. "No wonder he could not resist the longing, unwise though it might have been, to return in summer, to this home of beauty," Margaret observed.[9]

At dawn on the Fourth of July, William took Margaret on a fishing trip to Eagle's Rock. "It was the fourth of July, and certainly I think I had never felt so happy that I was born in America. I do believe Rome and Florence are suburbs compared to this capital of Nature's art."[10] On the evening of the Fourth, about twenty guests attended a party at Uncle William's house. At the end of the huge meal, everyone took turns cranking the handle of an ice cream maker. After sunset, while watching the fireworks, they rowed across the river to town, where three hundred people from the area were celebrating Independence Day. Fiddlers played all night, and the dancing continued well past midnight, when everyone walked home singing and carrying lanterns.

Simple as this way of life may have seemed, when Margaret, William, Sarah, and Mrs. Clarke left Illinois and moved westward, all traces of civilization dissolved. After visiting Arthur Fuller in Belvidere, they returned to Chicago. There, Sarah and Margaret parted from the Clarkes and boarded a steamship, heading north along the Lake Michigan shore to the territory of Wisconsin. When they arrived at Milwaukee, they found the docks thronging with Welsh, Norwegian, German, and Swedish immigrants. Painted Pottawattami danced for coins, while their chief, wearing a fine red blanket and feathers, turned his back, as if he were ashamed. The carnival atmosphere was heightened by the variety of languages spoken and the brightly colored clothes worn by everyone they saw.

Sarah and Margaret stayed in a boarding house, astonished at the construction going on all around them. "The town promises to be sometime a fine one, as it is so well situated. It seems to grow before you, and has indeed but just emerged from thickets of oak and wild roses." The economy was stimulated by immigrant workers, who would often leave the docks carrying their belongings and walk due west until they found work. During their two weeks in Milwaukee, Margaret and Sarah met bigots, deathly ill Pottawattami, Norwegian nobility, independent women, and utopians from western New York. "Had I been rich I might have built a house or set up in business during my fortnight's stay in Milwaukee . . . matters move on there at so rapid a rate. . . . However, I was not sorry to exchange [that scene] for the much celebrated beauty of the island of Mackinaw."[11]

As Margaret and Sarah discovered, the week they had picked for their visit was a significant one at Mackinaw Island, for two thousand Chippewa, Pottawattami, and members of other Native American tribes were congregating there to receive their pensions from the U.S. government. The whole island was a campground teeming with tribespeople resting, courting, and going about their daily business. Margaret was drawn to them, and made her way through the encampment dressed in her usual simple elegance, holding up her parasol against the summer sun, like the proper Bostonian she was and always would be. Though she did not know the languages being spoken, Margaret discovered a way to communicate with these intriguing, gentle people: she sat among some women and took a turn grinding corn, something she had done many times back at the Groton farm. The women took turns examining her spectacles, her fan, her father's pocket watch, and her locket, but they were absolutely astounded by her parasol. A stern-looking

Chippewa father, responding gently to his baby's attraction to the parasol, offered to trade for it a model of a birchbark canoe. Margaret, quite naturally, accepted.

While Sarah remained at Mackinaw to sketch, Margaret took the *General Scott* to Point St. Joseph, an English fort. She persuaded the ship's gruff captain to row her out through the thick fog and help her gather wildflowers. The fog, however, turned into a storm, and after a tour of the island and its sugar maples, she was forced to spend the evening inside the ship. She was furious that she would not be able to shoot the rapids by canoe and camp along the banks of Lake Superior even though the tall tales and jokes told by the hunters and trappers in the dining room were entertaining.

Four days later, Sarah and Margaret journeyed homeward with their notebooks and sketchbooks, their pressed wildflowers, their mementos, and their memories. After their boat stopped for half a day at Detroit to take on additional passengers, they were rudely reminded of the pessimistic and puritanical society they would have to reenter. Overhearing a small group of socialists discussing the doctrines of Fourier, it struck Margaret that these idealists were all going the wrong direction. To establish a new socialist society, she wondered why they were not going "TO rather than FROM the rich and free country where it would be so much easier to try the great experiment of voluntary association."[12]

Before Margaret returned to the Boston area, she stopped in New York City to visit Emerson's brother, William, as well as Henry David Thoreau, who was tutoring William Emerson's children. She also saw Lydia Maria Child and William Henry Channing. In addition, she spoke with *Tribune* publisher Horace Greeley, a dedicated Fourierist who urged Margaret to complete an informed book on her travels. It was to include accurate

and ample documentation, as well as personal opinions and observations. When she returned home, Margaret persuaded the officials at Harvard University to allow her to use their library, thereby becoming the first woman to set foot inside the building.

When *Summer on the Lakes, in 1843* was published the following June by Little & Brown, it was reviewed with less enthusiasm than it deserved. It would seem that the book's major defect was that its author was a woman. Reviewers complained that Margaret was too enthusiastic, that she digressed too often, and that her language was "too cold" and "unfeminine." Orestes Brownson, one of the original Transcendentalists, commented, "Her writings we do not like. We dislike them exceedingly. They are sent out in a slipshod style and have a certain toss of the head about them which offends us. Miss Fuller seems to us to be wholly deficient in a pure, correct taste and especially in that tidiness we always look for in a woman." Even James Freeman Clarke seemed condescending when he called the book "a charming little volume, full of description of scenery and manners in a graceful form. . . . It belongs to a class of which we can rarely find a specimen."[13] It is no wonder, then, that after a second visit to New York in April 1844, Margaret thought she would accept Horace Greeley's offer of a job writing for the *Tribune.*

Before she could do that, however, Margaret knew she had one more thing to accomplish. Now thirty-four years old, she had reached a point in her life and career where the issue of women's rights had become supremely important. She understood that the controversial issue of women's rights deserved better-argued points and more concrete historical examples than her earlier essay, "The Great Lawsuit," had provided. In spring and summer of 1844, she did extensive research. To

complete *Woman in the Nineteenth Century* before her planned departure for New York City in December, Margaret wrote nonstop for seven weeks while vacationing with Caroline Sturgis at Fishkill Landing, on the Hudson River.

She wrote the book in her usual conversational style, sprinkling historical allusions, anecdotes, and fictional digressions throughout the text to make her points, just as she had in writing *Summer on the Lakes*. She finished her task on November 15, declaring herself in the best health she had been in for years and telling her friends that she was looking ahead to "the clangor" of New York, as she put it.

Fuller's conversational style did not compromise the book's importance or its influence. *Woman in the Nineteenth Century* was America's first and only defense of women's rights. It examined the twin issues of equal education and equal civil rights for women, and discussed the contributions made by women in western civilization. Though the women's rights movement was small and slow to develop compared with the abolitionist movement, *Woman in the Nineteenth Century* was well received by the public, despite reviews which called it absurd, hysterical, and immoral.

The most controversial issue in *Woman in the Nineteenth Century* was Margaret's view of the status of married women. She demonstrated that until a woman could get a good education that guaranteed a decent income, no woman could claim she married by choice. Fuller was able to name only three married women geniuses whose accomplishments and reputations exceeded that of their husbands: the French authors Madame de Staël (1766–1817) and George Sand (1804–1876), and the Englishwoman Mary Wollstonecraft (1759–1797). As Napoleon Bonaparte's foe, de Staël was

more a political figure than a literary one, but her 1807 novel *Corinne, or Italy* profoundly influenced Margaret, who even called herself the American Corinne. Mary Wollstonecraft was an English radical whose 1790 book, *Vindication of the Rights of Women*, was one of the few feminist treatises which preceded Margaret's. George Sand, Fuller's contemporary, was a French novelist who had separated from her husband and lived with her lovers, one of whom was the composer Frédéric Chopin. It was no secret that all three writers had also been involved in love affairs. "In breaking bonds," wrote Fuller, "they became outlaws."[14] By mentioning these three particular women, Margaret was treading on thin ice, for their private love lives were considered scandalous, and Fuller's use of them as role models correctly anticipated that not only would women one day demand sexual equality but birth control as well. Fuller protested that women's ignorance about reproduction prevented their enjoyment of sex, and that they were advised to submit passively to their husbands' "urges." By suggesting that married women's economic dependence upon their husbands was a form of prostitution, the conclusion of *Woman in the Nineteenth Century* created an uproar.

A review by Edgar Allan Poe, for example, published in the August 1846 issue of the widely circulated *Godey's Magazine and Lady's Book*, praised Fuller herself, but took her to task for her poor grammar and her subjective point of view:

> "Woman in the Nineteenth Century" is a book which few women in the country could have written, and no woman in the country would have published, with the exception of Miss Fuller. . . . She judges woman by the heart and

intellect of Miss Fuller, but there are not more than one or two dozen Miss Fullers on the whole face of the earth.[15]

By blending Emerson's theme of self-reliance and Goethe's message "to act" with Margaret's own enthusiasm, erudition, and experience, *Woman in the Nineteenth Century* had a lasting impact. It helped focus the efforts of countless other American feminists and educators whose message was being overshadowed by the slavery issue. (It would take, in fact, more than half a century before American women obtained the right to vote, and few late-twentieth-century feminists would claim that the struggle for women's rights is over.) Indeed, *Woman in the Nineteenth Century* correctly predicted that even after women attained the vote and educational equality, they would have to fight constantly to maintain their personal freedom. Margaret realized that there would always be a tendency for women to lose ground if they took their rights for granted. Men cannot be trusted to uphold women's rights forever, for as Margaret had observed many times, though liberal men "seemed so glad to esteem women whenever they could," they would never, under any circumstance, wish they *were* women.

CHAPTER FIVE

Journalist

Every fact, word, thought, idea, theory, notion, line, verse that crowded in the cranium of Margaret Fuller was a weapon. They shot from her like pellets from a steam gun. She bristled all over with transcendentalism, assaulted you with metaphysics, suffocated you with mythology, peppered you with ethics and struck you down with heavy history.[1]
—British reviewer (unknown)

Shall I tell you what always, more or less, mars my pleasure? ... The stream is abundant and beautiful; but it always seems to be *pumped,* rather than to *flow.*[2]
—Lydia Maria Child
letter to Margaret Fuller
August 23, 1844

MARGARET arrived by boat in New York Harbor just as Horace Greeley and his associate, Mr. McElrath, finished printing the first edition of *Woman in the Nineteenth Century*. Greeley and his wife, Mary, had invited Margaret to live with them while she wrote articles for his newspaper, the *Tribune*. The Greeleys' rented home seemed far from the elegant shops on Ladies' Row near Union Square and the commercial center of the city at the tip of Manhattan Island. Like most private homes in New York, the Greeleys' big old yellow farmhouse was constructed of wood. Its long veranda overlooked the picturesque bend in the East River known as Turtle Bay. All up and down the river sailed ships of all sizes and shapes: passenger ships, cargo ships, fishing vessels, steamships, sailboats, and ferries, for no bridge connected Manhattan Island to the mainland. The Greeleys' farm had all the quiet charm Margaret required, yet thanks to the Third Avenue stagecoach, which stopped at the gate, she could easily get to concert halls, museums, bookstores, and other places of interest to a journalist.

It was a good thing that the house and grounds were spacious, for there may never have been a more peculiar threesome under one roof. Like Margaret, both Greeleys were nonconformists who lived according to their own rules. Horace Greeley, a salty-tongued, self-educated eccentric, was so pale that he was sometimes mistaken for an albino. As if to emphasize his peculiar coloring, he always dressed in beige. Inside the Greeley home, the decor was spartan—no curtains, rugs, or pictures; the Greeleys drank no "stimulants"—no tea, no coffee, no liquor—and they were strict vegetarians, with an abhorrence for anything made of animal products such as ivory or leather. Margaret tolerated their bland meals of potatoes and beans, but she refused to give up her tea. In fact, she drank several strong cups a day, which the

Greeleys insisted caused her migraines. Margaret ignored their advice, though she finally consented to pay a visit to Dr. Theodore Leger, a hypnotist they recommended. Dr. Leger would simply point at Margaret's exposed back and gradually raise his hand up the spine toward the base of her head. Though he never touched her, Margaret told her friends that this felt "like having a rod of iron worked into her poor spine."[3] The migraines went away—at least, temporarily—and to the Greeley's vast relief, Margaret was spared the conventional medical treatment of opium, fasting, and bloodletting with leeches.

Mary Greeley, who had attended Margaret's Conversations in Boston, had so much affection for her that her husband was jealous. Greeley (who would one day run for President of the United States) was, as Margaret put it, "a man of the people, and of the *American* people." He teased her about the contradictions he discerned in her nature, for she expected him to offer her his arm to cross a room and to accompany her in the city late at night. Each time Margaret paused at a threshold to allow him to open a door for her, he would mock her by quoting her most famous feminist slogan, "Let them be sea-captains if they will!"

In time, Margaret won over Horace Greeley, and by his own admission, once he knew her better, her superficial faults faded away, allowing him to perceive what he termed her "radiant and lofty soul." Still, if Greeley expressed concern about Margaret's headaches, it was not out of compassion but anxiety that they interfered with her ability to meet his deadlines. A thoroughly professional journalist, Greeley expected all his writers to be as prolific and obsessed with the news as he was. Margaret was a slow writer, however, who enriched her essays with interesting digressions and personal comments. She was also eccentric in her punctuation and spelling. An

excellent editor, Greeley taught her a great deal about the art of writing, for he forced her to write faster and in a more conventional style and to cut her articles to fit the newspaper's limited space. Under his guidance, Margaret's florid style steadily improved. Her two hundred and fifty *Tribune* articles were accurate, forthright, well written, and fiercely liberal. Ultimately, Greeley had to concede that Margaret Fuller had turned out to be a first-class journalist.

Margaret wrote on many topics, and she never shied away from controversy. This was fine as far as Greeley was concerned. By nature sensitive to injustice and brought up to believe in ideals such as equality, fairness, and justice for all, she visited numerous public institutions, like Sing Sing and the Bloomingdale asylum, as well as city jails, and she wrote about the misery she saw there and the need for change. Most of the books she reviewed for the *Tribune* concerned social issues, and she gained a reputation for being an impartial critic of the arts. As a literary critic, she ruffled a few feathers by expressing a dim view of Longfellow, though she admired British and European writers like Sand, Balzac, Tennyson, and Elizabeth Barrett and Robert Browning. She praised American authors Poe, Melville, and Hawthorne, but she was not so enthusiastic about Emerson's second collection of essays, commenting that his ideas seemed too lofty. Emerson, convinced that Margaret's life in New York—indeed, anywhere but Concord—was a penance, asked her to return, but she ignored him, for his lack of enthusiasm for her achievements in New York chilled an already lukewarm friendship.

Not all of Margaret's relationships were tepid, however. Approaching thirty-five, her life was full. With her limited budget she still always managed to dress well, go to plays and concerts, other gatherings, dinner parties,

and where she encountered new people. Among her new friends was a thirty-four-year-old German-born businessman who aspired to be a writer. The charming, handsome, blonde, blue-eyed, and slightly melancholic James Nathan had not heard of Margaret before Mary Greeley introduced them at an evening party in the fall of 1844. Eager to get his poetry published, he confessed he was delighted to meet such a beautiful woman who might be able to help him. Proud of his Jewish heritage, he was looking forward to seeing a diorama of Jerusalem that was on exhibit in New York, and he invited Margaret to accompany him. Direct, eccentric, energetic, and a devoted reader of Goethe, James Nathan was completely different from Margaret's other friends. Their relationship began well, for James seemed knowledgeable, and his comments about Jerusalem's historical significance to both Jews and Christians charmed Margaret completely.

In the same open-minded spirit, Margaret suggested they attend a concert of Handel's *Messiah* together. After that, they sometimes met at the office of her hypnotist, Dr. Leger. None of her friends realized how much time she was spending with James Nathan, or how often love letters flew back and forth between them. Margaret's emotional intensity, Nathan's ambitions, and the secrecy surrounding their relationship set the stage for a passionate love affair. The imaginative Nathan confided his desire to travel and write about romantic places. Inspired by Goethe and Schiller, he would strum a guitar while serenading Margaret as they strolled along the shady banks of the East River.

Margaret was not naïve about relationships between men and women, but she believed that if passions could be restrained, romance could endure. James Nathan, however, was not as innocent as she when it came to affairs of the heart. In fact, once he discovered Marga-

ret's journalistic interest in "abandoned women," he asked her advice about a delicate matter: a young woman whom he had seduced in Germany had pursued him to New York. Instead of being shocked, Margaret met her and helped find her a place to live. Margaret was sympathetic to the woman, for she, too, had done some things she regretted. She never reflected that James Nathan had already run away from one woman who loved him, and that his hero was Goethe, the philanderer, not Emerson, the philosopher.

After three months of courtship, Nathan asked Margaret to become his lover. She reacted with anger and tears, then she wrote him an emotional letter.

Monday, 15th April

My Dear Friend,

What passed yesterday, seemed no less sad today. The last three days have effected as violent a change as the famous three days of Paris and the sweet little garden with which my mind had surrounded your image, lies all desecrated and trampled by the hoofs of the demon who conducted this revolution, pelting with his cruel hailstones me, poor child, just as I had laid aside the protections of reserve and laid open my soul in a heavenly trust. I must weep to think of it, and why, O God, must eyes that have never looked falsehood be doomed to shed such tears![4]

Nathan's reply must have been convincing, because only four days later, Margaret accepted the blame for their misunderstanding. She tried to keep him by her

side as her devoted "admirer," but James was not interested. Tragically, Margaret was too much in love to understand what this would cost her. To escape Margaret without alienating her—and without losing her useful literary connections—James suddenly announced that he had to return to Europe to visit his mother, as well as to write travel articles for the *Tribune*. Believing that he intended to return, Margaret encouraged him to travel, even going so far as to raise a small travel fund from some of her Boston friends and promising to take care of his dog, Josey. While abroad, Nathan hardly ever wrote, though Margaret corresponded faithfully. She remained cheerful, and no one noticed any signs of disappointment—not even her own mother, who visited her during this period. Over the winter months, Margaret herself made plans to go to Europe. James responded coolly to this, offering only to try to meet her in London, while reminding her to see that his article about the Holy Land got published. His cruel suggestion that she abandon his dog Josey on the street should have warned Margaret how things actually stood.

In the winter of 1845, despite her chronic migraines, Margaret was as energetic as ever. Her career as a writer seemed to be a success: sales of *Woman in the Nineteenth Century* were good, and a new edition was about to be printed. Another publishing company, Wiley and Putnam, wanted to publish a collection of her articles under the title *Papers on Literature and Art*, and she was expected to continue as a contributor to the *Tribune*. Though New York was now her permanent home, Margaret felt restless. Political turmoil, the arts—particularly the European novel—and James Nathan's silence were making Europe the focus of her attention.

The liberal Quaker philanthropists Marcus and Rebecca Spring, who were Margaret's friends, proposed that she accompany them and their little boy, Eddie, on an extensive European tour the following autumn. The Springs were socialists, who felt they had a duty to use their wealth to benefit society. Their mission would be to observe the social conditions in Europe and to evaluate the reforms they had heard had been instituted to help the poor. Most of their time in England and Scotland would therefore be spent listening to reformers and observing various institutions in the hope that some of them could be duplicated by the New York charities the Springs supported.

Margaret wanted to accept their offer, but her savings could not cover the costs. Her brothers and her friends, including Sam Ward, loaned her money. The social, economic, and political problems in Europe were ripe to erupt in civil unrest and revolution. Anticipating that these events abroad would be newsworthy, Horace Greeley agreed to pay Margaret ten dollars per article, even though her dispatches might take up to two months to reach New York by ship. Margaret knew this trip would offer unique opportunities to a journalist; but she doubted it would have the power to transform her personal life to the same degree that the European trip planned eleven years earlier. "I do not look forward to seeing Europe now as so very important to me. My mind and character are too much formed. I shall not modify them much but only add to my stores of knowledge. Still, even in this sense, I want much to go. It is important to me, almost needful in the career I am now engaged in. I feel that, if I persevere, there is nothing to hinder my having an important career even now. But it must be in the capacity of a journalist, and for that I need this field of observation."[5]

On August 1, 1846, after months of preparation, Margaret and the Springs sailed for Europe aboard the steamship *Cambria*, which crossed the Atlantic to Liverpool in record time, ten days and sixteen hours. The breakneck speed and the smell and noise of the engine made Margaret so violently seasick that she did not even climb up to the deck until she could see small land birds flying overhead and the outline of a shore in the distance.

Margaret's task was to write articles that would help form American public opinion about providing the poor with new housing, public baths in Edinburgh, and public laundries in London. She planned to report on the status of women employees, such as those who staffed publishing houses, museums, art galleries, and adult education centers for workers. Nevertheless, this was England's bleakest time. While the expansion of the British Empire had created enormous wealth for some, there was such a surplus of displaced peasants and unskilled workers that wages for the few who could find jobs were kept pitifully low. Even the most progressive social programs could not eradicate England's industrial slums. The stupefication and despair of the poor were so extreme that women fed their starving children opium rather than food.

Nothing prepared Margaret and the Springs for the shocking conditions they found. Semiskilled illiterate farm workers had poured into cities like Manchester and Liverpool to compete for jobs. Children, as the cheapest category of labor, filled factories. There were no schools, no health care, no rest, and no future for these children. The poor lived in overcrowded, airless compartments. Outdoors, the air was thick with factory soot. Beggars thronged the streets of Liverpool, and mill girls in Manchester were coarse and drunk. Prostitution and crimes

against personal property flourished. Debtors and thieves were punished by imprisonment, flogging, or deportation to Australian penal colonies. The few sanitary services that the government did provide—like baths and laundries—were instituted more out of fear of epidemics than compassion. The three American observers were overwhelmed. "Poverty in England has terrors of which I never dreamed at home," Margaret observed in her initial *Tribune* article, thus becoming America's first foreign correspondent.[6]

Margaret had read about these harsh conditions, but it was not until she saw them that she understood the socialist tracts of Fourier and others. The previous August, she had translated a long letter from the Paris correspondent of New York's German-language paper, the *Deutsche Schnellpost*, for the *Tribune*. Arguing that political change does not necessarily equate to social change, the article included a citation from Friedrich Engels's *The Condition of the Working Class in England*, which discussed some of Karl Marx's ideas. Margaret was interested in this newest development in socialist theory, for she had a sense of how it would become a political movement in the future. While Marx and Engels, communist theorists, were collaborating on *The Communist Manifesto* (published in 1848), Margaret was observing the same human suffering that was causing riots and revolution throughout Europe.

After a short trip to picturesque Chester, with its Roman and medieval ruins and pastoral beauty, Margaret and the Springs returned to Liverpool to hear a sermon given by the famous preacher, the Reverend James Martineau. They travelled to the Lake District with the preacher to visit his sister, Margaret's former friend, Harriet Martineau, but due to the resentment caused by Harriet's attack on Alcott and Margaret's scathing response,

the two women could not be reconciled, and Margaret spent most of her time with Harriet's other guests and residents of the area, including the elderly poet Wordsworth.

Departing from the Lake District, Margaret and the Springs took a stagecoach north, arriving in Edinburgh, the Scottish capital, after an overnight stop in Carlisle. Upon arrival, Margaret wrote to James Nathan in care of his friend, Thomas Delf, an agent of D. Appleton and Company, the London publishers. When Delf forwarded her letter to Nathan, he added a message of his own: "[H]ow stands your friendship with her, and how will it bear the effects of your contemplated foreign alliance? Is she prepared for such a condition of affairs?"[7]

Despite Edinburgh's romantic associations with Robert Burns and Sir Walter Scott, nothing could soften the blow of what James Nathan's reply finally revealed. Instead of naming a time and place for a romantic reunion, he informed her that he had become engaged to a woman from Hamburg. Margaret was so upset that at first she tried to convince herself that the letter was a forgery. She sent a cool response to Nathan, again in care of Thomas Delf, dismissing its importance, saying she was too busy to give his letter much thought. This, however, was a lie. Her heart was broken. The next day, when the group set off for the Scottish Highlands, Margaret claimed she wanted a good view of the countryside as they travelled. Despite the pouring rain, she climbed up to the coachman's box, where she could ride out of sight of friends who might read the sorrow in her eyes.

They stopped at Perth, at Loch Leven, and at Loch Katrine, and at sunset arrived at Loch Lomond's Lakeside Inn of Rowardennan, at the foot of Ben Lomond. The next day they were to ride to the top of the thirty-two-hundred-foot mountain, but it continued to rain.

Though the skies cleared the following morning, they discovered that the inn's horses had been borrowed by another group, so Rebecca and little Eddie Spring remained behind while Margaret and Marcus set out by foot. It was an exhausting climb, but well worth it; from the summit of Ben Lomond they had a spectacular view of Loch Lomond, a twenty-four-mile sliver of water surrounded by hills. In the late afternoon, Margaret and Marcus started down the mountain, but they lost the trail, for the muddy path had been trampled by a passing flock of sheep. Margaret sat down to rest while Marcus went ahead. After a brief search, he located the trail and called out to Margaret, but his voice echoed off the face of the mountain. When he could not locate Margaret, Marcus continued down the mountain, hoping to find her below.

Seeing the sun set and the fog grow thick around her, Margaret grew impatient. Stumbling and sliding down the muddy slope, she tried to find her way back to the inn on her own. The sunlight faded, and the lights of the inn became visible in the distance, but it was no use: a stream lay in her path, and it was too dark to risk crossing it. Without the sun, the air grew damp and cold. Shivering and shaking, Margaret wrapped her thin shawl around her and tried not to become frightened by the ghosts that seemed to loom before her in the fog. As she felt her body grow colder, she did not know if she could survive the night. This was such a severe test of her endurance and courage that it made James Nathan's betrayal seem unimportant. At dawn, Margaret followed the stream back to a waterfall. When she crossed under the fall, she was rescued by some shepherds who carried her back to her worried companions at the inn. Marcus Spring had organized a search party to look for her, but they had given her up for dead.

Margaret's survival of the near-fatal night on the

slopes of Ben Lomond proved once again that she must do more with her life. No longer would she be satisfied to be an observer or an intellectual commentator of events or injustices. She refused to let Nathan's betrayal paralyze her, for the anger that kept her awake had kept her alive. Therefore, in her next *Tribune* dispatch, in describing Glasgow's slums, she emphasized that poverty was not just a Scottish problem—rather, that the oppression of the working poor was universal, even in the United States. Increasingly alarmed about the potential for violence such conditions could provoke, Margaret tried to persuade her readers to support legislation and other forms of social reforms at home and abroad.

In London, she met British readers of *Woman in the Nineteenth Century*, and some of the British authors she admired. Though most of them appreciated Margaret's eccentric qualities and made her feel at home, the only exception, ironically, was Emerson's close friend, Thomas Carlyle, whose essays on Goethe had so profoundly affected Margaret and her friends in their youth. Emerson's letter of introduction somehow failed to impress Carlyle:

> Margaret Fuller's work as critic . . . has been honorable. . . . She is full of all nobleness, and with the generosity native to her mind and character appears to me an exotic in New England, a foreigner from some more sultry and expansive climate. She is, I suppose, the earliest reader and lover of Goethe in this Country, and nobody here knows him so well. Her love too of whatever is good in French, and especially in Italian genius, give her the best title to travel. In short, she is our citizen of the world by quite special diploma.[8]

Evidently, Carlyle was not persuaded. When they dined
together the first time, it was a highly charged evening,
with Carlyle actually managing to out-talk her. He per-
ceived her as "a strange lilting lean old maid, not nearly
such a bore as I expected." When Margaret paraphrased
Goethe, saying, "I accept the Universe," the acid-
tongued, impatient Carlyle shouted gleefully, "By Gad,
she better!" Later, Carlyle would recall Margaret in terms
that only an egoist like himself could have devised:

> Such a predetermination to *eat* this big Uni-
> verse as her oyster or egg and to be absolute
> empress of all height and glory in it that her
> heart could conceive, I have not before seen in
> any human soul.[9]

Margaret correctly sensed that Carlyle's attitude
stemmed from some secret internal torment, and she
refused to take offense. "[I]t is his nature . . . to crush
the dragons,"[10] was all she commented. After a second
dinner together, while Carlyle continued to harangue the
group with his stream of talk, Margaret drew aside Car-
lyle's elegant and graceful wife, Jane, whom she liked
very much. She also liked Jane's sad-eyed, handsome
Italian guest. This gentleman had been living in England
for twelve years. An essayist himself, who had written
articles about Dante, Goethe, Carlyle, and George Sand,
he had read Margaret's work and knew she was
esteemed by American liberals and literati. Margaret
thought him "by far the most beauteous person" she had
seen. A strikingly handsome man with a broad forehead,
graying hair, and a fashionably tidy beard and mous-
tache, he had a classic profile, with eyes so dark and
intense that Margaret described them as "pure music."
He dressed in black, "in mourning for my country," he

explained. Though he may have been ideal in the way
he presented himself, he was no idealist, but a revolu-
tionary, condemned as a traitor to death *in absentia* by
the Piedmont government in northern Italy. This charm-
ing, saintly man was Giuseppe Mazzini.

Delicate and precocious as a child, the brilliant Maz-
zini had completed his law studies at the University of
Genoa before the age of twenty-one. His intelligence and
generosity endeared him to his fellow students; but
believing in the violent struggle to free Italy from foreign
rule, he joined the *Carbonari,* an underground organiza-
tion that opposed the monarchy. Betrayed and impris-
oned for six months without evidence or trial, Mazzini
formulated his program, *La Giovine Italia* (Young Italy),
which aimed at educating and radicalizing young Ital-
ians. In 1833, after a small revolt within the ranks of
the Sardinian army, he escaped across the Alps, but sev-
eral of his friends were executed and he was sentenced
to death *in absentia.* When the Swiss expelled him from
Geneva, he fled to London, where he continued his mis-
sion, organizing various groups of Italian revolutionaries,
printing pamphlets, and running a night school for Ital-
ian boys. Even in England he was not free from intrigue:
all his correspondence was systematically opened by Sir
James Graham, the British Home Secretary. Based on
information obtained from Graham, the government of
Naples arrested and brutally executed the leaders of
another planned uprising. Once again, Mazzini suffered
the anguish of guilt in having caused suffering to his
comrades. In this connection, Carlyle protested in a letter
to the *Times* that Mazzini was a "man of genius and
virtue . . . worthy to be called martyr . . . who in silence,
piously in [his] daily life, practise[s] what is meant by
that."[11]

With many ideological and intellectual interests in

common, Margaret and Mazzini became close friends. On November 10, the eve of her departure for Paris, Margaret made a touching speech to his night-school students at their fifth-anniversary party. Margaret described that evening for the *Tribune*, reminding her New York readers of Mazzini's mission and adding that Americans should have "an especial interest in Italy, the mother of our language and our laws, our greatest bene-factress in the gift of genius."[12]

Margaret's enthusiastic support for Mazzini's political goals and revolutionary tactics shows how much she had changed. In the past, the risks she had taken had been limited to teaching at a controversial school and con-ducting a secret romance, but her ties to Mazzini put her in real danger. Mazzini had been convicted of treason, a capital crime; his associates were subject to arrest and interrogation, if not torture, imprisonment, and even execution without trial. Nevertheless, Margaret and the Springs boldly proposed to smuggle Mazzini back into Italy. If he could enter Paris in disguise, they felt certain they would be able to provide him with a false American passport and smuggle him into Rome as one of their party.

Margaret and the Springs spent the winter of 1846–47 in Paris. They had hoped for better weather, for in six weeks in London the factory smoke and fog had blocked the sun from view. The Parisian skies were not much better, however, and instead of a glittering jewel, Margaret found Paris in November to be a city of "mud and mist." Not one of the Parisians she had hoped to meet was receptive to her attempts to visit. Nevertheless, Margaret and the Springs made good use of their time. They visited night schools for adults and the *creches*, or day-care centers for the children of working mothers, which Margaret realized was a brilliant arrangement for women. They observed the inhumane, slavelike working

conditions of weavers at Lyons, and they wept while
visiting a school for the mentally disabled. Not only did
the poor suffer from hunger, but the truth about their
situation was suppressed. When a pamphlet called *The
Voice of Famine* began to circulate in Paris, all copies were
confiscated and burned by the police under orders signed
by the king himself. Prostitution was so commonplace
that Margaret decided to write a comprehensive study
of prostitution in all its economic, medical, and social
ramifications.

While the poor starved, the aristocracy continued to
waste money on luxuries. When Margaret and the
Springs attended a presentation at court and a ball at
the royal Palace of Tuileries, they were dazzled by the
opulent beauty and clothes of the gentlemen as well as
the ladies of the court, but they were shocked at the
contrast between the gold brocade garments of the rich
and the tattered rags of the poor. During Christmas Eve
Mass at the cathedral of St. Roch, where rich and poor
knelt before the same altar, Margaret expressed amaze-
ment that Christmas could still be celebrated when
"1800 years has produced so little of the result desired
by Jesus." There was so much tension in Paris that Maz-
zini prudently decided to remain in London. Margaret
understood his motives, yet she was crushed, for she
longed to get involved in something worthwhile. It was
an especially difficult time, since James Nathan's most
recent letter implied that he might extort a favor or
money from her before returning her love letters as she
had requested.

By coincidence, during Margaret's visit, a collection of
her work, *Essays on American Literature*, was published
in Paris in a French translation, though the printers had
mistakenly listed her first name as Elizabeth. Neverthe-
less, with the publication of this volume, and her letters

of introduction, she expected to be able to meet France's leading literary figures, but that was not to be. She especially wanted to meet the controversial novelist George Sand (the nom de plume of Aurore Dudevant), whom she had long admired. Margaret sent Sand a letter of introduction written by Mazzini. For weeks she waited for an invitation, but none arrived. In January 1847, disappointed that her favorite author was ignoring her, and with the day of departure approaching, Margaret decided to go to Sand's residence. When Sand's housekeeper attempted to keep her out, Margaret tried to explain matters, but her pronunciation was not clear. Luckily, just as she was about to give up, Sand appeared in a doorway.

> She was dressed in a robe of dark violet silk, with a black mantle on her shoulders, her beautiful hair dressed with the greatest taste, her whole appearance and attitude, in its simple and ladylike dignity, presenting an almost ludicrous contrast to the vulgar caricature idea of George Sand. . . . As our eyes met, she said, *"C'est vous,"* and held out her hand. . . . [It] made me very happy to see such a woman, so large and so developed a character, and everything that is good in it so *really* good. I loved, shall always love her.[13]

The second meeting between Fuller and Sand occurred a few days later. The composer Chopin, dying of tuberculosis and "frail as a snowdrop," as Margaret put it, performed his compositions for her. A charming conversationalist with a sly sense of humour, Chopin was no longer Sand's lover, but he remained in her household, where she continued to take care of him until his death

in 1849. Through George Sand, Margaret also met Adam
Mickiewicz, Chopin's fellow Pole, who was a poet and
political exile, and a passionate supporter and friend of
Mazzini. The fifty-year-old Mickiewicz, towering, vital,
blue-eyed, and blond, was considered Poland's national
poet for his epic *Pan Tadeusz*. Expelled from Poland by the
Russian czar, he had been allowed to teach Slavic literature
at the Sorbonne until his revolutionary rhetoric offended
King Louis Philippe. Though he had lost his position, Mic-
kiewicz was an optimist. The danger and isolation of a life
in exile, however, had caused his wife to suffer such severe
depression that she had gone insane.

Margaret wrote a letter to Adam Mickiewicz to suggest
that they meet and included a volume of Ralph Waldo
Emerson's poems. Upon meeting, Adam and Margaret
felt such affection for each other that it wasn't long
before they treated each other like brother and sister.
The burly poet ordered her to stop taking herself so seri-
ously, and told her bluntly how much he despised her
Puritanism, her sexual inhibitions, her Quaker friends,
and her bourgeois pretensions. Declaring that he ap-
preciated her *because* she was a woman, he cautioned her
not to let herself sink into depression. Pointing her
toward Italy and toward self-fulfilment, he urged her:

> Learn to appreciate yourself as a beauty, and
> after having admired the women of Rome, say,
> "And as for me, why, I am beautiful!" . . . I
> tried to make you understand that you should
> not confine your life to books and reveries.
> You have pleaded the liberty of woman in a
> masculine and frank style. Live and act as you
> write.[14]

CHAPTER SIX

Italian Romance

O voi che per la via d'Amor passate,
attendete e guardate
s'elli e dolore alcun, quanto'l mio, grave;

O you who tread the path of Love,
do stop and look:
is there such a grief as great as mine?[1]
—Dante, *Inferno*

JUST as Margaret and the Springs were preparing to leave Paris for Italy in the spring of 1847, a letter from Mazzini reached them. He sent his blessing on their journey to his homeland and urged Margaret to meet as many of his countrymen as she could. He knew that many foreigners, were only interested in Italy's art and scenic landscape. Since Italy certainly *looked* like paradise—with its magical blue skies, its immense coast, its magnificent mountains, its splendid architecture, and its

unsurpassed music—foreigners were often disappointed
to discover that real Italians were mere mortals who
could not, and indeed would not, behave like gods. "I
would like you to learn to love not Italy but the Ital-
ians," Mazzini wrote, knowing that Margaret would eas-
ily absorb the Italian spirit, for she had told him how
eager she was to love it.[2]

As Margaret's ship approached the Bay of Naples in
March, the Mediterranean was blasted by "a villainous
horrible wind, exactly like the worst east wind of Bos-
ton," as she described it. When the sun finally did
emerge over Naples, however, Margaret became intoxi-
cated by everything she saw: the view of the Bay of
Naples from Mount Vesuvius, Posillipo, Sorrento, and
Capri. They visited Baia's ruins of ancient temples and
a thermal bath, as well as Cuma, the site of ancient
Cumae, where the sibyls had made their prophecies in
antiquity. Having referred to herself as a sybil, Margaret
breathed in this atmosphere and felt her "Anglo-Saxon
crust" growing thinner and her health improving. Not
only was the climate exhilarating, but all the Italians she
saw seemed full of joy and in tune with the beauty of
their natural environment. Upon her arrival she sent her
first dispatch to the *Tribune* announcing, "Here at
Naples, I have at last found *my* Italy."[3]

Unfortunately, as Margaret would discover, "*her* Italy"
had been divided, both by nature and by man. The 750-
mile-long mountainous peninsula and its two major
islands had been carved into seven different governments
which differed in form, politics, and even currency. All
Italians wanted their nation to be unified, as it had been
in ancient times, although not all agreed on who should
rule. The Pope, as the head of the Roman Catholic
Church, governed the largest area, while Italian aristo-
cratic dynasties and foreign powers controlled the rest.

The economy was weak, illiteracy was widespread, and there were few public services. Peasants and farm workers lived harsh lives, but they were not likely to suffer the abject poverty and degrading human conditions of the industrial north. There was a good-sized middle class and a nationalistic Italian-born aristocracy, though many authorities had unlimited power, for there was no vote, no freedom of speech, and no representative form of government. Hence, there was no legal means to depose them.

Margaret and the Springs departed from Naples, which was ruled by the Bourbons, and travelled north to the Papal States, arriving in Rome in time for Holy Week. Eastertide is Rome's most splendid season, for it celebrates the most profound part of the Roman Catholic liturgy, as well as the beginning of the magnificent Roman spring. Churches are decorated with exquisite flowers and candles, bonfires are lit, and the whole atmosphere, indoors and out, is sacred. The liturgy of that particular week is dramatic, with its reenactment of Christ's triumphant entry into Jerusalem, his suffering, death, and Resurrection. Even for non-Catholics, the elaborate rituals, the incense, the music, and the majestic presence of the papal hierarchy and other dignitaries make this week a spectacle for all the senses.

Margaret and the Springs were welcomed to Rome by a number of Americans. Among the American artists working in the city were two old friends from the Brook Farm community, George W. Curtis and Christopher Cranch. Luther Terry, Thomas Hicks, and the sculptor Thomas Crawford also had studios there. It was a pleasure to be among old friends, but Margaret preferred to visit monuments and churches alone, either during services or during the chanting of Holy Office, when there were no chattering tourists to distract her. Mar-

garet studied the sculptures of Michelangelo and the faded frescoes of Raphael in the dimly lit chapels and churches, and she viewed the Colosseum under the full Easter moon.

She and the Springs went to St. Peter's Basilica on Holy Thursday to observe the rich ceremony that reenacts Christ's triumphant entry into Jerusalem. They returned again on Easter Sunday, April 4. In the event they got separated while exiting the vast basilica, Margaret and the Springs had designated a spot near the entrance where they would meet. After the magnificent Mass was concluded, as Margaret made her way through the throngs of worshipers in Bernini's piazza, she indeed lost sight of her companions. When she arrived at their meeting place, the Springs were nowhere to be found. Observing the sunlight dimming, Margaret fretted that if she waited too long, she might become stranded as she had on the slopes of Ben Lomond, and in Rome, it was not heard of for a woman to walk alone at night.

Once the huge basilica and piazza emptied out, Margaret found herself nearly alone, and uncertain what to do. At last, she heard the sound of footsteps coming her way. Turning, she saw a handsome young gentleman, slender and military in bearing, coming her way. From the way she was dressed and her anxious expression, the young man knew immediately that this interesting foreign lady needed his help. When he bowed and offered his assistance, his gentle, dark eyes and his aristocratic, almost delicate features assured Margaret that he was trustworthy. Margaret found his natural gestures and lively smile were astoundingly graceful. He introduced himself as Giovanni Angelo Ossoli della Torre, the youngest son of a marquis. She showed him the calling card of her hotel on the Corso in the heart of the city,

and he understood that she needed help getting back. There were no more carriages for hire, so they strolled beneath Bernini's long colonnade in the rose-gold sunset. Conversing awkwardly in French and Italian, they walked toward the Tiber, past the Castel Sant'Angelo, crossed the Ponte Sant'Angelo to the other side of the Tiber, then followed the river to the small street that turns into the via Condotti.

After a long silence, Margaret asked Ossoli how he knew the Vatican so well. He explained his family's connection to the papal government: his eldest brother was an administrator who was in charge of one section of Rome and secretary to the Pope's Privy Council, and the other two were colonels in the Pope's *Guardia Nobile* (Guard of Noblemen). Ossoli knew that the antiquated political system no longer worked, and he fervently believed in Mazzini's vision that one day Italy would be united as a democratic republic, without a king or an established religion. When Margaret told him of her friendship with his hero Mazzini, young Ossoli was astonished.

Somehow they communicated beautifully, as if they had always known each other. Margaret spoke awkwardly in Italian, which may have been an asset, for between her simple sentences and his patient, half-French, half-Italian replies, there was no chance of a misunderstanding. Ossoli's eyes told him all he needed to know about Margaret's best qualities—her maternal warmth, her enthusiasm for Italy, and her appreciation of his native city. When they reached the Corso they said good-bye at the doorway of Margaret's hotel, knowing they would meet again.

The next day and the day after that, Giovanni Angelo Ossoli returned to Margaret's residence in the Corso. Serene and solemn, he stood below her window until

she finally noticed him. She dressed quickly and flew downstairs; when she appeared in the doorway—parasol in hand, her bonnet, hat, gloves, and shawl hastily thrown on—his face broke into a bright smile, all the more tender because he had looked so sad just an instant before. He bowed and put himself at her disposal to escort her and her friends around Rome.

As they toured the city in a rented carriage, the Springs explained to Ossoli that they would be leaving Rome in six weeks to journey north through Switzerland and Germany, then home by ship. Ossoli protested that there was so much to see and learn in Rome. Looking steadily at Margaret, he added that there was much to write about.

Ossoli accompanied them to the park which was privately owned by the Borghese family. The Galleria Borghese contained, as it does today, a magnificent collection of paintings and sculptures. As the group walked through the lovely museum, Ossoli seemed more and more fascinated by Margaret, not just as an interesting foreigner but as a woman he desired. Had they noticed, the Springs might have been concerned, though Ossoli would not have understood why. To an Italian like Ossoli, accomplished, gracious, older women like Margaret Fuller were far more desirable than girls who had only beauty to offer. Add to this Margaret's international fame and her connections with Mazzini, and it is easy to see why a young man like Ossoli would be likely to fall in love with her. As for Margaret, who enjoyed the company of younger people, this motherless but earthy and practical aristocrat, with his strong resemblance to her brother Eugene, was already making her heart beat faster.

In the last room of the Galleria, Sala XX, hung the

Galleria's greatest treasure, Titian's masterpiece, the so-called *Amor sacro e Amor profano (Sacred and Profane Love)*. This painting depicts twins: one a sensuous female nude, and the other a worldly woman dressed in a rich, yellow satin gown. Margaret was taken aback. It was not the nude figure that embarrassed her, for she had once said of herself, "I am very destitute of what is commonly called modesty."[4] It was startling how much both figures in the painting resembled Margaret in the red-blond color of their hair and in the features of their mature faces. The natural passionate twin leans toward her more modest but materialistic sister as if to embrace her, for Titian, a neo-Platonist, believed that when passion and intellect—the twin Venuses, or Geminae Veneres—united they form the bridge between heaven and earth. Margaret was well aware that within her were two personalities—an intellectual one and an emotional one—for she had often felt them struggle for dominance and had noted this conflict in her journals. Indeed, Adam Mickiewicz recognized this internal conflict and he had identified what was tormenting her in a recent letter to her in which he stated "For you the first step of your deliverance . . . is to know whether you are to be permitted to remain a virgin."[5] It was blunt, but accurate, her relationship with Ossoli proved that Adam's instincts were right.

Socially, Margaret Fuller and Giovanni Angelo Ossoli were a good match, despite what others thought. They were both poor and neither would ever inherit much money, but both came from prominent and politically powerful aristocratic families. Through her relatives and schoolmates, Margaret was a member of the American elite and her family ties connected her with nearly all the prominent Americans of her day. Similiarly, Ossoli

was an aristocrat, though as the youngest son he depended on his family for his necessities, who in turn depended upon the Pope.

The Ossoli della Torre family is such an old and prestigious clan that inside the fifteenth-century chiesa della Maddalena in Rome stands the family chapel and tomb—which includes Baciccia's "Christ, the Virgin and St. Nicola" (1698)—and an altar dedicated by Pope Clement XIII in April 1767. The family name and crest had been recorded in the Golden Book of Italian nobility for many generations. In the Middle Ages, the family had lived in northern Italy, near Lago di Garda in Lombardy. In more recent times, their property included the castle and lands of Pietraforte, near L'Aquila, and by 1685 they had acquired the Roman *palazzo* on the via Tor di Specchi, where Giovanni now lived with his seventy-year-old father, the Marchese Filippo. One floor of the *palazzo* had been given to Giovanni's older sister, Angela, as part of her dowry when she married the Marchese de Andreis. Giovanni's younger sister, Matilde, lived in Ireland with her husband. His strong-willed eldest brother, Giuseppe, twenty-one years his senior, would one day inherit the estate and the power that went with it. Though the next two brothers, Alessandro and Ottavio, were more kind-hearted, they always sided with Giuseppe in his disputes with Giovanni.

Giovanni Angelo Ossoli had been brought up for only one purpose in life—to be an Ossoli—and for that he was well prepared. As a Roman, he had absorbed information and culture by osmosis. As an aristocrat, "history" to him meant family history. While Margaret had studied Latin in order to read Ovid and Cicero, Ossoli had learned Latin for purely practical reasons: it enabled him to read the family's genealogy, legal documents, and

deeds. Her Italian was that of Petrarch and Dante; his was that of conversation. He knew about practical things, like managing agricultural property, maintaining a *palazzo*, and most important, taking care of horses, weapons, and other military paraphernalia. He was an excellent rider, marksman, and swordsman. As the youngest son, with hardly any income, the practical Giovanni Angelo Ossoli would have been wise to court a woman with a substantial dowry, not a penniless Protestant foreign writer like Margaret Fuller.

Anticipating her departure from Rome, Margaret wrote to her outspoken friend Adam Mickiewicz, describing her impressions of the city and her new friends. The perceptive, intuitive Mickiewicz wrote back, warning her, "Don't leave too hurriedly the places where you feel well; one is rarely free to return. Prolong your good moments! Don't leave lightly those who would remain close to you. In this I refer to that young Italian whom you met in the church."[6] Ossoli was indeed young. Not only was he ten years younger than Margaret, but he seemed vulnerable. When tenderly describing his memories of his mother to Margaret, he spoke like a boy still unable to accept the separation. He would point proudly to a scar on his face, made twenty-five years before by a pet dog who was jealous of his mother's attentions to him as an infant. Now Giovanni dreaded losing his father, whom he deeply loved.

Ossoli may have had a boy's need for mothering, but he had a man's needs as well. Each day that Ossoli spent with Margaret was a day of harmony and joy. Like any other Roman couple, they strolled along the romantic paths of the Pincio, listening to the church bells and watching the processions and rallies in the piazza below. They went by carriage to the countryside, where the perfumed, warm May air and the clear blue skies made all

things seem possible. They shared feelings rather than words. By now, Margaret had experienced infatuation often enough, but this was different. Ossoli was so passionately in love with her, that he spoke about marriage. Margaret was astonished. It seemed impossible that any man would love and desire her this much. A Platonic relationship seemed much more suitable, given their differences in age, nationality, and religion. Marriage to a Protestant required a dispensation from the Church, which would be impossible to obtain over his family's objections. Therefore, Ossoli begged Margaret to become his lover, at least until his father passed away. She refused, urging him to be reasonable. But for Ossoli, it was too late. If she wanted admiration, if she wanted friendship, if she wanted anything but passion, she was dealing with the wrong man.

Much later, Margaret wrote her sister Ellen, "I loved him and felt very unhappy to leave him; but the connection seemed so every way unfit, I did not hesitate a moment."[7] Ossoli suffered, but he did not give up. Until Margaret left Rome, presumably forever, they continued to roam the old walls and columns and sit by the fountains as they had before—only this time, both hearts were aching. "Those nights . . . were worth an age of pain—only one hates pain in Italy."[8] Though it seemed Margaret and Ossoli would never meet again, he did not lose faith. In early June 1847, on the eve of her departure, they said their last good-byes. Ossoli gazed steadily at Margaret and told her firmly, "You will return to me."

"To know the common people, and to feel truly in Italy, I ought to speak and understand the spoken Italian well, and I am now cultivating this sedulously," Margaret wrote to Emerson on June 20, only a few days after leaving Rome. Using her column for the *Tribune* as her

excuse, she informed him she was considering the possi-
bility of not returning to the United States. "If I remain,
I shall have, for many reasons, advantages for observa-
tion and enjoyment, such as are seldom permitted to a
foreigner."[9] It looked as though her financial situation
would improve, for Margaret's disagreeable wealthy
uncle Abraham had died. She was one of his beneficiar-
ies, but as there were a total of sixty-three heirs, her
share of his estate would be tiny. Nevertheless, she asked
her brother Richard to borrow five hundred dollars
against her inheritance. By writing more articles for the
Tribune and living frugally, she thought she might be
able to stay in Italy through the following spring. The
political events were heating up, and she would be able
to report almost firsthand what promised to be history
in the making.

With warmer weather in Rome, there was always the
risk of malaria. In June, Margaret and the Springs con-
tinued to follow their itinerary for the trip north. They
travelled by coach to Florence, 277 kilometers away.
While Rome had seemed opulent, powerful, and danger-
ous, Florence, an independent state ruled by its own
grand duke, appeared to embody the spirit of the Renais-
sance. Relatively inexpensive, the city contained a small
colony of American and British writers and artists. Its
galleries and churches contained works by the great
Renaissance artists and architects, such as Giotto, Bru-
nelleschi, Michelangelo, Leonardo da Vinci, Donatello,
and Botticelli. The restrained and spiritual Florentine
taste suited many people, but Margaret thought the city
lacked the vitality and sensuality she had found in
Rome. The sedate, intellectual Florentines irritated her.
They even insisted on speaking French, just when Mar-
garet was eager to practice speaking Italian. Neverthe-
less, even though Florence was simply too much like

Boston, there were a number of important people living there.

One was the political activist Costanza Arconati, the Marchesa Visconti. The marchesa and her husband were both Milanese. In fact, it would be more accurate to state that the Visconti family *was* Milan. Not always merciful and not always just, for centuries the Visconti dynasty had been independent and powerful. The Arconati family was wealthy, old, and respected, too, but less powerful and certainly less ruthless. During Milan's uprisings of 1821, Costanza and her husband had committed themselves to the liberal cause, financing and organizing the resistance against the Austrians who occupied Lombardy. Too important to be sent to prison, their lands had been confiscated and they had lived in exile in Paris for twenty-six years. In May 1847, the first official act of the newly elected Pope Pius IX had been to grant a general amnesty to political prisoners and exiles. The Viscontis returned to Italy, but they were still barred from Milan.

The election of popular, progressive Pius IX raised the hopes of Italians that their nation would soon be united and freed from foreign domination. Pio Nono was a Lombard whose nationalistic statements had won the support of the people. Margaret had witnessed thousands of singing and cheering Romans throng the streets, in a torchlight parade from the Piazza del Popolo, down the Corso to the Vatican, celebrating the new Pope's announcement that he would allow Rome to have a representative council. Finally, Romans would have a voice in some of the decisions made regarding their city.

Moderates like Costanza thought that Mazzini's vision of a secular government for Italy was too extreme. The Viscontis supported the policies of Abbot Vincenzo Gio-

berti, who advocated the unification of Italy under the Pope. Gioberti's concept made sense, since ninety-eight percent of Italians were Roman Catholics. Religion, however, was not the problem. The problem was that the Vatican's power to make and break laws would become absolute.

To Margaret, with her American ideas about the separation of church and state, and with her Protestant view that the papacy was corrupt and merciless, papal rule over the entire peninsula seemed dangerous. Thus, she and Costanza were far apart politically, though on a personal level, Costanza was a kind-hearted, intelligent, passionate woman who became Margaret's dearest and most intimate friend in Italy.

Margaret had not forgotten the pragmatic Ossoli's observation that there was much to learn and see in Rome. She was, after all, a working journalist, and Italy's struggle for nationhood was the greatest news story of her day. After ten days away from the city and from Ossoli, Margaret made her final decision, and she wrote her brother Richard, "I should always suffer the pain of Tantalus thinking of Rome, if I could not see it more thoroughly than I have yet begun to."[10] She would go with the Springs as far as Switzerland, but she would return in autumn to Rome, where she would spend the winter.

Margaret's *Tribune* articles emphasized the social and political events of the day, rather than the beautiful scenery and landmarks. Her private emotional turmoil seemed to be mirrored by the social upheavals that she was witnessing all around her. As she and the Springs travelled north, they visited the tranquil Umbrian hill towns of Assisi, Perugia, and Arezzo. Margaret's dispatch notes the red poppies and the vineyards and the pale oxen, yet does not fail to observe that the motto *"Viva*

Pio IX!'' was often scrawled defiantly on Assisi's medi-
eval walls. Her feminist eye observed many things that
others had missed in their travels. While visiting an
archaeological excavation of an Etruscan tomb, she was
captivated by several female figures, "dignified and calm,
as the dim lamp-light fell on them by turns. The expres-
sion of these figures shows that the position of women
in these states was noble." Whether Etruscan women
had been equal to their men remains a mystery. Never-
theless, to Margaret these tomb figures resembled the
modern Tuscans she had met in Florence, and she com-
mented in her *Tribune* article how patiently the dignified,
calm Florentines tolerated the rule of their Grand Duke
Leopold: "the people are still and glum as death. This is
all on the outside; within, Tuscany burns."[11]

Margaret and the Springs went northeast to Bologna,
an agricultural city so prosperous it was nicknamed
"Bologna the fat." Europe's first university had been
founded in Bologna in 1075, and for two centuries it
had admitted women as doctoral candidates. Margaret
described memorial plaques which honored Matilda
Tambroni, a professor of Greek, and another woman,
a professor of anatomy, mentioning that Laura Maria
Caterina Bassi had earned her doctorate in philosophy
at the University of Bologna in May 1732 by writing
two theses on Aristotle. The paintings of successful Ital-
ian women artists such as Prosperzia di Rossi, Elizabetta
Sirani, and Lavinia Fontana hung in public galleries in
Bologna. Though the average Italian woman was poorly
educated, the respect Italians gave to women had no
parallel in the United States. Margaret was one of the
few foreigners who recognized the leadership role played
by women saints—such as Saint Catherine of Siena,
Saint Clare of Assisi, and Saint Angela Merici—in Italian

affairs of state, literature, health, and education. She also observed how popular devotion to the Madonna seemed to have had beneficial effects on the way Italian men treated women of all classes.

Seventy-four kilometers east of Bologna lies Ravenna, near the Adriatic coast. In addition to the exquisite medieval mosaics at the Basilica of San Vitale and the Church of San Apollinare Nuovo, Margaret and the Springs visited two tombs of particular interest. The first was the so called Mausoleum of Galla Placidia, daughter, hostage, sister, wife, and mother of emperors, who at the time of her death in 450 A.D. was one of the most powerful women in antiquity. The other mausoleum was the tomb of Dante, Italy's supreme poet. As a political exile from his native Florence, Dante had spent his last four years in Ravenna, where he died on September 14, 1321. For decades, the papal authorities who governed the region had neglected the port, and it had gradually filled in. Without access to the Mediterranean, Ravenna's economy was ruined, and the city was in such decline that there was not a single hotel. Fortunately, Marchesa Costanza Visconti had arranged for Margaret and the Springs to stay as guests of the Count Pasolini at his palace.

The three travellers also visited Ferrara and Padua. In the twelfth century, Ferrara had been a free state and a commercial center due to good management by the powerful Este family. Through marriage, Isabella d'Este and Lucrezia Borgia, two of the greatest women in history, joined this powerful dynasty. The city was full of marvelous *palazzi* and museums. The massive Castello Estense contained two things of interest to Margaret: the elegant Protestant chapel of Renata di Francia, a convert to Calvinism, and the dungeons far below ground, where

Parisina Malatesta, the wife of Niccolo III, and her step-
son Ugo had been imprisoned before their executions for
their adulterous love affair.

Bologna could boast that its university was slightly
older, but its rival at Padua—where the astronomer Gali-
leo had taught—was the first university in the world to
award a doctoral degree to a woman. In 1678, Elena
Cornaro Piscopia completed two philosophy theses, *Si
igitur scire est ut posuimus* and *Quod igitur contraria quo-
dammodum.* A brilliant scholar, Elena was so beloved by
her students and colleagues that after her death in 1684
at the age of thirty-eight, the university had a bronze
coin struck in her memory and permanently installed a
statue of her in the stairway of the lecture hall. Marga-
ret's vision of American women faculty teaching women
students made Elena Cornaro Piscopia's story especially
significant.

Venice, only a short distance from Padua, was so
beautiful and yet so difficult to describe that Margaret
refused to try. Her *Tribune* readers had to be satisfied
with her comment, "Of Venice and its enchanted life I
could not speak; it should only be echoed back in
music."[12] At Venice, Margaret and the Springs parted
company. Having travelled together nearly a year, the
relationship had become strained. Margaret blamed her-
self, noting in her journal, "I was always out of the
body, and they, good friends, were in."[13] This, however,
was not the reason she decided to stay in Europe, as
she had explained to them weeks before. She simply
felt that Europe offered a great opportunity for her.
The Springs worried about Margaret's safety, but they
could not postpone their return voyage. With her net-
work of friends and her increasing fluency, Margaret
was not afraid to remain in a strange and turbulent

country. Indeed, she believed that she was gradually becoming an Italian.

Once the Springs departed, Margaret concentrated on studying Venetian architecture and art at her own pace, which, for the first time, seemed to be slowing down. In a letter to Caroline Sturgis, she wrote, "In the first week, floating alone in a gondola, I seemed to find myself again."[14] After two weeks alone in Venice, Margaret went north to Vicenza to see the splendid Palladio villas; to Verona to see its Roman amphitheater and Juliet's balcony; and to Mantua, the birthplace of Virgil. At Mantua, founded, according to myth, by a woman named Manto, she toured the palace designed and built by Isabella d'Este, the daughter of the Duke of Ferrara. Isabella had lived in Mantua for most of her life as the wife of Francesco II Gonzaga. A great patron of the arts, a warrior, and mother of a dozen children, at her death in 1539 at the age of seventy-five the beautiful Isabella was praised as "the fount and origin of all that is finest in Italy."

From Mantua, Margaret headed north to the lakes. She stopped at one of Byron's favorite haunts, Lago di Garda, a glacial lake rimmed with mountains at the narrow north end and as wide as a sea at the south. From this charming, romantic spot, Margaret travelled to Brescia intending to see its remarkable marble-clad buildings and its ironworks, but she became desperately ill with fever. She was so frightened that she had her carriage stocked with bottled water and went directly to Milan, where friends of the Marchesa Arconati Visconti took care of her. Recovering slightly, she interviewed some young radicals about their experiences as political prisoners held by the Austrians at the dreaded Spielberg prison. They showed her the scars of the tortures they

had endured: branding with hot irons, "Spanish shoes," and iron gloves which had squeezed and maimed the delicate bones and membranes of their hands. She met Gaetano De Castilla, who had survived fifteen years in the Spielberg, after which he had been deported to the United States. He had been allowed to return to Milan since he was so crippled and brain damaged he was considered harmless. Margaret wanted to continue her investigation, for the men were revealing brutal atrocities that would underscore the need for Americans to support the Italian nationalist movement.

The weather, however, turned so hot that as soon as she was strong enough to travel, Margaret hurried north to the Alps and spent the last two weeks of August at the Arconati estate in Bellagio on Lake Como. During this wonderful visit with her friend Costanza, she met other aristocrats—including the brilliant Princess Radziwill of Poland, whose family stories entertained Margaret, who was, as always, an eager listener. Margaret now understood that Italians, no matter how divided they seemed to be by region and custom, were not divided by social class. The histories of these vast and once-powerful families were so intertwined with that of their people that the Italian unity was a cause most of them courageously supported. The Lombard nobility, for example, as descendants of Germanic nomads, might have claimed a distant kinship with their repressive Austrian overlords. In fact, they detested them.

In the fall of 1847, when Margaret returned to Milan to continue interviewing former political prisoners, she discovered that new developments had pushed Italians even closer to revolution. Just after Pope Pius IX had appointed a pro-Italian archbishop as prelate of Milan, the Austrians invaded Ferrara, which was within the Papal States. Margaret's dispatch regarding the outrage

felt by citizens of Milan was published in the *Tribune* in October 1847:

> The Austrian rule is always equally hated, and time, instead of melting differences only makes them more glaring. . . . The Italian nobility have always kept the invader at a distance; they have not been at all seduced or corrupted by the lures of pleasure or power, but have shown a passive patriotism highly honorable to them. In the middle class ferments much thought, and there is a capacity for effort. . . . The lower classes . . . are in a dull state, indeed. The censorship of the press prevents all easy natural ways of instructing them; there are no public meetings, no free access to them by more instructed and aspiring minds. The Austrian policy is to all of them a degree of material well being, and though so much wealth is drained from the country for the service of the foreigners, yet enough must remain on these rich plains comfortably to feed and clothe the inhabitants. Yet the great moral influence of the Pope's action . . . does reach and rouse them, and they, too, felt the thrill of indignation at the occupation of Ferrara.[15]

As if this were not enough, during the celebration in honor of the elevation and consecration of the archbishop, the Austrian police began harassing a group of young men who sang a song praising the Pope. When a group of aristocrats protested, the Austrian military officers were ready to relent, but the Austrian police had already begun rushing the crowd to drive them out of the piazza, and shot them in the back as they tried to

escape. Margaret observed that Austria's policy had become so rigid and merciless that violence would continue until Austrian rule was overthrown. Margaret rallied her readers by reminding them that the most perfect model for all democratic movements was the American Revolution.

> Yet do I meet persons who call themselves Americans . . . who think . . . that the Lombard peasant supping full of his polenta, is happy enough. Alas! I have the more reason to be ashamed of my countrymen . . . who are rich, who travel,—. . . Absorbed at home by the lust of gain, the love of show, abroad they see only the equipages, the fine clothes, the food,—they have no heart for the idea, for the destiny of our own great nation: how can they feel the spirit that is struggling now in this and others of Europe?[16]

Heading back to Florence, Margaret stopped at Pavia to visit the Visconti castle at Belgioioso; at Parma, which had recently returned to Bourbon jurisdiction following the death of the French Empress Marie Louise; and then at Modena, ruled by an Austrian Hapsburg prince who was an Este descendant. These three cities had once known glory as independent states. Their decline under foreign rule was so depressing that as Margaret toured the castles and galleries, she imagined that the portraits of former sovereigns seemed sullen, as if they were skulking in corners, "hoping to hide from the coming storm."[17]

By now, Margaret's strenuous itinerary put her at the brink of collapse. Exhausted and ill, she arrived back in Florence where the sculptor Joseph Mozier and his wife

nursed Margaret back to health. (Formerly an Ohio mer-
chant, the quarrelsome Mozier had risked his life's sav-
ings to study sculpture in Florence.) By early October,
Margaret was fully recovered and eager to be on her
way back to Rome.

CHAPTER SEVEN

Ossoli

My life in Rome is thus far all I hoped. I have not
been so well since I was a child, nor so happy ever,
as during the last six weeks.[1]
 —Margaret Fuller

ON October 13, 1847, Margaret Fuller returned to Rome,
which seemed to welcome her like a mother. Upon
arrival, she wrote to Marcus Spring, "All mean things
were forgotten in the joy that rushed over me like a
flood . . . all other places faded away, now that I again
saw St. Peter's and heard the music of the fountains."[2]

Among the letters being held for her, one from her
mother contained news of family and old friends. Ellen's
marriage to Ellery Channing was failing; William Henry
was doing well as a merchant in Cincinnati; Eugene was
in New Orleans; Arthur remained at home; and Lloyd
had been committed to the Asylum for the Insane in
Brattleborough. Mrs. Fuller described her visit to the

Greeleys in New York City, where she had witnessed a terrible battle between Mary Greeley and her young son, "Pickie." Mrs. Fuller related that little Pickie missed his friend Margaret so much that he had presented Mrs. Fuller with two carnelians that James Nathan had once given him. "Mrs. G. says Mr. Nathan married his wife for her love and knowledge of musick," she commented naïvely, "and that he wishes her to teach after she recovers from the birth of her child."[3] The impact of these words struck Margaret with full force. For years she had secretly longed to have a child of her own. She had written in her journal, "I have no child, and the woman in me has so craved this experience that it has seemed the want of it must paralyze me."[4] More apprehensive than ever about the fate of her love letters, Margaret now had to accept the bitter fact that James Nathan was a married man and a father.

Three days later, on October 16, Margaret found permanent lodgings at 519 via del Corso near the vast Piazza del Popolo. This was an excellent place to observe the political activity that was going on in the streets below her balcony. Replying to her mother's fateful letter, Margaret described her apartment and her landlady, "formerly the mistress of a man of quality who loved her so much that she made him marry her before his death, so that she is a Marchioness, but not received into society. . . . [H]er present lover . . . is a distinguished Italian artist . . . [and] officer of note in the newly organized Civic Guard."[5]

On Monday nights, Margaret received visits from her own friends, such as Christopher and Elizabeth Cranch and the American painters Jaspar Cropsey and Thomas Hicks, as well as Princess Radziwill. In November 1847, the young sculptor William Wetmore Story and his wife Emelyn arrived in Rome from Boston. Story, the son

of a Supreme Court justice, was another Yankee turned
bohemian. The Storys liked the changed Margaret Fuller
they found in Rome. She helped them find a place to
live and saw them daily. Emelyn Story described their
new friendship in her published memoirs this way:

> As soon as she heard of our arrival, [Margaret]
> stretched forth a friendly, cordial hand, and
> greeted us most warmly. . . . To me she seemed
> so unlike what I had known of her in America
> that I continually said to her, "how have I mis-
> judged you—you are not [at] all such a person
> as I took you to be in America." To this she
> replied, "I am not the same person, I am in
> many respects another, my life has new chan-
> nels now and how thankful I am that I have
> been able to come out into larger interests—
> but partly, you did not know me at home in
> the true light."
> . . . Through her [Bostonian] friends . . . I
> learned to think of her as a person on intellec-
> tual stilts, with a large share of arrogance and
> little sweetness of temper. How unlike to this
> was she now—so delicate, so simple, confiding
> and affectionate with a true womanly heart
> and soul sensitive and generous, and, what
> was to me a still greater surprise, possessed
> with broad charity, that she could cover with
> its mantle the faults and defects of those about
> her.
> We soon became acquainted with the young
> Marquis Ossoli and met him frequently at
> Margaret's rooms. He appeared to be of a
> reserved and gentle nature, with quiet, gentle-
> man-like manners, and there was something

melancholy in the expression of his face,
which makes one desire to know more of him.
In figure, he was tall and of slender frame,
dark eyes and hair, and we judged that he was
about thirty years of age, possibly younger. . . .

When at length his Father died, he told Mar-
garet that he [loved her and] must marry her
or be miserable. She still refused to look upon
him as a lover and insisted that it was not
fitting, that it was best he should marry a
younger woman—that she would be his friend
but not his wife. In this way it rested for some
time, during which we saw Ossoli pale,
dejected and unhappy. He was always with
her, but in a sort of hopeless, desperate man-
ner attending her, until at length he convinced
her of his love and she married him.[6]

What Emelyn could not possibly have guessed was
that Margaret and Ossoli had not actually married, but
they had become lovers sometime in November. From
her statements, we know that Margaret did not believe
in marriage. She had always been a passionate woman,
however, without a way of expressing her sexual needs.
Furthermore, with her feelings of oneness with Ossoli,
combined with their mutual desires, Margaret could
finally forget James Nathan's betrayal of her love. To
balance her own needs against society's expectations,
she resorted to deception to protect her family from the
pain they would feel were they to know she was living
what they would consider an immoral life. Her bond
with Ossoli was sincere and complete.

Ossoli assisted Margaret's journalistic work, too.
Through his family connections, he informed her what
Romans were saying and what was happening in the

City. Costanza Arconati supplied news about events in the north, while Mazzini and his supporters in Rome furnished additional information. Margaret's dispatches to the *Tribune* reveal how adept she was at putting together bits of information to verify events and ascertain the truth.

Conditions were ripe for a popular leader to sway the mob with emotional appeals with tragic results as the French Revolution had demonstrated. Angelo Brunetti was such a man. A charismatic man of the people, this rotund wine merchant and horse trader had the full support of the people. Thanks to Brunetti's leadership, the Pope had given in to popular demand for the formation of the Civic Guard, or *Guardia Civica*, which took orders from the new Rome city council. With Margaret's support, Ossoli became a sergeant in the *Guardia Civica*, to the mortification of his elder brothers.

Ossoli's strength of character and courage sustained Margaret. For the benefit of her readers, she proudly described a military review of Ossoli's regiment: "This morning I was out, with half Rome, to see the Civic Guard maneuvering in that great field near the tomb of Cecilia Metella, which is full of ruins. The effect was noble, as the band played the Bolognese march, and six thousand Romans passed in battle array amid these fragments of the great time." Margaret was not the only American in Rome who supported the Republican movement. Other Americans were there to cheer the regiments, and the patriotic sculptor Thomas Crawford had even joined the Civic Guard. Most of the American expatriates were outraged by the indifference of the papal government toward poverty and education, and they found the harsh censorship of all literature and public opinion to be intolerable.

The independent kingdom of Sardinia included the

region of Savoy and the island of Sardinia. These territories were governed by King Charles Albert, whom Margaret regarded as "worthless," though he had relaxed press censorship somewhat. Count Camillo Cavour took advantage of this to found a newspaper, *Il Risorgimento*, the name by which Italy's fragmented and lengthy unification process became known. Thanks to Cavour's paper, the grievances and injustices which provoked sporadic uprisings throughout the Italian peninsula began to be better understood, and some common political goals were identified. As a journalist, Margaret was pleased that she could have access to more accurate information, but she was skeptical, for she would never trust a king who had condemned a man like Mazzini and who had permitted the execution, exile, and torture of political prisoners. Margaret could foresee that neither this king nor the indecisive Pope could institute enough reforms in time to prevent bloodshed. Throughout Italy there were extremists: at one end of the political spectrum were the ultraconservative San Fedists, and at the other end were the radical leftist *Carbonari*. Increasingly, petty issues exploded into street violence between the two factions. For this reason, the Pope banned all flags except those bearing the papal colors on the day Rome's new Council of State was to be inaugurated. He feared flags of other Italian states would appear draped in black for mourning, which would lead to clashes in the street. The ban infuriated the Americans who had gotten together to stitch up their own Old Glory, expecting it to receive an enthusiastic response.

As Margaret grew closer and closer to the Republican movement in Rome, she began to rally support for the cause of the abolitionists back home. In a persuasive *Tribune* article, she passionately assailed the prejudices of her countrymen:

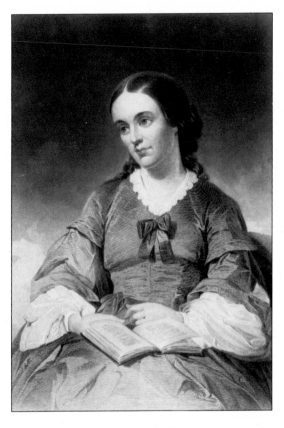

Margaret Fuller.
(Courtesy of the Concord Free Public Library,
Concord, Massachusetts)

The Margaret Fuller House, birthplace of Margaret Fuller, located at 71 Cherry Street, Cambridgeport, Massachusetts. It is a three-story house with four rooms on each floor and a one-room attic. The Fuller family occupied the house until 1826 and owned it until 1844 when it was acquired by Rufus Lamson, a mason. The Margaret Fuller House has been a settlement house since 1902.

(Courtesy of the Cambridge Historical Commission)

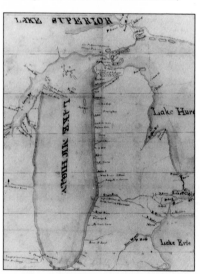

Hand-drawn map of the territory of Michigan, circa 1819.

(Courtesy of the William Clements Library, The University of Michigan)

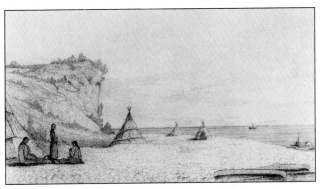

Mackinaw Beach. An engraving of the beach and cliffs on Mackinaw Island, Michigan, by Sarah Clarke, reproduced from *Summer on the Lakes, in 1843*, by Margaret Fuller.
(Courtesy of the William Clements Library, The University of Michigan)

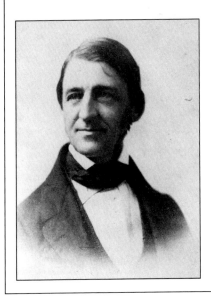

Ralph Waldo Emerson.

(Courtesy of the Concord Free Public Library, Concord, Massachusetts)

Top: Henry David Thoreau.
(Courtesy of the Concord Free Public Library,
Concord, Massachusetts)

Bottom: Portrait of Horace Greeley,
reproduced from his autobiography
Life Without and Life Within, 1859.

(Courtesy of the William Clements Library,
The University of Michigan)

Margaret reading.

(Courtesy of The Schlesinger Library, Radcliffe College)

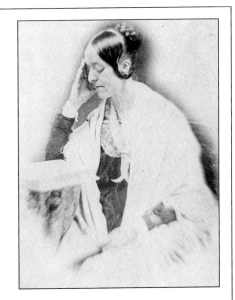

Photograph of Giuseppe Mazzini reproduced from the biography *Joseph Mazzini, A Memoir* by Emile Ashurst Venturi.

(Courtesy of the Harlan Hatcher Graduate Library, The University of Michigan)

Portrait of Giovanni Angelo Ossoli
reproduced from the original daguerreotype.
(Used by permission of the Houghton Library,
Harvard University)

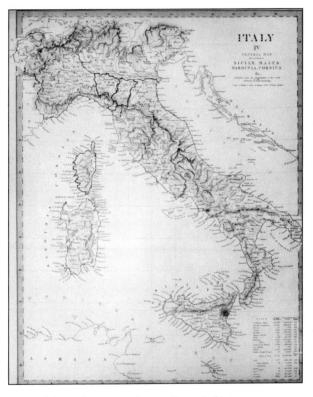

Map showing the political divisions
within the Italian Peninsula, 1845.

(Courtesy of the Department of Rare Books and
Special Collections, The University of Michigan)

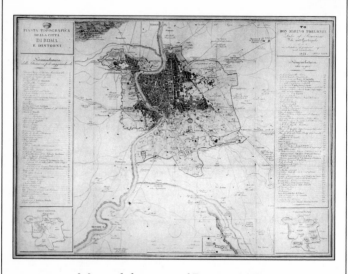

Map of the city of Rome, 1851.

I am sorry to say that a large portion of my countrymen here take the same slothful and prejudiced view as the English, and, after many years' sojourn, betray entire ignorance of Italian literature and Italian life. . . . They talk about the corrupt and degenerate state of Italy as they do about that of our slaves at home. They come ready trained to that mode of reasoning which affirms that, because men are degraded by bad institutions, they are not fit for better.[7]

For the first two weeks in December, Margaret prepared a long article that she urged Horace Greeley to publish on New Year's Day, 1848. She knew that the cause of Italian nationalism and unification deserved American support, for freedom is a universal and eternal issue, and the struggle for civil rights never ends.

Worst of all is this cancer of slavery and the wicked [Mexican] War which has grown out of it. How dare I speak of these things here? I listen to the same arguments against the emancipation of Italy that are used against the emancipation of our blacks; the same arguments in favor of the spoilation of Poland as for the conquest of Mexico. I find the cause of tyranny and wrong everywhere the same—and lo! my country! the darkest offender, because with the least excuse. . . . How it pleases me here to think of the Abolitionists! I could never endure to be with them at home, they were so tedious, often so narrow, always so rabid and exaggerated in their tone. But, after all . . . it was really something worth living and

dying for, to free a great nation from such a
terrible blot, such a threatening plague. God
strengthen them![8]

While Margaret reported on events in Italy, she was
finding it almost impossible to maintain her journalistic
objectivity. "The Italians sympathize with my character
and understand my organization as no other people ever
did," she wrote her mother. "They admire the ready
eloquence of my nature and highly prize my intelligent
sympathy (such as they do not often find in foreigners)
with their sufferings in the past and their hopes for the
future."[9] Margaret could feel the tension mount within
the city. Clearly, an uprising was imminent. Still, she felt
happier than she'd ever felt before. On December 16,
she wrote to her mother, "My life in Rome is thus far
all I hoped. I have not been so well since I was a child,
nor so happy ever, as during the last six weeks."[10]

As happy as she and Ossoli were in their love,
between December 16 and New Year's Day, Margaret
must have become aware of the possibility that she was
expecting a baby. As the Roman skies clouded over and
the rain and dampness penetrated Margaret's apartment
walls, she began to complain of headaches. "I am not
well at all this fortnight," she wrote her brother Richard.
"The first two months of my stay in Rome were the best
time I have had abroad. . . . I passed all my days in the
open air; my nights were tranquil; my appetite and
strength returned. But now, 16 days of rain, unhappily
preceded by three or four of writing, have quite destroyed
me for the present. My health will never be good for
anything to sustain me in any work of value. I must
content myself with doing very little and, by and by,
comes Death to reorganize perhaps for a fuller life."[11]

Letters written to her closest friends in late December

and early January continued to have a morbid tone. To Emerson, Margaret wrote, "Nothing less than two or three years, free from care and forced labor, would heal all my hurts and renew my life-blood at its source. Since Destiny will not grant me that, I hope she will not leave me long in the world, for I am tired of keeping myself up in the water without corks, and without strength to swim." She added that having had some good days in Rome, those days were ending. "Soon I must begin to exert myself, for there is this incubus of the future, and none to help me, if I am not prudent to face it."[12]

By early January, other symptoms must have eliminated all doubt that she was pregnant. Sadly, she could not confide her problem to her mother or even to her closest friends for fear of causing a scandal. She wrote Caroline Sturgis a letter which hints at her condition and her distress.

> I have known some happy hours, but they all lead to sorrow; and not only the cups of wine, but of milk, seem drugged with poison for me. . . . When I first arrived in Rome, I was at first intoxicated to be here. . . . That is all over now, and with this year I enter upon a sphere of my destiny so difficult that at present I see no way out except through the gate of death. It is useless to write of it. You are at a distance and cannot help me. . . . I have no reason to hope I shall not reap what I have sown, and do not. Yet how I shall endure it I cannot guess; it is all a dark sad enigma. The beautiful forms of art charm no more, and a love in which there is all fondness but no help, flatters in vain. I am all alone; nobody around me sees any of this.[13]

Margaret was caught in a paradox: while a woman's passion is equal to a man's only the woman has to deal with the physical discomfort and danger of childbearing. Margaret's lifelong cause was freedom of choice. Though she had freely chosen Ossoli, ironically, the relationship led to a pregnancy which threatened to trap her and prevent her from accomplishing her goals just when they seemed within her grasp.

Nevertheless, seeing her small income being consumed by the costs of heating and lighting her apartment, Margaret wrote more dispatches. Her reports depict some astonishing events that she felt American readers should know about. For example, to circumvent the censors, Giuseppe Verdi, the great Italian opera composer, had to use historical themes to mask the nationalistic messages of his operas. That month, Margaret had attended a performance of Verdi's opera about the Germanic barbarian, Attila the Hun. When the tenor sang out, "Let the shades of our ancestors arise!" the Romans in the audience rose to their feet and responded with a wild outburst, chanting over and over, *"Libertà! Libertà!"*[14]

CHAPTER EIGHT

Political Tensions

Our age is one where all things tend to a great crisis;
not merely to revolution, but to radical reform.[1]
—Margaret Fuller

IN Rome, the winter solstice with its long nights and its
short, gray days is the time to celebrate mysteries and
miracles. In pagan times, this was called the Saturnalia;
for Christians, it is Christmas, the Nativity of Jesus
Christ. It is a bittersweet holiday, for every birth, even
that of the Christ Child, is the miracle that begins life's
path to death, and from death to Paradise. The Catholic
liturgy celebrates five Holy Days during the Christmas
season: the Eve of the Nativity, the Nativity of Christ,
the Eve and the Feast of Christ's Circumcision, and the
Feast of the Epiphany. On January 6, the Feast of the
Epiphany, also called the Day of the Magi, good Roman
children receive gifts from the witch Befana (short for
epifana), while the bad are punished. Another Roman

Christmas tradition is the veneration of a doll-like figure
of the Holy Child—the Santo Bambino—in the *presepio*.
The Santo Bambino stays in a glass case above the altar
of a small chapel in the sacristy in the church known as
the Ara Coeli unless one of the priests carries him to the
bedside of a dying child. Carved from the branch of an
olive tree from the Garden of Gethsemane, where Jesus
agonized in dread of his death on the Cross, the Santo
Bambino has performed many miraculous cures. Out
of gratitude, Roman parents have covered the figu-
rine's gown with splendid jewels; one of these had
been donated by Ossoli's grandmother. When Gio-
vanni pointed this gem out to Margaret, he also confided
to her that this same wealthy grandmother, ignoring her
grandchildren's needs, had willed a vineyard to her
favorite priest.

On Christmas Eve 1847, after midnight Mass at the
basilica of Santa Maria Maggiore, a procession ac-
companied the Pope to his residence at the Quirinal.
Margaret recalled the previous Christmas Eve, when she
had seen enthusiastic crowds calling out the Pope's
name in gratitude for the reforms he had promised to
make. This year, there were only a hundred people who
gathered, and "just as he returned, the moon looked
palely out from amid the wet clouds, and shone upon
the fountain, and the noble [marble] figures above it,
and the long white cloaks of the *Guardia Nobile* who
followed his carriage on horseback."[2] Ossoli's three older
brothers were among the ghostly riders.

In early January, 1848, the Marchese Ossoli died. It
was a terrible emotional blow for his son Giovanni, even
though the death had been long anticipated. The Mar-
chese was buried in the family chapel after a sumptuous
state funeral procession that, according to Margaret,
included "long files of armed men, the rich coaches and

liveried retinues of the princes."[3] Young Ossoli was now entirely dependent upon his older brothers. Shorn of his father's support and protection, the animosity between himself and his eldest brother, now the head of the family, increased. Giovanni Ossoli moved into his sister's quarters in the *palazzo* so that his brother could rent out the upstairs floor to a lawyer. (In his youth, Ossoli had had such vivid dreams about a treasure hidden behind a certain panel in the library wall that one day he had battered the panel to pieces, only to find nothing. Yet his dreams had been prophetic, for the tenant grew unaccountably rich, even as Ossoli's own finances declined.)

The Pope had previously abolished secret tribunals for political prisoners, issued an amnesty, granted more freedom to the press, and promised a more liberal educational system. When he proposed additional reforms, however, conservatives within his administration blocked them. In creating a Chamber of Deputies and a Council of State, he intended to delegate only one member of the clergy, a Cardinal, to act as his secretary of state. Overruling his wishes, the Curia appointed members of the clergy to every single seat in the new Council. This outraged the Roman people so much that on December 27 their spokesman, Angelo Brunetti—nicknamed "Ciceruacchio" (big pea)—presented a list of demands, including one to prevent members of the Society of Jesus—the powerful religious order known as the Jesuits—from taking over rights promised to the citizens of Rome.

On New Year's Day, 1848, access to the Pope's residence, the Quirinale, was blocked by soldiers, for a riot seemed about to erupt. Claiming illness, the Pope said he had not read Brunetti's list of demands and knew nothing about the demonstrations in the streets outside

the walls of his palace. The next day, to reassure his people, the Pope drove through the city in the misty rain. "We all had our windows open, and the red and yellow tapestries hung out," Margaret reported. "The people threw themselves on their knees and cried out 'O Holy Father, don't desert us!' " Shouts were heard of *"Viva Pius IX alone. Death to the Jesuits."*[4]

Margaret was outspoken in her *Tribune* articles. Partly through her influence, a rally had been held in late November in New York City to express support for the democratic movement in Italy. Seven hundred people signed a petition, and prominent Americans had made speeches praising the Pope for his enlightenment while condemning Austria for its atrocities in northern Italy. Citing Italy's role in the history of democracy, six resolutions were approved, and President James K. Polk recommended that Congress appoint a delegate to the Papal States. For Americans living north of the Mason-Dixon line, national unity was a vital political issue, for southern slave-owning states were already talking about forming a Confederacy and seceding from the Union.

All Americans could identify with Italy's situation. Northerners saw the sanctity of a united country as supremely important, whereas Southerners sympathized with the Italians' effort to obtain independence from stronger, larger political powers. With the borders of the United States still not established and Native Americans trying to defend their territorial rights, the constitutional principle of the separation of church and state seemed like a secondary issue.

Costanza Arconati, having heard about the disturbances in Rome and concerned about Margaret's welfare, sent her a book and some money. When she did not receive a reply, she wrote again, saying, "I am uneasy . . . drop me a word which will reassure me. . . .

We are continually in alarm for Milan which is under a reign of terror."[5] Inspired by the Boston Tea Party, the Lombards had boycotted the heavily taxed and state-controlled sale of tobacco. This was a great sacrifice, for Italian men have always been heavy smokers. The boycott was so effective that the Austrians' tobacco tax revenues evaporated. Fed up with the Lombards' peaceful protest, the Austrians distributed cigars to their officers and supporters and ordered them to blow smoke in the faces of all Italians in the street. The insult was too much. On January second, third, and fourth, the "Tobacco Riots" broke out in Milan. After some Austrian officers were attacked, eighty unarmed civilians were killed by Austrian soldiers, and the last shred of Lombard patience vanished. Milan, as Costanza indicated, had been placed under martial law.

About a week after the uprising in Milan, the citizens of Palermo, Sicily, discovered that their Bourbon king, Ferdinando II, did not intend to make the concessions he had promised. Instead, ships carrying his royal troops had sailed from Naples to bomb them into submission. Thirty thousand people rose in revolt and expelled the soldiers from the city, raised the flag of Italy, and proclaimed a popular constitution. According to Margaret's dispatch to the *Tribune*, when news of the insurrection in Palermo reached Ferdinando in Naples, "that even the women quelled the troops—showering on them stones, furniture, boiling oil, such means of warfare as the household may easily furnish to a thoughtful matron,"[6] he suffered a slight stroke, then offered amnesty and reform, hoping that his navy would ignore his orders about the bombardment.

When Margaret's family in Massachusetts learned of the violence in Milan, Palermo, and Rome, they begged her to return, but Margaret was neither willing to leave

Ossoli, whom she deeply loved, nor strong enough to face an ocean journey in winter. She complained of having "constant nervous headaches without strength to bear it, nightly fever, want of appetite." That winter, it rained continuously from December 16 to March 19, and she let her friends and readers know how she felt about it. Pregnancy was also causing her both emotional and physical problems. Wretchedly ill, Margaret seemed willing to accept death as an outcome of childbirth for herself or her baby, or both.

Although she was corresponding with Costanza Arconati, Margaret needed friends nearby in Rome, particularly confidants who would neither betray her secret nor judge her by puritanical standards. It was a wish that was fulfilled when Adam Mickiewicz arrived to recruit Polish exiles on behalf of the Roman cause. Staying with Margaret in her small apartment, he could see how ill and anxious she had become. She confided everything to him, and he advised her to think positively and to resist the temptation to give in to her fears. Speaking as a man who had seen his own wife drift in and out of depression, he insisted, "It depends on you whether you want to suffer more or less. . . . You can still regain your health and live robust and gay. Believe it."[7]

The late winter gloom and the bone-chilling dampness, however, were no comfort to Margaret in her hours of despair. She had never had any patience with setbacks and delays. Her lack of strength made her pessimistic, and she seemed to exaggerate her discomforts. About this time, she found out through friends that in December Caroline Sturgis had married William Tappan of New York without informing her. Most likely, Caroline's letter had been lost, but to Margaret, the news made it difficult to confide in Caroline.

In early February, Rome celebrates the traditional *Car-*

nevale, a week-long festivity preceding Lent, the forty-day fast before Easter. That year, however, the poor were already fasting, for food was scarce. In Margaret's March 19 *Tribune* article she noted that despite the pretty costumes and the festivities, the poor must have been desperate, for something unprecedented had happened: a precious jewel-encrusted relic of the head of Saint Andrew had been stolen. "It is quite a new era for this population to plunder the churches," Margaret reported, "but they are suffering terribly, and Pio's municipality does, as yet, nothing."[8] Though she was so weak she could barely move, Margaret attended both the German Artists' Ball and the Italian masked ball, where she paid close attention to the political gossip. On February 22, however, Margaret was too ill to attend the Americans' Washington's Birthday Party, even though her dear old friend Henry Hedge was the guest of honor.

Shortly thereafter, Margaret met a friend of Mazzini: the remarkable Princess Cristina Trivulzio Belgioioso, a beautiful Milanese aristocrat who, like the Viscontis, had been exiled for her political activities. Married at sixteen to the twenty-four-year-old Prince Emilio Belgioioso, she and her husband were incompatible in every way except in their political ideals. Belgioioso was a *Carbonaro,* a member of the revolutionary underground. Arrested and nearly condemned to death, he and his wife were sent into exile. In Paris, the princess was constantly followed by spies. Her estates were confiscated, and though she eventually won them back, she had to endure some hard times. When she returned to Italy, she organized her workers into communes and shared the profits of her land with them.

As a scholar, a revolutionary, and an aristocrat, the princess had attracted many of the most gifted artists and political leaders to her salon in Paris in the 1830s. Maz-

zini was one; another had been the elderly General Lafa-
yette, the French soldier, aristocrat, and statesman who
had joined General George Washington in America's war
of independence from England. Costanza Arconati Vis-
conti knew and admired Princess Belgioioso, but she did
not approve of her morals, for the princess was known
to have had a number of lovers. To someone in Marga-
ret's situation, however, this very fact made the princess
an even more compassionate ally. If any woman ever
exceeded Margaret's idealism and passion, it was the
Princess Belgioioso. When they met, they became friends
right away, but the two women hardly had time to
become acquainted before the princess went to Naples
to organize efforts to form a constitutional government
for the Kingdom of the Two Sicilies.

After *Carnevale,* startling news reached Rome: follow-
ing an uprising in Paris, King Louis Philippe had been
dethroned. The Pope took this as a warning and insti-
tuted a Constitution for the Papal States. Instead of
appointing Roman citizens to the commission, however,
he nominated clerics; final decisions on all new laws
were in the hands of a secret consistory of Cardinals
who had the right of veto. Holding out hope for the new
Constitution, the Romans welcomed this as better than
nothing, although they did protest that the Jesuits had
prevented the Pope from breaking his alliance with
Austria.

Next, the Hungarians revolted against Austria. On
March 8, 1848, the people of Vienna followed suit.
Prince Metternich, the Austrian prime minister, resigned
and fled to England. When this news arrived in Milan
late on the evening of March 17, everyone rushed into
the streets. Five days of riots forced the Austrian Marshal
Josef Radetzky (1766–1858) to withdraw his army of
fifteen thousand soldiers from the city. Likewise, in Ven-

ice, the Austrian troops were ejected and the citizens declared the Republic of Saint Mark. Modena and Parma were set for uprisings of their own: indeed, most of Austrian-occupied northern Italy succeeded in driving out the Austrians, at least for the time being.

News of these events was greeted in Rome, according to Margaret, with indescribable rapture. Men danced, women wept, and young men volunteered to go to the frontier to defend the borders. Symbols of the Austrian government were torn down and dragged through the streets, while a banner that read *"Alta Italia"* (northern Italy) was hoisted over the entrance to the Palazzo Venezia. According to Margaret, the Italians embraced one another and cried out *Miracolo! Providenza!* While the Pope made empty speeches, the Princess Belgioioso chartered a small steamship to transport a regiment of two hundred volunteers from Naples to Genoa, and ten thousand Neapolitans crowded the docks, eager to fight for the freedom of their northern compatriots.

Margaret was not frightened by the mounting danger, and she knew she had made the right decision to witness the events to come. Toward the end of March, she wrote to her old friend William Henry Channing, "I have been engrossed, stunned, almost, by the public events that have succeeded one another with such rapidity and grandeur. It is a time such as I always dreamed of, and for long secretly hoped to see. I rejoice to be in Europe at this time, and shall return possessed of a great history. . . . War is everywhere. I cannot leave Rome."[9]

In April, Ossoli took Margaret to Ostia, Rome's port at the mouth of the Tiber, to restore her health. The sandy beaches and the oak and pine forests were vague reminders of Margaret's native Massachusetts shore. His calm devotion fortified Margaret and his gentle humor made her laugh. Ossoli's character was so natural that

she always felt he was not just looking at nature, but that he was himself part of it. By supporting Margaret's needs, Ossoli buffered her superabundant electric energy. His own patient, receptive nature balanced Margaret's restlessness and soothed her like the warmth of a glowing hearth. For Ossoli, Margaret represented the world outside Italy—she was a woman who had done many things and had known great men. Yet she loved *him*. She was carrying *his* child. As long as they were together, he could continue to have faith that the future would be better for himself and his country. On the sandy dunes of Ostia, they ate simple meals of fruit and cheese and read poetry to one another.

Upon their return to Rome, Margaret and Ossoli rejoiced to learn that after seventeen years of exile, Mazzini had returned to Italy. He had been welcomed by the provisional government of Milan. With Austrian troops scattered and disorganized, Mazzini made a speech calling for military action. King Carlo Alberto insisted, however, that Piedmont and Lombardy be reorganized as one kingdom under his jurisdiction first. While the two factions wasted time bickering, Austria reorganized its command and prepared to reinvade Lombardy. Even though Margaret championed Mazzini's cause and his strategies, she realized that Italy had a long way to go before it could attain the economic advantages of an industrial nation like Austria. In her *Tribune* report, she even criticized her friend Mazzini for failing to consider alternative systems, such as Communism, to help the Italians redistribute the private wealth and resources they had left.

Carlo Alberto, hoping to become King of Italy, granted a charter to his own kingdom. The new government would include a nominated Senate and an elected Chamber of Deputies; furthermore, it would allow free-

dom of speech and give voting rights to all literate citizens. The king also made a trade agreement with Piedmont, Tuscany, and Rome and raised an army of sixty thousand troops. The Charter formed the nucleus of the first modern representative government in Italy. By signing the constitution, Carlo Alberto divested himself of his powers of absolute monarch—powers which his family had held for eleven centuries. On March 17, the Grand Duke Leopold II of Tuscany granted similar rights to his people. At the end of April, Carlo Alberto and thirty thousand of his soldiers defeated the Austrians at Pastrengo. Unfortunately, he did not follow through with his military advantage.

While the revolution stalled in the north, it continued in the south. The Sicilians unanimously voted to depose the Bourbons. Outraged, Ferdinando sent a fleet of ships to bomb Palermo. In Naples in mid-May, a protest against the Jesuits turned into a massacre, and for a while, it almost seemed as if England would intervene. Though the Sicilians and Neapolitans were unable to rid themselves of King Ferdinando, the series of bloody skirmishes kept the Bourbon troops too busy to attack Rome. The northern triumph over the Austrians backfired in August, when Radetzky chased the retreating troops into Milan and forced Carlo Alberto to sign an armistice.

Meanwhile, Pope Pius IX had made a series of blunders. First, he had never met the Romans' demands to curtail the political influence of the Jesuits. Second, he had failed to punish Austria for hanging a member of the Civic Guard, a Roman artist who had been captured in battle in Lombardy. And finally, in addressing the people, the Pope had said he regretted that his name had been invoked in the battle, claiming he had never intended to do more than institute a few local reforms

in the Papal States. Following this speech, there was a moment or two of stunned silence, followed by mutterings of "Traitor" and "Imbecile." Though the crowd reacted with restraint, according to Margaret's *Tribune* report, the Pope sensed danger. Papal troops garrisoned at the Pope's fortress, the Castel Sant'Angelo, went on alert, and aimed their cannon straight at residential areas across the Tiber. The public reaction was so strong that even Costanza Arconati was disillusioned about Pio Nono, writing Margaret, "His reign is finished."[10]

As the danger mounted, Margaret's friends and family continued to beg her to leave Italy. Even Emerson, in England at the time on a lecture tour, wrote to his "dear compatriot, sister and friend," urging her to return, even suggesting she come home to live in the little house opposite his in Concord. Emerson's lectures in England had attracted only small audiences. People in the cities on his itinerary stayed home, fearing that commonplace street violence might erupt into large-scale riots. At the end of April, the normally complacent Emerson was concerned enough about Margaret's safety to insist once again that she come home, saying it was foolish to stay. "Can you not safely take the first steamer to Marseilles, come to Paris, & go home with me?" It was a moment to choose—an old dear friend extending his hand, beckoning her to return to America in safety. Yet Emerson could never have guessed that for Margaret, the dangers in the streets of Rome were nothing compared with the other risks she faced. "I should like to return with you," she replied, "but I have much to do and learn in Europe yet. I am deeply interested in this public drama and wish to see it played out. Methinks I have my part therein, either as actor or historian."[11]

On May 23, 1848, her thirty-eighth birthday, Margaret and Ossoli toured the hilly countryside around Rome,

going to Tivoli to see the magnificent waterworks at the Villa d'Este and the ancient ruins of Hadrian's Villa. The late May weather was perfect for their holiday, and they cherished their time together. Margaret would have to go into seclusion soon, for her pregnancy could not be hidden forever. The heat of the summer and the threat of malaria provided her with a ready-made excuse to leave Rome. Knowing only that by autumn she would give birth to her child, she began to put her affairs in order, like someone contemplating death. She wrote to the family friend she called "Aunt" Mary Rotch, "You must always love me, whatever I do. I depend on that. . . . I am now hoping in the silence and retirement of the country to write more at length on the subjects that have engaged my attentions for some time back. But who knows! The disturbances of the times or an unfavorable state of my health may mar my purpose, as has happened before. . . . Good-bye, dear Aunt Mary. If I live, you will always hear from me now and then."[12]

Members of the Fuller family continued to write, urging Margaret to come home and offering to pay for her return ticket. Her twenty-three-year-old brother Richard asked her to live with him. When she declined, Richard wrote again, insisting that she join him, promising to support her while she wrote her books. To this she replied, "There are reasons why I cannot answer positively till the autumn. . . . There are circumstances . . . not likely to find their issue till then. If you still wish it, I think I shall be able to answer in October."[13] She told him she would be going to the mountains to save money. Bidding him a final farewell, she begged him to remember that she had always allowed him to be himself when he was under her care as a child.

After entrusting her private papers with the American artist Thomas Hicks, Margaret packed her things. She

took with her a daguerreotype of Ossoli made by Latilla, her passport, and her research materials—pamphlets, posters, cartoons, and official documents relating to recent events—for she was planning to write a history of the developments. On her last day in Rome, May 27, she scribbled a letter to her friend Costanza that provides a glimpse of the Romans' enthusiastic reception the night before, in honor of Costanza's moderate hero, Gioberti. As if congratulating herself for being able to see some of her political theories turning into real events, Margaret claimed, "He is received here with great triumph ... with shouts of 'viva Gioberti, morte ai Gesuiti!' I sit in my obscure corner and watch the progress of events. Everything confirms ... my radicalism."[14] Though Margaret's Transcendentalist days were over, as if in farewell to her former self she concluded her *Tribune* dispatch—the last she would write for many months— on a romantic note: "Meanwhile, the nightingales sing; every tree and plant is in flower, and the sun and moon shine as if paradise were already re-established on earth. I go to one of the villas to dream it is so, beneath the pale light of the stars."[15]

CHAPTER NINE

Motherhood and the Republic

With this year, I enter upon a sphere of my destiny so difficult, that I, at present, see no way out, except through the gate of death ... I have no reason to hope I shall not reap what I have sown, and do not. Yet how I shall endure it, I cannot guess; it is all a dark, sad enigma. The beautiful forms of art charm no more, and a love, in which there is all fondness, but not help flatters in vain. I am all alone.[1]
—Margaret Fuller
letter to Caroline Sturgis Tappan
January 12, 1848

To keep her pregnancy a secret from her friends in Rome, Margaret went to L'Aquila, a city in the distant and forbidding mountains of the Abruzzi. Ossoli and Margaret travelled the 115-kilometer route by carriage, along steep mountain roads. Since this region was within the borders of the Papal States, Margaret did not

need special documents to go there. The city, at an altitude of 675 meters has cool mountain air and spectacular views, of the Gran Sasso, twenty-six hundred meters high, and the Velino and the Sirente mountains. It would help increase Margaret's appetite and encourage her to walk. Ossoli left immediately to report back to the Civic Guard, as well as to one of his uncles, who employed him as clerk and paid him a modest wage. He did not want anyone to suspect that he had been absent from Rome for anything other than hunting in the mountains on his family's estate.

Though alone, Margaret was content to be in L'Aquila. For the first time, she introduced herself as Margherita Ossoli, which was the name she used on her documents. She was now quite a different woman from Margaret Fuller of Boston. Among those peaceful mountains, Margaret felt transformed, as if she had entered a world of myth and mystery, utterly removed from ordinary time and space.

> I am in the midst of a theatre of glorious, snow crowned mountains, whose pedestals are garlanded with the olive and mulberry and along whose sides run bridle-paths fringed with almond groves and vineyards. The valleys are yellow with saffron flowers; the grain fields enamelled with the brilliant blue corn-flower and red poppy. They are of intoxicating beauty, and like nothing in America. The old genius of Europe has so mellowed even the marbles here, that one cannot have the feeling of holy virgin loneliness, as in the New World. The spirits of the dead crowd me in most solitary places.[2]

The provincial city of L'Aquila fascinated Margaret: its monks, its ruins, the imposing silence of the landscape, and the inner silence of the people. Visiting the churches and the cathedral, she gazed with intense interest at the Madonnas caressing and nursing the infant Jesus. Now that she was more fluent in Italian, those who met her took her for the English wife of one of the many members of the Ossoli family. At first, everything went smoothly and her health improved; however, her tranquility was disturbed by the arrival of the first set of letters that Ossoli forwarded to her from Rome. Costanza Arconati had written, asking her bluntly, "What mystery is there in your last lines? Yes, I am faithful and capable of sympathy without regard to the opinions of others— but what is this? Someone has told me that you had a lover in Rome, a Roman in the Civic Guard. I did not wish to believe it, but your mysterious words make doubt enter my heart."[3] Margaret knew Costanza would never betray her, but these sharp questions reminded her that she could easily be found out and her family scandalized.

There was also a furious, almost desperate letter from Emerson, who by now was in Paris. "I go to London tomorrow. . . . You will not wait, but will come to London immediately and sail home with me!" he commanded. "Write immediately on receiving this."[4] Emerson included news of friends at home, too, as if to sweeten his argument, but Margaret could not do as he wished: Boston, Cambridge, Groton, Providence, and Concord were all part of the past. If she was not pregnant, in love, or interested in political events, she still would have refused. She had broken forever with New England. Her future was with Ossoli and her baby and the new Italy she hoped they would live to see. Despite her turmoil and her need for the comfort of her friends, telling the truth was out of the question. When she wrote back to

Emerson, she evaded the issue entirely, pointing out that she was no longer a daughter of New England, adding for emphasis, "I never see any English or Americans, and now think wholly in Italian."[5] Even to Costanza she admitted nothing and confined her remarks to politics and the book she was writing in her mountain retreat.

Ossoli, whom Margaret began addressing by his middle name, Angelo, wrote to reassure her that his exhausting two-day ride back to Rome had been safe. His informative letter included a promise to send more details on his next visit, adding gently, "I hope that you are well and brave and that the little apartment is good."[6] Every three days Margaret wrote to him in Italian. Interestingly, in her Italian correspondence to Ossoli, Costanza, and others, her handwriting appears so much more rounded and relaxed, suggesting that Margaret was a more tranquil, more patient person when thinking in Italian.

Ossoli's letters, though always affectionate, were filled with political news. "This morning, Rome is in great agitation because of rumors of the surrender of Vicenza to the Austrians by General Durando. This news has caused groups to assemble on the Corso to await more official reports." He went on to chide her for not having written, "for I am always anxious to hear from you, and believe me to be always yours, G.A.O." Though grateful for the information, Margaret wanted to know more about Ossoli's own experiences. She joked that she might refuse to write to him if he failed to cooperate. When the servants, Giuditta and Maria Bernani from the Ossoli family estate, started to get on Margaret's nerves, he asked her to "try to be courageous, thus making me happier. Imagine how sad I must be, for I cannot be near you, my dear, to take care of your needs. I hope on the first of next month to come to your arms for a

day. . . . I salute you and embrace you an infinite number of times. Affectionately, G.A.O."[7]

Thereafter, letters from Ossoli began to arrive late and out of sequence. At first Margaret blamed the antiquated postal system and the treacherous roads, but she soon began to suspect that censors were intercepting and reading her mail. Perhaps someone suspected that she was connected with Mazzini. Margaret began to worry that one or both of them would be arrested. When Ossoli next visited, they agreed that Margaret would be safer in Rieti, a small city closer to Rome. Though Rieti was situated on the route most likely to be taken by troops marching in or out of Rome, Ossoli had a dear friend there who could be trusted to send word to him promptly in case of emergency.

Although Margaret sensed she was being watched, she did not think the danger was imminent. However, after Ossoli left for Rome, Ferdinando's Bourbon soldiers marched into L'Aquila from Naples. Margaret wrote to Ossoli immediately: "and people say that a great many are quartered in the Città Ducale. It's uncertain whether I may be forced to flee from here and go to Rieti. I ask every day, but I hear nothing sure." Two days later, she informed Ossoli that soldiers "had picked out six persons from the village and imprisoned them in the castle and disarmed the local guard." Margaret feared that she could be next. Even so, afflicted by headaches and growing heavier, Margaret was in no condition to attempt to try to escape alone. She could tell from the newspapers that Ossoli sent her—sometimes with a secret note tucked inside—that Rome was enduring hard times. "I can't imagine the end. The deplorable weakness of the Pope has done Italy more harm than the King of Naples' treason."[8]

Ossoli helped Margaret move to Rieti around the first

of August. Though encircled by mountains, Rieti is less austere and isolated than L'Aquila. After a short stay at an inn named the Locanda Rienzi, she moved to a small apartment in the Villa Papetti on Bondara Street, overlooking the Velino rapids and an ancient Roman bridge. From her window she could see the via Salaria, the road to Rome. Wrapped around the villa was a long wooden *loggia* where Margaret paced all night during the last weeks of her pregnancy, worried about her own health, the ordeal of childbirth, and her desperate need for money. By now, her headaches had become so severe that a number of times she had had to summon a doctor to bleed her by applying leeches to the veins of her arms to reduce her blood pressure.

On August 11, when Ossoli returned to Rome from Rieti, he learned that fighting had erupted in Bologna. Having first forced Piedmont to sign a truce, the Austrians had tried to invade the Papal States. Though the Austrians had been pushed back, the possibility remained that the Pope would send his regular troops to defend Bologna against renewed Austrian attacks and would summon Rome's Civic Guard as reinforcements. In this event, Ossoli would have to march with his men, and Margaret would have to face labor and childbirth alone. With the Pope on the verge of calling up the Civic Guard, Ossoli was desperate: "At this time, I can't leave you alone, I can't go away from you, my dear love. Oh, how cruel is my destiny!"[9] Ossoli prayed he would be given a chance to see his child once and to know that Margaret was well before he left.

War seemed inevitable. The Pope, indecisive as ever, knew that his troops could not defeat the powerful Austrians unless France or England offered to intervene on his behalf. When Ossoli confirmed that the Pope had not yet made an announcement and that the crisis seemed

to be fading, Margaret was greatly relieved. "If I were sure of being all right," she wrote, trying to be brave, "I would want very much to pass through this trial before your arrival. But—when I think that I could die alone, without being able to touch a dear hand, I want to wait some more."[10]

The last week passed slowly, and Margaret had always hated waiting. So she waited out the last few days—for all she knew, the last days of her life—both dreading the birth and impatient for it to be over. Ossoli wrote once again, on Friday, to reassure her that he would be able to be at her side, for his unit had not yet been called to arms. "Dear—Tomorrow I leave Rome, and hope to hold you in my arms on Sunday. . . . *Addio* until then."[11] Faithful to his promise, Ossoli arrived on Saturday, expecting to leave on Monday. When Margaret's labor began on Monday, he summoned the midwife but he could not bring himself to leave Margaret.

On Tuesday, September 5, after a long labor, a baby boy was born. At long last, there in Margaret's arms lay the tiny creature who would be named Angelo Eugenio Filippo Ossoli: *Angelo* for his father, *Eugenio* for Margaret's brother, and *Filippo* in memory of the late marchese. To his adoring parents, the infant would be their Angelino, or little angel. Impish, knowing, fragile, noisy, and adorable, he was fair-haired, like Margaret, with pale, almost turquoise eyes, but he resembled Ossoli in the shape of his mouth, hands, and feet. Months later, after her family had been informed about Ossoli and her son, Margaret revealed to her sister Ellen what she had been feeling at this time.

The great novelty, the immense gain, to me, is
my relation with my child. I thought the moth-
er's heart lived in me before, but it did not—I

knew nothing about it. Yet before his birth I
dreaded it. I thought I should not survive; but
if I did and my child did, was I not cruel to
bring another into this terrible world? I could
not at that time get any other view. When he
was born, that deep melancholy changed at
once into rapture, but did not last long. Then
came the prudential motherhood. . . . I became
a coward. . . . I seemed wicked to have
brought the tender thing into the midst of cares
and perplexities we had not feared in the least
for ourselves.[12]

On the same day that the baby was born, the very
emotional but very relieved new father was forced to
return to Rome to resume his duties. On Wednesday
morning, Ossoli wrote, "I am well, but you can imagine
in what state at having left you in such a condition. I
beg you to take care of yourself and our dear little boy."
Too weak to write, Margaret dictated a letter to reassure
him she was well: "The child is well, too, though he
still cries much."[13] Within two or three days, the fever
known as mastitis prevented Margaret from nursing
Angelino. She blamed her nursing problems on tension
created by her servant Giuditta, so she dismissed her and
hired a beautiful young mother named Chiara to nurse
him, along with her own newborn baby. As Margaret
rested, her fever subsided and she gradually regained her
strength.

Ossoli, though a proud new father, did not forget to
convey the news that during the week of his baby's
birth, King Ferdinando's navy had mercilessly bombed
the Sicilian city of Messina, earning for himself the nick-
name "King Bomba." The reaction in Rome had been
impressive: "As I am writing, the Pope had gone to the

sanctuary for his service as usual, but what silence in the streets where he passed! The Civic Guard had been called to do the honors but few were there, which shows clearly they are not following orders."[14]

Ossoli sent more details of events in Rome. Count Pellegrino Rossi had been appointed chief minister to the Holy See. The pale, scholarly Rossi was a moderate who was hated by liberals and conservatives alike. Though his economic policies were sound, his personality was abrasive. His contempt for his opponents was so extreme that he made a poor negotiator. Rossi regarded the papacy as "the one great thing that was left to Italy." He promised to use force to maintain law and order and to maintain the Pope's authority, though he failed to offer any new reforms to the people.

With the return of cooler weather, Margaret's friends expected her back in Rome. If she did not return, they might speculate about the reason for her absence and alarm her family at home. Once back in Rome, she would be able to write more dispatches for the *Tribune*. Though she absolutely needed the income, this was the most difficult decision she had ever made. She could not bear to think of leaving her baby in Rieti, but Ossoli persuaded her that the baby was safer with his wet nurse. Ossoli asked only that the baby be baptized, for a certificate of baptism would one day be required to obtain a passport and other legal documents. In addition to the spiritual importance of the sacrament, this documentation of his parentage would make Ossoli's son heir to his property and titles. By declaring himself the child's father, Ossoli reaffirmed his own rights of inheritance. With brothers so much older than himself, Ossoli had a chance of outliving them all, and with luck, the final disposition of his father's estate might one day benefit his son. Margaret was reluctant to have the baby bap-

tized, but she realized how important it was to Ossoli, a devout Catholic, despite his opposition to the Church's political power.

The baptism was not that easy to arrange, for a sponsor or godfather was needed. Margaret's first choice was Adam Mickiewicz, but she did not know how to contact him. Ossoli's nephew Pietro, the son of Ossoli's beloved sister, Angela, agreed to lend his name to the certificate as godfather by proxy. A document was drawn up authorizing Ossoli to take the child to be baptized with whatever names he saw fit. The names of the mother and father were omitted. On November 6, the baby was baptized. He was given a baptismal certificate and a document conferring on him all the rights and privileges of the Ossoli name, including the title of marchese. After the baptism, a doctor inoculated the baby against smallpox with a vaccine Ossoli had sent by messenger from Rome.

Margaret and Ossoli had steeled themselves for the ordeal of leaving their beautiful baby behind, but on the day of departure there was a tremendous rainstorm, and the deluge forced them to postpone their journey. This was indeed a stroke of luck, for they later learned that the stagecoach that they had planned to take to Rome had been swept away in a flood and all passengers had drowned. After a few more precious days with Angelino, the rain turned to snow, making travel somewhat safer, for the rain had swollen the mountain streams and the Tiber in the valley below had flooded. They drove toward Rome by way of the via Salaria, down through the snow-covered mountain passes in the cold moonlight, along the winding Tiber's east bank. There was so much water that Rome, with its white domes and spires, resembled a low cloud on the horizon. Margaret was so enchanted by the beauty of the scene that she completely

forgot about the danger to her life, were the carriage wheels to slip and plunge them into the icy river.

Margaret's new lodgings were once again in the Corso, in a large sunny room that Ossoli had found for her. It had good heat and a beautiful view of the Piazza Barberini, as well as the Pope's residence, the Quirinale. The rent was economical, and her new neighbors were congenial. One neighbor was an English lady who had created a terrace of potted flowers. Margaret wrote her mother to assure her that her health had improved after having taken "the grape cure"—an ancient Roman custom of purifying the body with a diet of grapes harvested in the autumn. It was an agony to hide her happiness from her mother. Instead, she could only hint, in her letter, "Were you here, I would confide in you fully [as I] have more than once, in the silence of the night, recited to you those most strange and romantic chapters in the story of my sad life."[15]

As Ossoli had predicted, the Pope's appointment of Count Pellegrino Rossi, the former French ambassador to Rome, had been a tragic mistake. Rossi infuriated everyone, and all political factions hated him. Everyone wanted to get rid of him, yet there was no democratic means to remove him from office. When men are desperate, they will do desperate things. On November 15, as Rossi stepped from his carriage in front of the Palazzo della Cancelleria on his way to the Chamber of Deputies, he was assassinated by a group of men with drawn daggers. There were cries of *Abbasso Rossi! Abbasso Rossi! Morte a Rossi!* ("Down with Rossi! Death to Rossi!") A man believed to be Luigi Brunetti, son of Ciceruacchio, stabbed Rossi in the throat, severing the carotid artery. Rossi's blood spurted out at the feet of his enemies, who watched him bleed to death within minutes. After it was

over, no one moved; not a single witness flinched or spoke a single word. Within the halls of the Chamber of Deputies, there was a cold silence.

Hours later, crowds gathered in the streets to celebrate. The next day, the people of Rome thronged to the gates of the Quirinale to demand reforms. This time, however, the crowd was out of control. Unlike Milan and Bologna, Rome was not just a city; it was the capital of the Papal States and the seat of its power. A coup d'état and assassination on the Pope himself was unthinkable, but open insurrection and anarchy would effectively draw the world's major powers into the conflict. The Pope's bewilderment and fearful overreaction made things worse. He ordered that the gates to the Quirinale be bolted, and refusing to address the people, he posted the Swiss Guard at the immense portals. Panicking, Monsignor Palma, the Pope's confessor, fired his pistol from a window directly into the unarmed crowd, causing a panic. Next, the Swiss Guard fired on the crowd, injuring at least one man. A riot broke out, and in the turmoil, the crowd set fire to the Quirinale doors. Somehow, someone managed to kill Palma. To subdue the crowd and end the violence, the Pope agreed to the formation of a cabinet which included two of Mazzini's supporters, Piero Sterbini and Giuseppe Galletti.

When the streets were calm and it was safe to go out, Margaret walked to the Quirinale to inspect the damage. In her next article for the *Tribune*, she noted "the broken windows, the burnt doors, the walls marked with shot" below the *loggia* where the Pope had so often blessed his loving flock.[16] Like the deputies and many aristocrats, the Cardinals fled the city. Wild rumors flew that the Cardinals were going to convene in a secret session to elect an anti-Pope who wouldn't even listen to the will of the people, as Pius IX had at least tried to do. In

defending the Quirinale, the papal police and the Civic Guard restored order. Though they protected the Pope, he was a prisoner of sorts for nine days. Rome was now being run by two men, Charles Bonaparte and Piero Sterbini. On November 24, Pope Pius, disguised as a bespectacled parish priest, sneaked past his own Swiss Guards in the carriage of the Bavarian minister and his wife. Escaping to the mighty seaside fortress of Gaeta in the Kingdom of the Two Sicilies, the Pope placed himself under the protection of Ferdinando, the hated "King Bomba" himself. The Romans, suddenly free of Pope and clergy, lost no time in declaring Rome a republic. A democratic election by secret ballot and universal male suffrage would be held to form a constitutional government. On November 29, 1848, while Rome celebrated with bonfires and music, the Pope denounced the Republic and threatened to excommunicate anyone who voted. This was another blunder, for it cost the Pope his personal popularity, and he was ridiculed and despised as an enemy of the people.

Margaret's *Tribune* articles about these violent events offended the Catholic hierarchy in New York. Bishop John Hughes interpreted her attack on the papacy as an attack on the faith and harmful to Catholics living in his diocese—many of whom were victims of enough anti-Catholic prejudice as it was. Nevertheless, Greeley continued to print Margaret's dispatches, for they were America's only source of information about the events in Italy. While the United States did not know exactly what to do with these enthusiastic but unstable new Italian republics, public opinion pressured President James Buchanan to send a delegate to Rome to help protect American interests. The first delegate to the Papal States died shortly upon arrival in April 1848. It took another ten months to designate his replacement, Lewis

Cass, Jr., who sailed for Italy in January 1849 under orders to do nothing, but to wait for further instructions. The delays in the appointment process, Lewis Cass's lack of authority, and America's neutrality infuriated Margaret. She expected her nation to support democratic movements with arms, money, or diplomacy.

Having said what she had to say in her *Tribune* articles, Margaret went to see her son at Christmas. She arrived at Rieti to find that Angelino was recovering from chicken pox. Chiara had fattened him up, and the cold rooms of Chiara's house were making him as sturdy as a peasant. Angelino, a picture of health swaddled in his warm woolen wrappings, made Margaret laugh while he played with his rattle and cooed at the bells that chimed on Christmas Eve. Margaret noticed that he did not seem to sleep well when she, with all her nervous energy, was around. It didn't matter; for her, there was only one happiness: holding her son in her arms. Margaret vowed to live in the present, to enjoy her baby and not to worry about future calamities. Months later, after she finally confided to Caroline Sturgis Tappan about Ossoli and their baby, she described that Christmas visit: "When I first took him in my arms, he made no sound but leaned his head against my bosom, and stayed so, he seemed to say, how could you abandon me. . . . All the solid happiness I have known has been at times when he went to sleep in my arms. . . . I do not look forward to his career and manly life: it is *now* I want to be with him."[17]

CHAPTER TEN

The Battle for Rome

In memory of the Martyrs of Human Liberty who fell during the siege, May and June, 1849 as defenders of Rome, against the machinations of despotism, the wiles of ambitious hypocrisy and the infernal perfidy of monarchical villains who have stolen power in France by means of hollow professions of that republicanism they mortally hate, and swearing fidelity to that constitution which they hastened most glaringly to violate: Thus richly deserving, the loathing detestation of the honest and just. Not so they who fell on the ramparts of Rome, strongly struggling against overwhelming numbers, against ample munitions, against fate: Their highest hope that in them, living or dead, the sacred cause should not be dishonored. Their proudest wish, that freedom's champions throughout the world might recognize them as brethren: Nobly dying that surviving millions may duly abhor tyranny and love

liberty: Closing their eyes serenely in the generous
faith that rights for all, dominion for none, will soon
revivify the earth baptized in their blood. Stay, heed-
less wanderer! Defile not with listless step the ashes
of heroes! But on the relics of these martyrs swear a
deeper and sterner hate to every form of oppression.
Here learn to feel a dearer love for all who strive for
liberty. Here breathe a Prayer for the speedy triumph
of right over might, light over night: And for Rome's
fallen defenders, That the God of the oppressed and
afflicted may have them in His holy keeping.

"They never die who fall in a great cause;
The block may soak their gore,
Their heads may sodden in the sun,
Their limbs be strung to city gates or castle walls,
But still their spirits stalk abroad."[1]
 —*New York Tribune*, Friday, July 27, 1849

WHEN Margaret and Ossoli got back to Rome after vis-
iting their son, things seemed quiet. They spent as much
time as they could together. They would ride to the out-
skirts of the city with their pockets full of roasted chest-
nuts' to share a simple dinner at some country inn and
return at sunset. The dry, sunny weather that winter
made a great deal of difference to Margaret, for she had
no headaches. In the evenings, they visited many of the
city's beautiful churches and monuments by moonlight,
always as if it were for the last time. They knew, as the
rest of the world knew, that the peaceful, enchanted
days of the Roman Republic were numbered.

On the first of the year, Margaret purchased a new
notebook to keep a journal of political events. Certain
that 1849 would be a turning point in history, she was

determined to witness and record the events as they unfolded. In the first few days of January, there were rallies and marches in Rome amid constant rumors that the Pope would return from Gaeta on the feast of the Epiphany, January 6. Instead, he announced his intent to excommunicate all those who had participated in violent events of mid-November. The Romans laughed at this, throwing copies of the Pope's proclamation into privies. By late January, Margaret foresaw that peace could not last. "The Romans go on as if nothing were pending," she noted in her journal. "Yet it seems very probable that the French will soon be at Civitavecchia and with hostile intentions."[2]

Mazzini, among others, was elected to a seat in the Roman assembly. On February 5 the assembly convened, and after three days of continuous speeches and debates, a constitution was approved. At two in the morning on February 9, Rome officially became a republic. That day, a parade of veterans marched through the city, and everywhere red, white, and green banners and scarves were displayed. The celebration of the birth of the Republic coincided with *Carnevale*. Free of censorship, puppeteers in outdoor marionette theaters had everyone howling with their political satires. For the first time, the *palazzi* on the Campidoglio opened their doors to display the fabulous sculptures of ancient Rome.

During the public celebration and parade, Margaret was taken aback at the appearance of the legendary republican patriot Giuseppe Garibaldi marching stiffly next to Charles Bonaparte. The flamboyant Garibaldi was easy to pick out, for he wore a long red tunic and a black felt hat trimmed with an ostrich feather. He was a powerfully built man with shoulder-length red hair, a moustache, and a beard, but his arthritis was so painful that he had to be carried into the assembly rooms. A

champion of nationalism, Garibaldi had been a fugitive from a death sentence for political crimes and had fought bravely in Argentina for the same republican principles. But Margaret did not trust Garibaldi. She considered him a renegade and a mercenary, and his troops had a bad reputation. Mazzini was angry with Garibaldi for offering his military services to Carlo Alberto to fight the Austrians, for Mazzini opposed any form of government that was not a democratic republic, even an Italian monarchy.

One of the first acts of the assembly was to give honorary Roman citizenship to Mazzini. Travelling to Rome from Milan, he had stopped in Florence to see if he could get the Florentines to declare themselves a republic, since their grand duke had also fled to Gaeta. Then, summoned by a message from the young poet Goffredo Mameli—*"Roma, Repubblica, Venite!"*—on the night of March 5, Mazzini quietly entered Rome by foot through the Porta del Popolo and went straight to the Albergo Cesari. It was a night Mazzini would never forget; as he wrote in his memoirs many years later,

> Rome was the dream of my youth, the religion of my soul. I entered the city with a deep sense of awe, almost of worship. . . I had journeyed towards the sacred city with a heart sick unto death from the defeat of Lombardy, the new deceptions I had met in Tuscany and the dismemberment of our republican party over the whole of Italy. Nevertheless, passing through the Porta del Popolo, I felt an electric thrill run through me—a spring of new life.[3]

When word got out that Mazzini had arrived, Romans gathered beneath his hotel windows to welcome him.

Mazzini reassured them that he would stay with them to the end. Three days after his arrival, Mazzini appeared, unannounced, at Margaret's apartment while Ossoli was with her. They spoke for two hours, and he assured her he would return as often as he could. He looked "more divine and more exhausted than ever," she noted, "as if the great battle he has fought had been too much for his strength, and that he was only sustained by the fire of his soul." Mazzini was an advocate of armed revolution, yet it was his gentle charisma that made him dangerous to his enemies. They knew that he was a modest, altruistic leader without bombast or ego. They could not take revenge for Rossi's murder by arranging the same sort of fate for him. They knew that were he assassinated, Mazzini would become the martyr for whom the masses would willingly die. As Margaret wisely observed in her journal, "He said, *We will conquer':* whether Rome will, this time is not to me certain, but such men as Mazzini always . . . conquer in defeat."[4]

Rome was calm, though everyone understood that this peace could not last. Most Americans evacuated the city, although William and Emelyn Story remained, for they considered Rome their permanent home. Another American couple who had committed their lives to the fate of Rome were Thomas Crawford, the sculptor, and his wife Louisa. (Louisa's family was also idealistic in their belief in constitutional republics. Her sister was Julia Ward Howe, the author of the lyrics of "The Battle Hymn of the Republic," the Union's anthem during the American Civil War.) Crawford and his wife lived at the elegant Villa Negroni, supposedly landscaped by Michelangelo. In her *Tribune* dispatch, Margaret mentioned viewing Crawford's model for an equestrian statue of George Washington. But her visit probably had another purpose, for the fiery Crawford was a member of the Civic Guard,

like Ossoli, and the situation in Rome was becoming more dangerous.

The companionship of American friends like the Storys and the Crawfords was especially important to Margaret at this time. Two years before this, she had written an objective criticism of the great American poet James Russell Lowell's verses, calling them "absolutely wanting in the true spirit and tone of poesy. . . . [H]is thought sounds no depth, and posterity will not remember him." In 1848, Lowell published a volume of poems entitled *A Fable for Critics,* a collection of satires. One of his poems ridiculed Margaret:

> *She may enter on duty today, if she chooses*
> *And remain Tiring-woman for life to the Muses.*
> *Miranda meanwhile has succeeded in driving*
> *Up into a corner, in spite of their striving*
> *A small flock of terrified victims, and there*
> *With an I-turn-the-crank-of-the-Universe air.*[5]

Lowell's best-selling volume created quite a stir in the United States. When William Story received a copy in Rome, he was shocked and saddened by the insult to Margaret. He wrote to his old friend Lowell, defending Margaret as best he could: "There is but one thing I regretted, and that was that you drove your arrow so sharply through Miranda. The joke of 'Tiring-woman to the Muses' is too happy; but because fate has really been unkind to her, and because she depends on her pen for her bread-and-water (and that is nearly all she has to eat), and because she is her own worst enemy, and because through her disappointment and disease, which embitter everyone, she has struggled most stoutfully and manfully, I could have wished you had let her pass scot-free."[6] Lowell apologized and attributed his ignorance of

her poverty to his erroneous assumption that she had been her uncle Abraham's beneficiary. But Margaret had already seen the poem, and she knew that back home, all her friends and relatives had seen it too. She admitted to Caroline Sturgis Tappan how demoralized she felt: "This last plot against me has been too cruel and cunningly wrought."[7]

Margaret's feeling that she had been betrayed by one and all was worsened by the fact that her dear friend, the elderly "Aunt" Mary Rotch, had died without leaving her a penny of her $150,000 estate. Then she heard some family news secondhand: her brother Richard had suddenly decided to get married; and her sister Ellen had separated from her husband Ellery Channing. On top of everything else, with her finances strained to the limit and Angelino's nurse Chiara demanding her long-overdue wages, Margaret discovered that someone had intercepted a check that her brother Richard had sent her. With most of her circle of friends gone from Rome, Margaret now felt alone. She resumed her correspondence with Costanza, but unable to tell her everything, she finally found the courage to write to Caroline Sturgis Tappan to confide in her about Ossoli and the birth of Angelino. She also confessed her fears for the baby's safety in the hills of Rieti, where Garibaldi's troops and Neapolitan soldiers were converging: "Every day is to me one of mental doubt and conflict: how it will end, I do not know. I try to hold myself ready every way, body and mind, for any necessity."[8]

On March 17, the new French government in Paris refused to speak to the ambassadors the Roman Republic had sent. This diplomatic insult confirmed Margaret's suspicions that the French were hostile to the Republic. The next day, she learned that Carlo Alberto of Piedmont had been defeated by the Austrians at Novara. The sur-

render was so humiliating that he abdicated in favor of his son, Victor Emmanuel, and fled to Portugal, where he soon died. The terms of the armistice were dreadful. With the north crippled, Rome was exposed to attack from Ferdinando in the south while French troops were sailing toward Rome. The Roman assembly met to deal with the impending crisis: The Republic would have to prepare itself to go to war with the greatest armies of Europe.

With danger mounting, Margaret sent a dispatch to the *Tribune* and obtained a passport to go to Rieti to see her son. Her new Republican passport was issued under the name Margherita Ossoli, indicating her age as twenty-nine. By concealing her foreign birth and age, she may have hoped to pass unnoticed across frontiers when and if flight became necessary.

With Garibaldi's troops stationed in Rieti, Margaret was fearful that her son's nurse, the beautiful Chiara, would be abducted. Although Garibaldi's mercenaries were fierce-looking, they were well behaved. Still, peasants and rural folk were too frightened of them to refuse their demands for food. It was peaceful in Rieti, although Ossoli's letters indicated that more trouble was brewing: another division of Garibaldi's troops had attempted to invade Bourbon territory. Meanwhile, Count Aurelio Saffi, the attorney Carlo Armellini, and Mazzini had been elected as a triumvirate with equal executive powers to administer the Republic, although, in fact, it was Mazzini who made the decisions. Almost immediately upon their election, the three men were threatened with assassination, and Ossoli's unit of the Civic Guard was called to protect them. There was some street fighting in which some people were wounded and perhaps two died. Afterward, eight hundred supporters of the Pope

rallied against the republic, and to outsiders, it may have seemed that the Romans were divided.

The enemies of the Republic were stronger outside the city walls than within, however. On the April day that Margaret returned to Rome, the French announced their intent to send troops to the city to control the violence. Evidently, Louis Napoleon, once a liberal and a former *Carbonaro*, wanted to accomplish one thing: to restore the title of "emperor" to the Bonapartes. For this, he needed an empire and a Pope to anoint him. Although France was a Catholic country, its constitution protected its citizens from submitting to the Pope's secular powers and laws. If Austria seized half of Italy, France was ready to claim the rest.

The Roman Republic never attacked the Roman Catholic religion directly. It aimed at becoming a modern democracy in which church is separate from state, and its constitution guaranteed religious freedom to all, which was especially important to the ancient Jewish community in Rome. Financially, however, the Republic ran into trouble. To raise revenue, estates belonging to the church were seized. This led to false rumors published in New York about priests being butchered in the streets. In fact there had been relatively little violence since the Republic was declared, though evidence emerged of the repression and corruption of the papal regime. Lewis Cass, Jr., the United States chargé d'affaires, had been raised in France when his father was U.S. minister there. Well educated, multilingual, and observant, Cass's signed depositions to the U.S. State Department established that the Cardinals had not permitted fair trials and that priests had made a practice of illegally appropriating inheritances from the dying. Cass himself attested that the Republicans were not commu-

nists but were owners of property who agreed that no degree of freedom was possible under the rule of the Cardinals. He urged the U.S. government to intervene on behalf of the new Republic. There was no time to act, however. Before Cass's letter arrived in Washington, ten thousand French troops arrived at Civitavecchia, the port of Rome. The next day, April 25, the Civic Guard assembled, and the gates into the city of Rome were barricaded. On April 26, a French staff officer, Colonel Leblanc, arrived in Rome to inform Mazzini that the French had come to restore the Pope.

"And, if the people do not want the Pope restored," Mazzini inquired, "what then?"

"He will be restored just the same," replied the colonel.

On April 27, Garibaldi and his Legionaires marched into the city. The sight of Garibaldi inspired action. Artists, students, and others enlisted in the Legion or the Guard. They were an enthusiastic but untrained group. A regiment of top-notch *bersaglieri* arrived from Lombardy the next day, astonished to find themselves surrounded by men dressed up in soldiers' uniforms, like actors in a play. Yet even these elegant *bersaglieri* were unlikely defenders of Rome, for they were staunch monarchists. They refused to salute the Roman general Avezzana's call to arms of *"Viva la Repubblica!"* until their own leader, Manara, shouted "Present arms! *Viva l'Italia!"* No wonder the French public underestimated Italian willpower and believed the French general Oudinot's assurances that his troops would be welcomed by most Romans as liberators, insisting, "Italians never fight!"

Rome braced itself for attack. A homemade American flag was flown at Casa Diez, the residence of the American chargé d'affaires, where the city's remaining American residents gathered for safety. On April 30, when it

was still quiet and not a shot had been fired, a message arrived from Princess Belgioioso for Margaret: she had been named director of the Hospital of the Fate Bene Fratelli. Six thousand Roman women had volunteered to serve the wounded in hospitals throughout the city. Margaret was instructed to go to the hospital at noon to organize her group of volunteers and wait for the wounded. The hospital's location on an island in the Tiber near the western wall of the city was closest to the front line of attack, so Margaret knew that most of the casualties would be brought there.

The Italian commanders, General Avezzana and Colonel Roselli, who were well trained in conventional warfare, positioned Garibaldi's twelve hundred guerrillas on the fortified slopes of the Janiculum, the hill that forms part of the western wall of the city. About eighteen hundred troops were posted at the Villa Pamphili and the Villa Corsini, and four battalions were placed along the Vatican Hill. The love these volunteers felt for their ancestral city and for their new independence made them determined to fight to the death. If the French expected the Romans to surrender without a fight, they were wrong. Marching toward Rome, French troops saw posters on the walls of the buildings along the route that mocked them with the text of the fifth article of their own constitution: "France respects foreign nationalities. Her might will never be employed against the liberty of any people."

The battle began at noon, just as Margaret was taking her post at the hospital. Seventy men were brought in before the shooting died down at five o'clock. Students and artists, guerrillas and officers had fought side by side. That first night in the hospital Margaret witnessed the terrible mental and physical agonies of the wounded. "The Italians fought like lions," she wrote later. "It is

truly a heroic spirit that animates them. They make a
stand here for honour and their rights, with little ground
for hope that they can resist, now that they are betrayed
by France."[9] To everyone's surprise, however, the
French were defeated, with 500 dead and 365 men
taken prisoner. French soldiers were treated in Roman
hospitals and returned to their regiments, while captured
soldiers were sent back with fifty thousand cigars and
handbills denouncing the French government as traitors.

Garibaldi, though wounded in the side, went to the
assembly to warn that if Bourbon troops arrived from
Naples, the Romans could not defend the Republic on
two fronts. He begged the triumvirate to allow him to
push the French west to the sea, but Mazzini refused,
for he wanted to appear to be defending Rome, not
attacking France itself. It was not long before Rome was
under seige. French troops surrounded the city. No one
could enter or leave, all roads were guarded and the port
was closed. A whole month went by with no action and
no resolution. Even Margaret did not believe that the
Republic could survive against French, Bourbon, and
possibly Austrian forces, but true to her ideals, she was
as loyal to the cause of the Roman Republic as she was
to Ossoli. She vowed to do whatever she could for both,
even at the cost of her life.

The Americans in Rome raised $250 for the care of
the wounded and William and Emelyn Story brought
the donation to the Princess Belgioioso. Together with
Margaret, they carried food out to Ossoli, who refused
to leave his post. He showed them the battlefield. Look-
ing down from the ancient walls of the city, they could
see corpses below, for the French had retreated so
quickly, they had left their dead behind.

Garibaldi had managed to slip out of Rome with twen-
ty-five hundred troops to face ten thousand Bourbon

troops in the hills. The guerrillas attacked at night, forcing the Bourbons to halt, but Mazzini called Garibaldi back to Rome to let his men rest before the inevitable second assault. Mazzini took hope in reports that liberal factions in France supported the Roman Republic and that they would vote to prevent any further attack on the city.

A twenty-day truce was declared. Ferdinand de Lesseps (who would later oversee the construction of the Suez canal) negotiated an armistice. Pleased with his rapport with Mazzini and the spirit of the Republic, de Lesseps' terms would have allowed French troops to remain nearby to protect Rome from the menacing Austrian and Bourbon forces. The compromise was so favorable to the Romans that the French government feared that the French electorate would be outraged once they realized that their troops had been defeated and that General Oudinot had lied when he claimed that "the affair of April 30 . . . was one of the most brilliant in which French troops have taken part."

Garibaldi attacked the Bourbon troops a second time, pushing them back across their own border. Meanwhile, the Austrians were marching south, so Mazzini summoned Garibaldi's troops back to Rome. The only hope was that the French presence would discourage an Austrian attack. Fortunately, once the French notified Ferdinando that they did not need his help, he turned his troops back to Sicily. When four thousand Spanish troops landed at Gaeta, however, it seemed that all the armies of Europe were about to converge on Rome. Margaret and Ossoli felt the situation was hopeless. Ossoli sent notes telling her to take care of her health so that their son could grow up with at least one parent.

With the approach of May 20, the day the truce would expire, Margaret was convinced that neither she nor

Ossoli would survive the next attack of the French. In the event of their deaths, only someone in Italy could save her son, and so she told Emelyn Story a version of the truth, claiming that she and Ossoli had married secretly to avoid losing his claim to his father's estate. Giving Emelyn a packet of documents that included Angelino's baptismal certificate, she asked Emelyn to take her son back to the United States to be raised by her mother and Caroline Sturgis Tappan in the event that she and Ossoli died. When the Storys decided to seek safety in Switzerland for the sake of their own children, they brought these documents back to Margaret and bade her and Ossoli an emotional farewell.

This left Margaret and Lewis Cass as part of a handful of American civilians within the city. Cass was concerned about Margaret's safety. He genuinely liked and respected her, and he had kept her informed about the impending negotiations with the French for the sake of her *Tribune* articles. Also remaining inside the city walls was Thomas Hicks, who painted a miniature portrait of Margaret during the seige that reveals her despair. Thomas Crawford and another American artist, Frederick Mason, both members of the Civic Guard, were stationed among the troops at the Porta San Pancrazio, where the French were expected to make a deadly assault when the truce came to an end.

Early on Friday, June 1, Cass assured Margaret that he had been officially informed that French troops had been ordered to remain in the vicinity to defend Rome from Bourbon and Austrian attacks while the de Lesseps treaty was debated and ratified in Paris. This was a great relief. The French general, Oudinot, however, refused to comply with the terms of this agreement, claiming that young de Lesseps had overstepped his authority. Later that same day, General Oudinot notified Mazzini that,

under orders from his government, he would attack on Monday, June 4, to allow two days for French citizens to evacuate Rome.

As soon as Mazzini received Oudinot's letter, he immediately contacted the ailing Garibaldi, who replied, "I can exist for the good of the Republic only in one of two ways—a dictator with unlimited powers or a simple soldier. Choose!" There could be no choice. Garibaldi was an uncompromising general, a maverick who took too many risks and who did not play by the rules of limited warfare. Mazzini and his advisers knew that the French had already taken advantage of the weeks of de Lesseps's negotiations to transport more troops to Rome. Now there were thirty-five thousand French soldiers and seventy-five heavy cannon poised within striking distance of the city's western wall. This time, Rome could not hope to defeat the French; all they could hope to do was to fight so valiantly for their honor that they would win the respect of the French people. A swift ratification of de Lesseps' treaty and a cease-fire might save the city.

To the rest of the world, the possibility of a French victory over the volunteer Roman army was regarded as dishonorable. General Oudinot, however, refused to accept the disgrace of his temporary defeat. With Garibaldi's men back in Rome, Oudinot decided to break his promise. He ordered his troops to strike on Sunday, June 3, one day earlier than he had indicated. At three o'clock in the morning, while everyone was sleeping, the French overran the four large estates on the western edge of Rome, the biggest of which was the Villa Doria Pamphili. With nineteen thousand Roman volunteers available, these villas could have been better defended, but only four hundred soldiers had been deployed that night. The Italian commander-in-chief never expected that his French counterpart, General Oudinot, as a Catholic and

a man of honor, would break his word let alone attack on the Sabbath.

After two hours, Garibaldi and his troops retook the Villa Vascello. Inside the city, all the church bells of Rome rang out. At the sound of the *campanile* and the firing of the cannons, Romans poured into the streets, chanting *"Roma o Morte!"* ("Rome or Death!") Mazzini proclaimed, "Romans arise! To the walls, to the gates, to the barricades! Let us show that not even treachery can vanquish Rome!" The Roman people and the Republican soldiers fought as no one had ever dreamed they could. Students, young aristocrats, mercenaries, guerrillas, and even some former papal guards charged forward with bayonets, determined to fight to the death. If they could not be victors, they would be martyrs, the heros in whose memory the rest of the Risorgimento would be fought. Garibaldi rode into battle shouting "Courage! Courage, my boys!" while the brave young volunteers—mostly students and artists—rushed up the slopes of the hills around the Porta San Pancrazio to their deaths. Inside the gate of San Pancrazio, crowds cheered their troops, rescuing some of the wounded while a Roman band taunted the French with their own national anthem, the Marseillaise. In his whole military career, Garibaldi claimed he never again saw anything to match the butchery and bloodshed of that day.

As the barrage of French cannon and rockets continued day after day and the wards of her hospital filled with the dying and wounded, Margaret expected to see Ossoli among the casualties. Her devotion to his wounded comrades was intensified by the realization that unless the world were at peace, one day her own son might also die on a battlefield. Lewis Cass recalled her manner of taking care of the wounded.

The weather was intensely hot, her health was
feeble and delicate, the dead and dying were
around her in every form of pain and horror,
but she never shrank from the duty she had
assumed. Her heart and soul were in the cause
for which these men had fought, and all was
done that woman could do to comfort them in
their suffering. I have seen the eyes of the
dying, as she moved among them, extended
upon opposite beds, meet in commendation of
her unwearied kindness . . . nothing of tender-
ness and attention was wanting to soothe their
last moments. And I have heard many of those
who recovered speak, with all the passionate-
ness and fervor of Italian natures, of her whose
sympathy and compassion throughout their
long illness fulfilled all the offices of love.[10]

By nightfall, the fate of the Republic had been decided,
but the Romans refused to surrender. Mazzini knew that
the heroism of that day had forged the romantic spirit
of the rest of the Risorgimento. "Romans, you have sus-
tained the honour of Rome, the honour of Italy," he
told them. "Romans! This is a day of heroes, a page of
history. Yesterday we said to you, be great; today we
say to you, you are great."

Every day for the rest of the month, the fiercely hot
city shook with incessant bombing. The Romans defended
their city without flinching. When the French gained the
Janiculum hill on June 22, the Romans knew all hope
was gone. Still, they refused to surrender. On the 29th,
just after midnight, exhausted and without hope, Marga-
ret summoned Lewis Cass and gave him her documents,
telling him that her husband, the Marchese Ossoli, was

in command of a battery on the Pincio. "That being the highest and most exposed position in Rome, and directly in the line of the bombs from the French camp," Cass recorded, "it was not expected that he could escape the dangers of another night such as the last, and it therefore was her intention to remain with him and share his fate."[11]

That night, the French broke through the gates of the city. While the Romans were holding them back in hand-to-hand combat, Margaret found her way to Ossoli. Together, they awaited death. As if by a miracle, the cannonade stopped, and they survived to see another dawn.

The next day, July 1, Garibaldi, soaked in blood and covered with dirt, his bent sword sticking out of its scabbard, arrived at the Assembly to report that his men had given up the Aurelian wall, that his second in command had been killed, and that with no more amunition left, he and his men had fought with swords. He said that the French were ready to bomb the city to the ground and that street fighting would be useless. He proposed to withdraw the troops to the hills. "Wherever we are, there will Rome be." The assembly voted that it was impossible to defend the city. But the triumvirate refused to execute the decree and resigned.

Thousands assembled in St. Peter's square, some to protest the cost in bloodshed and others to praise Garibaldi. Four thousand volunteers, including the wounded, were ready to follow Garibaldi to help Venice fight off the Austrians, though he promised them nothing but "hunger, cold, forced marches, battles and death." Margaret followed the crowd down the Corso to the Palazzo Doria, where Garibaldi's lancers galloped past, a romantic, beautiful, sad sight.

Mazzini refused to flee, even though Margaret obtained

an American passport from Lewis Cass for him. Cass provided Mazzini with a false name, George Moore, and a letter of introduction to the American consul in Genoa. Finally, they convinced Mazzini to leave. The horrors of the last weeks had turned his hair white and his skin yellow, so that he was barely recognizable. He managed to reach Marseilles by boat, then Geneva by land, and from there he made his way back to London.

Incredible as it may seem, the constitution was approved on July 1, 1849. It was read from the steps of the capitol on July 3. It broke Margaret's heart to see French troops marching into Rome—on July 4, 1849, of all days. On July 5, the French burst into the Assembly, forced the deputies out at gunpoint, and locked the doors behind them. Like his fellow Romans, Ossoli wept openly at the defeat of everything he had hoped for. Expecting to be cheered as liberators, the French were astonished to find instead that the Romans gathered alongside the roads remained silent. When the crowds finally did cry out, it was to scream *"Viva la Repubblica Romana!"* When a priest shouted *"Viva Pio Nono!"*—Long Live the Pope!— he was immediately stabbed to death. After this, the crowd howled and hissed at the soldiers, menacing them and blocking the road until the French soldiers forced them aside at bayonet-point. The only government which remained in Rome was the ninety-member municipal government, which resigned rather than present arms to the Pope as ordered by Oudinot.

Margaret wanted to remain in Rome to continue to take care of the wounded, but the French were transporting all the wounded to prison, where they denied them humane medical treatment. In a newspaper item, the Princess Belgioioso denounced the French for filling her former hospitals with monks who were starving dying patients until they recanted their republican politi-

cal views. She herself had been presented with a bill for the costs of running the hospitals. The sight of so many brave young men suffering from their unattended wounds and amputations on their way to prison infuriated Margaret. She completed a dispatch to the *Tribune*, describing the ghastly battlefield and the Republic's defeat and pleading with her fellow Americans to support democratic movements around the world. Obsessed by a need to hold her own son in her arms, she packed her things and put her manuscripts and journals in her writing case. When Lewis Cass brought her the last horse and carriage in the city, she and Ossoli escaped to Rieti, leaving behind the smoldering and vanquished city for which they had been willing to die.

CHAPTER ELEVEN

Death and Remembrance

If my mother is content; if Ossoli and I are content; if our child, when grown up, shall be content—that is enough. You and I know enough of the United States to be sure that many persons there will blame whatever is peculiar.[1]

—Margaret Fuller
letter to Emelyn Story

The timorous said, "What shall she do?" . . . But she had only to open her mouth and a triumphant success awaited her. She would fast enough have disposed of the circumstances and the bystanders. Here were already mothers waiting tediously for her coming, for the education of their daughters.[2]

—Ralph Waldo Emerson

THROUGHOUT the siege, communication between Rome
and the world outside had been difficult. Everything was
in a state of suspension. It was difficult to find food
or obtain services. Angelino's nurse, Chiara, had sent a
messenger to request that Margaret pay her the wages
she was owed, or she could not continue to take care of
the baby. With her son's life at stake, Margaret quickly
found some money, but she became terrified at the
thought that Chiara might abandon a helpless child. She
may not have understood how much food nursing
required, especially when a second child was to be fed.
When she and Ossoli finally reached Rieti, Angelino's
condition confirmed their worst fears: he was near death
from malnutrition. Margaret bitterly accused Chiara of
betraying her baby for a few pennies, although that
might have been unfair. Not knowing if Angelino's par-
ents had survived the French attack, and with the health
of her own baby and herself at stake, Chiara had let
Angelino suck on bread soaked in wine to soothe his
pain. Margaret found another woman to nurse the baby,
and with Ossoli's help, they were able to save him.

While trying to deal with this crisis, Margaret forced
herself to reply to a letter from Horace Greeley that she
had received just as she was about to leave Rome.
Though she had been brave through all the ordeals of
the last weeks, her strength crumbled when she read his
words: "Ah, Margaret, the world grows dark with us!
You grieve, for Rome is fallen—I mourn, for Pickie is
dead." Margaret wept and wept at the news that the
Greeleys' irascible five-year-old son had died of cholera.
"One would think I might have become familiar enough
with images of death and destruction; yet somehow the
image of Pickie's little dancing figure, lying stiff and
stark, had made me weep more than all else."[3]

Once Angelino was strong and healthy, Margaret

began to plan ahead. That summer in Rieti she wrote her history of the Roman Republic, based on the documents and journal notes she had amassed. She wrote to a British publisher about the proposed book in the hope that they might send her an advance. This money would have eased their financial worries, but it did not work out, even though Carlyle himself tried to induce the editors to accept the project. In September, Ossoli went to Rome to see if could obtain some money. He even tried to persuade his brothers to give him a lump sum as a settlement of his share of his father's estate, for Rome's civil courts had been shut down. Even had it been possible to divide the estate at that time, Giuseppe Ossoli blamed his younger brother for the humiliation he had endured during the short-lived Roman Republic, when he had hidden in the cellar of his *palazzo* in fear of his life. The only income that Margaret and Ossoli had was a tiny amount of interest from a modest trust fund that had been established by Margaret's friends in America.

Apart from the financial problem, there was the constant danger of arrest as political enemies. Indeed, one day Ossoli was apprehended and detained overnight by Bourbon authorities for crossing into Neapolitan territory by mistake while riding. After this fright, Margaret and Ossoli agreed that the safest place for them—at least for a few years—was the United States. They decided to spend the winter in Florence and then, when winds died down and the Atlantic was calm, to sail home to America. With this decision, however, came another. There were a number of American friends and acquaintances in Florence with ties to Margaret's friends and family in New England and New York. Knowing how cruel it would be if her loved ones found out about Ossoli and the baby through rumor, she finally found the courage to tell friends and family herself. While some

were stunned, and some, like Horace Greeley, were silent, the opinion that counted the most—that of her mother—was everything she could have hoped for:

> This brings me to the main object of my present letter,—a piece of intelligence about myself, which I had hoped I might be able to communicate in such a way as to give you *pleasure*. That I cannot,—after suffering much in silence with that hope,—is like the rest of my earthly destiny.
>
> The first moment, it may cause you a pang to know that your eldest child might long ago have been addressed by another name than yours, and has a little son a year old.
>
> But, beloved mother, do not feel this long. I do assure you, that it was only great love for you that kept me silent. I have abstained a hundred times, when your sympathy, your counsel, would have been most precious, from a wish not to harass you with anxiety. Even now I would abstain, but it has become necessary, on account of the child, for us to live publicly and permanently together; and we have no hope, in the present state of Italian affairs, that we can do it at any better advantage, for several years, than now. . . .
>
> He is not in any respect such a person as people in general would expect to find with me. He had no instructor except an old priest, who entirely neglected his education; and of all that is contained in books he is absolutely ignorant, and he has no enthusiasm of character. On the other hand, he has excellent practi-

cal sense; has been a judicious observer of all
that passed before his eyes; has a nice sense of
duty, which, in its unfailing, minute activity,
may put most enthusiasts to shame; a very
sweet temper; and great native refinement. His
love for me has been unswerving and most
tender. I have never suffered a pain that he
could relieve. His devotion, when I am ill, is
to be compared only with yours. His delicacy
in trifles, his sweet domestic graces, remind me
of E[ugene]. In him I have found a home, and
one that interferes with no tie. Amid many ills
and cares, we have had much joy together, in
the sympathy with natural beauty,—with our
child,—with all that is innocent and sweet.

I do not know whether he will always love
me so well, for I am the elder, and the differ-
ence will become, in a few years, more percep-
tible than now. But life is so uncertain, and it
is so necessary to take good things with their
limitations, that I have not thought it worth
while to calculate too curiously.

However my other friends may feel, I am
sure that *you* will love him very much, and
that he will love you no less. Could we all live
together, on a moderate income, you would
find peace with us. Heaven grant, that, on
returning, I may gain means to effect this
object. He, of course, can do nothing, while
we are in the United States, but perhaps I can;
and now that my health is better, I shall be
able to exert myself, if sure that my child is
watched by those who love him, and who are
good and pure.[4]

Margarett Crane Fuller's tender reply said everything her daughter needed to hear.

> I send my first kiss with my fervent blessing to my grandson. I hope your husband will understand a little of my English, for I am too old to speak Italian fluently enough to make him understand how dearly I shall love him if he brings you safe to me.[5]

Margaret immediately wrote back:

> Dearest Mother,
> Of all your endless acts and words of love, never was any so dear to me as your last letter so generous, so sweet, so holy. What on earth is so precious as a mother's love; and who has a mother like mine! . . .
> Ossoli wishes you were here, almost as much as I. When there is anything really lovely and tranquil, he often says, "Would not *'La Madre'* like that?" He wept when he heard your letter. I never saw him weep at any other time, except when his father died, and when the French entered Rome. He has, I think, even a more holy feeling about a mother, from having lost his own, when very small. It has been a life-long want with him.[6]

Others however, would respond to the news with less sympathy. Within Margaret's New England circle, some, like James Russell Lowell, had yearned for Margaret to disgrace herself. What better triumph could there be than this: Margaret Fuller, mistress of a younger man and mother of an illegitimate child, returning to America in

desperate financial trouble. On the other hand, there were readers who might have felt that the author of *Woman in the Nineteenth Century* was a hypocrite. Having seen what public outcry had done to Emerson's earnings, she knew she could not afford a scandal. Fortunately, the political turmoil that year had caused so much confusion among the American contingent living in Italy that no one could challenge her claim that she and Ossoli were legally married. When she and Ossoli arrived in Florence in October, they were received with joy and affection, for many were relieved to discover that Margaret had survived the siege and the ensuing battle.

When the Marchesa Costanza Arconati came to Florence, she adopted Ossoli and Angelino, declaring that far from resenting Margaret's secrecy, she loved her all the more, for they were now both mothers. Some friends observed that Ossoli seemed taciturn when the conversation was in English. When visiting Margaret's English-speaking friends, such as the poets Elizabeth Barrett and Robert Browning, he would excuse himself for part of the evening to stroll by himself along the Arno River to a caffé where he could catch up on the news of the day. Ossoli, however, enjoyed company when the conversation was in Italian, for he had a dry sense of humor. His deferential manner toward Margaret was a matter of his aristocratic, courtly upbringing, but it set him apart from the Anglo-American husbands with whom he now mingled. Those who knew him liked him, for he was handsome and graceful in every way, and they were charmed by the fact that he made no effort to cover up his love for his wife.

Though Florence was relatively safe, Austrian officers and police agents were on the lookout for Republican agitators. They had made an issue of Ossoli's American passport, threatening to expel him, until Lewis Cass and

the artist Horatio Greenough convinced the authorities that he was not dangerous. (In private, in his own home, Ossoli proudly wore his brown uniform of the *Guardia Civica*.) They spent the winter in an apartment on the Piazza Santa Maria Novella. Margaret wrote while the baby slept, and she doted on him when he was awake, regretting she had not been with him during his first year of life. She described in loving detail the baby's routine in a letter to Caroline Sturgis Tappan:

> [Angelino] kisses me, rather violently pats my face . . . stretches himself and says *bravo* . . . he still calls to us to sing and drum and enliven the scene. Sometimes he calls me to kiss his hand; he laughs very much at this. Enchanting is that baby laugh all dimples and glitter, so strangely arch and innocent. Then I wash and dress him; that is his great time. He makes it as long as he can insisting to dress and wash me the while; kicking, throwing the water about full of all manner of tricks that I think girls never dream of. Then is his walk; we have beautiful walks here for him.[7]

Motherhood, paradoxically, did not dampen Margaret's socialism or compromise her plans to continue to teach and write; it simply unified her spirit and absorbed her restless energy. If she seemed subdued, it was the aftereffect of witnessing the suffering of the soldiers she had tried to comfort, and the demoralizing defeat of the Republic. Those who had never really known Margaret no doubt thought motherhood had changed her but those closest to her knew how ardent and loving she had always been, especially toward her younger siblings and pupils.

Christmas that year was delightful, for finally there was a child to entertain and spoil. Angelino received gifts from his American relatives, who were growing impatient to see him in the coming year. Unexpectedly, a beautiful snowfall transformed Florence into a vision of peace. The unusually cold weather, however, brought an outbreak of flu. Both Ossoli and Margaret were ill for weeks, and she became so weak, she could barely do anything more strenuous than read by the fire. When they recovered, their social life resumed among the artists and intellectuals, which included the Brownings, the Arconatis, and others. Among their friends was young Horace Sumner, a Transcendentalist friend from Brook Farm. (His father, the liberal Charles Pinkney Sumner, had been Timothy Fuller's friend at the Massachusetts legislature. His brother, Charles, Jr., would become famous as a statesman and abolitionist.) Gentle Horace visited Margaret daily, always bringing her a bouquet of fresh flowers.

In early March 1850, with the arrival of glorious spring weather, Tuscany seemed like paradise, but the time to leave was approaching. Ossoli and Margaret planned to stay in the United States for one or two years, for the future looked uncertain. Ossoli would be dependent on Margaret in many ways. There was a chance he could use his military experience and equestrian skills in a professional capacity. He was not the only Italian republican escaping to America. New York, New Orleans, and San Francisco had received a number of them already, and many Americans supported their cause.

The real question that faced them was whether Margaret's friends would respect Ossoli. Everyone had been told that they had married privately while in Florence, and in the spring of 1850. With a little embarrassment,

Margaret added the title *marchesa* to her name. Still, she did not know what her liberal friends would make of Ossoli, a young man of action, not words. Though intelligent and sympathetic, he was a quiet man whose poor English would keep him out of the discussions and debates her friends enjoyed. Fearing that her loyalties might become divided, she wrote to her once-beloved Sam Ward, "You are among the very few of my friends who I think may be able to see why we can live together and may appreciate the unspoiled nature and loveliness of his character. . . . To me the simplicity, the reality, the great tenderness and refinement of his character make a domestic place in this world, and as it is for my heart that he loves me, I hope he may always be able to feel the same, but that is as God pleases."[8] In letters to other friends, she acknowledged that the difference in their ages might eventually cause them to drift apart, but wisely asserted her right to live in the present. She sent Ossoli's portrait ahead so that her family could begin to know how handsome and noble a man he really was.

Margaret was not concerned about supporting Ossoli and their child. Her essays in the *Tribune* had made her a celebrity, and she was returning to America better known than ever. With her experiences in Italy as material, she expected to find a good audience for lectures about the Roman Republic and the siege. Margaret knew that if she, Ossoli, and their son had survived the last dangerous and desperate months, they could survive any hardship, as long as they were together.

Mrs. Mozier, who, together with her husband, had once nursed Margaret back to health in Florence, accompanied Margaret to the port of Livorno. They examined a five-year-old, 351-ton ship owned by an old friend of hers, Captain Seth Hasty from Maine. The *Elizabeth* was designed to draw seventeen feet of water and was such

a sturdy-looking Yankee-built vessel that Margaret felt
confident in booking passage for herself and her family.
She was almost relieved that this sluggish cargo ship was
not likely to break any records for speed, as her first
transatlantic steamer had. In fact, the voyage was sup-
posed to take two months, for it would be burdened
with 150 tons of Carrara marble and a marble statue of
John Calhoun by the American sculptor Hiram Powers.
Margaret decided she liked Captain and Mrs. Hasty, and
she returned to Florence to make arrangements to depart
in mid-May. Marcus Spring had offered to pay her
expenses when she reached New York, so she went
about stocking up on food and supplies and preparing
for a long voyage with a young child.

Westbound Atlantic crossings were usually safe in the
spring, but there had been a number of shipwrecks that
year. Margaret had heard that a ship carrying a statue
by Hiram Powers had gone down. A friend in Paris, who
was just about to return a muff to Margaret, died sud-
denly on the same day that a ship Margaret had chosen
not to book passage on had sunk. A packet boat and a
steamer, both of which were considered safer for the
open seas than merchant ships like the *Elizabeth*, had
also been recently shipwrecked. Not only had Margaret
experienced a number of close calls on or near water,
but years before, a fortune teller had prophesied that
Ossoli would experience death by water. Even so, it was
too late to change plans. Hoping for the best, Margaret
bade farewell to her friends, writing to Costanza Arco-
nati, "may it not be my lot to lose my babe at sea. . . . Or
that if I should it may be brief anguish, and Ossoli, he
and I go together."[9]

Five passengers boarded the *Elizabeth* at Livorno on
May 17, 1850: Margaret, Ossoli, and the baby Nino, as
they were now calling him, as well as Celesta Pardena,

an Italian girl formerly employed by the artist Henry Peters Gray in Florence, who would take care of the baby until they arrived in New York. Their young friend Horace Sumner was also sailing with them. Everything had been done to make the passengers comfortable, and Captain Hasty and his crew enjoyed showing Nino around the ship to make him familiar with the riggings and rules of life at sea. Everything began well. Even Margaret's headaches disappeared. The atmosphere was festive and relaxed. She worked on her history of the Roman Republic in the mornings and sang and played piano in the evenings. Horace instructed Ossoli in English, in exchange for Ossoli's Italian lessons, which Captain Hasty and his wife joined.

They had not yet left the Mediterranean when Captain Hasty began to experience pains in his head and back. He did not seem seriously ill, so Margaret and Nino kept him company. The captain's symptoms worsened and after ten days of suffering, he died of confluent smallpox and was buried at sea. The ship was quarantined by British authorities at Gibraltar for a week, but it was released when no one else came down with fever. On June 9, Mr. Bangs, the first mate, took command, and the ship set sail. Two days later, Nino fell ill with the same disfiguring symptoms of facial swellings and fever. Ossoli believed his son was lost, but Margaret refused to give up. They kept a constant vigil and took scrupulous care of him. After nine days, the child took a turn for the better and gradually recovered without a scar.

A strong westerly wind accelerated the crossing of the cargo ship. Mr. Bangs was confident that the ship would reach New York on July 19. On the evening of the eighteenth, when the *Elizabeth* was still east of Bermuda, the passengers brought their trunks to the main cabin, anticipating that they would disembark sometime the

next day. At 2:30 in the morning, however, a southeast
gale-force wind began to blow off New Jersey's Atlantic
coast. The choppy seas and high winds threw the ship
off course. At 3:50 a.m., having overshot the port of
New York by forty miles, the three-masted *Elizabeth*
struck a sandbar off Fire Island, which parallels the
southern edge of Long Island.

Propelled by mountainous waves, the ship's bow
struck the sandbar a second time. This time, it stuck.
Then the stern swung around so violently that the 150
tons of glistening-white Carrara marble below shattered
the hull, and the ship began to take on water. All five
passengers had been thrown from their beds to the floor
of their cabins and had then stumbled up to the main
cabin. Margaret held her screaming child. Ossoli tried to
calm Celesta by praying with her. In the pitch black,
amid the noise of the storm and the splintering ship, the
passengers and Mrs. Hasty in the main cabin became
separated from the crew on the forecastle. For quite a
while, each group thought the other had been washed
overboard. Indeed, the ship's only lifeboat had been torn
away in the wind.

Though the distance to shore was only fifty yards, it
could not be crossed in such a wind with such an under-
tow and such huge waves. The only way anyone could
survive was by clinging to wooden planks of the ship
and hanging on until they were thrown ashore like drift-
wood. Horace Sumner attempted to save himself, but he
drowned while the others watched. Onshore, a thousand
people gathered from Rockaway to Montauk to watch
as the ship broke up and sank, but they were scavengers,
not heroes.

The wind and waves made the ship lurch for hours.
The wind was so strong it blew sailors off the deck.
Everyone was terrified when the tide turned. The rising

water began to push the shattered ship off the sandbar into deep water. The sea would swallow everything in a matter of minutes. Celesta shrieked in terror. Ossoli, as calm as he had been under the bombs and rockets on the Pincio, continued to pray aloud with her. George Sanford and Henry Wetervelt, both Swedish seamen, drowned when they were washed overboard. George Bates, the steward, saw a massive wave about to crest overhead. Hoping to save Angelino, he snatched the child from Margaret's arms. When the forecastle and foremast cracked in two from the sheer force of the wind, Bates plunged into the sea. The wave hit, and Ossoli and Celesta were swept from the deck. Thrown against the rigging, Ossoli reached out for Margaret before he was thrust under the next murderous wave. The crewmen who remained held out a plank, and Margaret stepped forward. For a few seconds, Margaret Fuller stood alone on the deck of the *Elizabeth*. Her drenched white nightgown made her visible to those gathered on the beach. She could not have known that Ossoli was already dead or that Angelino's body was washing up onto the sand only 150 feet away. Nevertheless, she cried out, "I see nothing but death before me!" A second later, the foremast crashed down to the deck over Margaret's head, and she, too, was gone. Neither her body nor Ossoli's was ever found, for they had been swallowed by the sea forever.

On that dreadful day, July 19, 1850, one year after the height of the bombardment of Rome and less than a month after Margaret's fortieth birthday, she was dead. Not of stroke, as her migraines and nosebleeds had predicted, nor of exposure on a mountainside, nor of the complications of childbirth, nor of bombs and gunfire, but of a blow to the head during a shipwreck. When Margaret's family and friends received the astounding

news, they were shocked. So alive, so full of energy, so overflowing with ideas, and toward the end, so happy, Margaret Fuller had seemed invincible. Her death was never truly accepted by her contemporaries, and even as her friends grew old, they were never able to resolve the great question about what her life might have been had she survived the shipwreck.

Earlier that year, when Emerson had learned that Margaret was about to return to America with her husband and son, he had written her, trying to persuade her to remain in Europe: "I am sure it is needless that you should cross the ocean only to make a bargain for your book, whilst I am here, even if I were a far clumsier agent than I am. I can see plainly, too, the very important advantages which continued residence in Italy will give to your factors at home."[10] When he heard the news of her death, Emerson seemed almost relieved, telling Carlyle it might be better this way, in view of her perennial problems with health and money. However, the real issue for him was jealousy. "Her marriage would have taken her away from us all," he admitted. It is not surprising, therefore, that when it came time to edit Margaret's *Memoirs*, her closest male friends—Emerson, James Freeman Clarke, and William Henry Channing— censored her private papers. In the early stages of the project, Emerson had written to Samuel Ward that a biography of Margaret could be done, if one would devote himself to it head high, ignoring the prudes. "Nay, if, for the glory & honor of Margaret such a hecatomb were prepared, and all scruples magnificently renounced, I think when the first experiments came to be made, it might turn out to be a work above our courage."[11]

While some may have been too timid to look closely at her private life, Margaret herself had been candid about her feelings and beliefs. She had always insisted

on the truth. "Give me Truth, cheat me by no illusion" was one of her sayings. As she shouted her last words toward America, perhaps she understood at last how full of life her life had been. She may have found the answer to the profound question she had asked herself as a girl pausing on her way upstairs: "how is it that I seem to be *this Margaret Fuller*? What does it mean? What shall I do about it? I remember all the times and ways in which the same thought returned. I saw how long it must be before the soul can learn to act under these limitations of time and space of human nature, but I saw also that it must do it."[12]

Margaret Fuller's whole life had been a quest, a rapid journey across a violent sea of random events. Her ideals had been harshly tested, yet she never backed down. When her family needed help, she had found a way to earn a living. When women were silent, she had spoken out. If her short life was tragic, it was triumphant as well. The beauty of her life was that it was *hers* and hers alone, shaped by necessity but made by choice and lived out courageously, passionately, and defiantly according to her own nature.

The significance of Margaret Fuller's life was instantly recognized at her death. On July 24, Henry David Thoreau and Arthur Fuller went to Fire Island to search through the sand dunes for her body, her papers, and her property. Mrs. Fuller and her two sons left Boston the next day for New York. Ellery Channing followed on the twenty-sixth. Some of her letters and those written by Ossoli had been well packed, and somehow they and some of Angelino's clothes were recovered. The manuscript and notes pertaining to Margaret's history of the Roman Republic, however, have never been found. Upon her death, the news about the wreck, as well as

obituaries and tributes, appeared in more than thirty newspapers, including one in Germany.

At first, Angelino was buried in the sands of Fire Island. His remains were then taken to Valley Cemetery in Manchester, New Hampshire, and were finally interred at Mount Auburn Cemetery in Cambridge, Massachusetts, where friends and family erected a granite memorial:

IN MEMORY OF
MARGARET FULLER OSSOLI
BORN IN CAMBRIDGE, MASSACHUSETTS, MAY 23, 1810
BY BIRTH A CHILD OF NEW ENGLAND
BY ADOPTION A CITIZEN OF ROME
BY GENIUS BELONGING TO THE WORLD
IN YOUTH
AN INSATIABLE STUDENT SEEKING THE HIGHEST CULTURE
IN RIPER YEARS
TEACHER, WRITER, CRITIC OF LITERATURE AND ART
IN MATURER AGE
COMPANION AND HELPER OF MANY
EARNEST REFORMER IN AMERICA AND EUROPE
AND OF HER HUSBAND
GIOVANNI ANGELO MARQUIS OSSOLI
HE GAVE UP RANK STATION AND HOME
FOR THE ROMAN REPUBLIC
AND FOR HIS WIFE AND CHILD
AND OF THAT CHILD
ANGELO EUGENIO PHILIP OSSOLI
BORN IN RIETI, ITALY, SEPTEMBER 5, 1848
WHOSE DUST REPOSES AT THE FOOT OF THIS STONE

THEY PASSED FROM THIS LIFE TOGETHER
BY SHIPWRECK JULY 19, 1850
UNITED IN LIFE THE MERCIFUL FATHER TOOK THEM
TOGETHER IN DEATH THEY WERE NOT DIVIDED

Some have speculated that Margaret allowed herself to die without a struggle, for many of her letters seem so pessimistic. Her last letter, believed to have been written just before the ill-fated *Elizabeth* sailed from Livorno on May 17, 1850, certainly seems fatalistic:

> I am absurdly fearful, and various omens have combined to give me a dark feeling. I am becoming indeed a miserable coward, for the sake of Angelino. I fear heat and cold, fear the voyage, fear biting poverty. I hope I shall not have to be forced to be brave for him, as I have been for myself, and that, if I succeed to rear him, he will be neither a weak nor a bad man. But I love him too much! In case of mishap, however, I shall perish with my husband and my child, and we may be transferred to some happier state. . . . I feel perfectly willing to stay my threescore years and ten, if it be thought I need so much tuition on this planet; but it seems to me that my future upon earth will soon close. It may be terribly trying, but it will not be so very long now. God will transplant the root, if he will to rear it into fruit bearing. . . . I have a vague expectation of some crisis,—I know not what. But it has long seemed that in the year 1850, I should stand

on a plateau in the ascent of life, where I should be allowed to pause for a while, and take more clear and commanding view than ever before. My life proceeds as regularly as the fates of a Greek tragedy, and I can but accept the pages as they turn.[13]

Margaret Fuller was not forgotten. As long as her contemporaries lived—and Emerson lived to 1882—she was sorely missed. She was spoken about and memorialized, her books were reprinted, and her unpublished work was brought out with great success. In the century and a half since her death, Margaret Fuller's life story has been written by a dozen biographers. Various collections of her letters and journals have been published, and after the death of James Nathan, her love letters to him were issued. What Henry James termed "the Margaret ghost" lives on in fictional characters such as the outspoken New England "bluestocking," or the "spinster" who awakens to life and love abroad, in novels such as Hawthorne's *The Blithedale Romance* and *The Marble Faun* and in Henry James's *The Europeans, The Portrait of a Lady, Daisy Miller,* and *The Turn of the Screw.* As a woman of action and ideas, Margaret Fuller's life should inspire women to think for themselves, and to act on what they believe.

The Mount Auburn memorial to Margaret Fuller is impressive in its cold, granite, Yankee dignity. A finer tribute to her, however, was given her by the people of Rome, at the foot of the Janiculum, on the grounds of a villa that Goethe had visited. Once a blood-soaked battlefield during the short-lived but glorious Roman Republic of 1849, the streets in this beautiful residential area have been named in honor of the great heroes of that struggle. Tucked off to one side of the viale di Mura

is a narrow, shady path which winds gracefully around patches of wildflowers and vines to the crest of the Janiculum. Here the Romans honor a heroic woman, for this little nook—perhaps the most romantic corner in all of Rome—is called viale Margaret Ossoli Fuller.

Chronology

1810	Sarah Margaret Fuller born at Cambridgeport, Massachusetts (May 23).
1824–25	Attends Miss Prescott's Academy in Groton, Massachusetts.
1825–33	Lives in Cambridge.
1833	Family moves to Groton.
1835	Takes summer trip with Farrars and Samuel Gray Ward. Meets Harriet Martineau. Becomes ill in Groton. Father, Timothy Fuller, dies (October 1).
1836	Meets Ralph Waldo Emerson at Concord (July). Becomes a teacher at Bronson Alcott's Temple School in Boston.
1837	Helps form Transcendentalist Club. Begins teaching at Green Street School in Providence, Rhode Island (June; to 1839).
1839	Moves to Jamaica Plain (April). Translation of *Eckermann's Conversations with Goethe* is published (May–June). Begins Conversations in Boston and Cambridge (November; to 1844).
1840	Begins editing the *Dial* (to July 1842).
1841	Brook Farm opens (April).

1842 Translation of *Correspondence of Fräulein Günderode with Bettina von Arnim* is published.

1843 Takes summer trip around the Great Lakes with Sarah Clarke (May–September).

1844 *Summer on the Lakes, in 1843*, is published (June). Moves to New York City to write for the *New-York Tribune* (November).

1845 *Woman in the Nineteenth Century* is published (February). Meets James Nathan.

1846 *Papers on Literature and Art* is published (August). Sails for Europe with the Springs (August). Visits Scotland and England. Meets Mazzini. Goes to Paris (November).

1847 Leaves Paris and travels to Genoa, Naples, and Rome (spring). Meets Giovanni Angelo Ossoli (April–May). Spends the summer in northern Italy and Switzerland. Returns to Rome and becomes Ossoli's lover (October).

1848 Witnesses uprisings in Italy (January–March). Goes to L'Aquila and Rieti (April–November). Son Angelo is born (September 5). Returns to Rome (November).

1849 Roman Republic is established (February). Siege of Rome (April–June). Runs a hospital for casualties. Flees to Rieti (July) and to Florence (September).

1850 Sails for the United States with Ossoli and son (May 17). All die in shipwreck at Fire Island. New York (July 19).

Notes

Page ii

1. James Freeman Clarke, letter to Thomas Wentworth Higginson in Thomas Wentworth Higginson, *Margaret Fuller Ossoli* (Boston: Houghton Mifflin, 1884; reprinted by Haskell House, 1968).

2. Sarah Freeman Clarke, in Higginson, *Margaret Fuller Ossoli*; cited in Beil Gale Chevigny, *The Woman and the Myth: Margaret Fuller's Life and Writings* (New York: The Feminist Press, 1976), p. 87.

Page xiii

1. Ednah Dow Cheney, *Reminiscences of Ednah Dow Cheney* (Boston: Lee and Shepard, 1902), p. 205.

Chapter 1: Childhood and Adolescence

1. Margaret Fuller, "Mariana," in *Summer on the Lakes, in 1843* (Boston: Charles C. Little and James Brown; New York: Charles S. Francis, 1844); cited in Chevigny, p. 52.

2. Fuller, letter to Timothy Fuller, January 16, 1820; Margaret Fuller papers at the Houghton Library [herein: Houghton Library]; cited in Chevigny, p. 54.

3. Fuller, *Memoirs of Margaret Fuller Ossoli*, Ralph Waldo Emerson, William Henry Channing, and James Freeman Clarke, eds. (Boston: Phillips, Sampson, 1852. Reprinted by Burt Franklin, 1972), vol. 1, p. 15 [herein: *Memoirs*]; cited in Chevigny, p. 36–37.

4. Ibid.

Chapter 2: Bohemian

1. Fuller, *Memoirs*, vol. 2, pp. 111–112; cited in Chevigny, p. 11.

2. James Freeman Clarke, in *Memoirs*, vol. 1, p. 132; cited in Paula Blanchard, *Margaret Fuller: From Transcendentalism to Revolution* (New York: Delacorte Press/Seymour Lawrence, 1978), p. 4.

3. Fuller, letter to Henry Hedge; Houghton Library; cited in Blanchard, p. 81.

4. Clarke, letter to Margaret Fuller; cited in Blanchard, p. 83.

5. Fuller, *Memoirs*, vol. 2, p. 154.

6. Ibid., p. 158.

7. Fuller, letter to Almira Barlow; Houghton Library; cited in Blanchard, p. 95.

8. Fuller, *Memoirs*, vol. 1, p. 161; cited in Blanchard, p. 96.

9. Fuller, *Memoirs*, vol. 1, p. 202; cited in Blanchard, p. 103.

10. Ibid.

11. Ralph Waldo Emerson, *The Letters of Ralph Waldo Emerson*, Ralph L. Rusk, ed. (New York: Columbia University Press, 1939); cited in Blanchard, p. 103.

12. Ibid.

Chapter 3: Transcendentalist and Teacher

1. Ralph Waldo Emerson, *Complete Essays*, p. 87; cited in Joseph Jay Deiss, *The Roman Years of Margaret Fuller* (New York: Thomas Y. Crowell, 1969), p. 148.

2. Margaret Fuller, letter to Richard Fuller; Houghton Library; cited in Chevigny, p. 121.

3. Fuller, *Memoirs*, vol. 2, p. 35.

4. Margaret Fuller, letter to Ralph Waldo Emerson; cited in Blanchard, p. 114.

5. Edgar Allan Poe, *The Complete Works of Edgar Allan Poe* (New York: G. P. Putnam's Sons, 1902), p. 7–8; cited in Chevigny, pp. 232–233.

6. Fuller, *Woman in the Nineteenth Century and Kindred Papers Relating to the Sphere, Condition, and Duties of Woman*, Arthur B. Fuller, ed. (1874; reprinted by Greenwood Press, New York, 1968) [herein: *Woman in the Nineteenth Century*]; cited in Chevigny, p. 241.

7. Fuller, "The Great Lawsuit: Man versus Men, Woman versus Women," The *Dial*, vol. 4, no. 1 (July 1843), p. 47 [herein: "The Great Lawsuit"]; cited in Blanchard, p. 162.

Chapter 4: Socialist, Feminist

1. Fuller, *Memoirs*, vol. 2, pp. 73–78; cited in Chevigny, p. 315.

2. Fuller, "The Great Lawsuit," The *Dial*, vol. 4, no. 1 (July 1843), p. 41.

3. Fuller, *Memoirs*, vol. 2, p. 35.

4. Fuller, "Margaret Fuller's 1842 Journal," ed. Joel Myerson, *Harvard Library Bulletin* 21 (1973), pp. 331–332; cited in Chevigny, p. 128.

5. Fuller, *Summer on the Lakes, in 1843*.

6. Ibid.

7. Ibid.

8. Ibid.

9. Ibid.

10. Ibid.

11. Ibid.

12. Ibid.

13. Orestes Brownson (review of *Summer on the Lakes, in 1843*) and James Freeman Clarke (review of *Summer on the Lakes, in 1843*); cited in Joel Myerson, *Critical Essays on Margaret Fuller* (Boston: G.K. Hall, Co., 1980), p. 56.

14. Fuller, *Woman in the Nineteenth Century*; cited in Eleanor Flexner, *Century of Struggle: The Woman's Rights Movement in the United States* (Cambridge: Harvard University Press, 1959), p. 93.

15. Edgar Allan Poe, review of *Woman in the Nineteenth Century* in *Broadway Journal* (August 1846), in *The Complete Works of Edgar Allan Poe*; cited in Chevigny, pp. 232–233.

Chapter 5: Journalist

1. Author unknown, *New Quarterly*, Barbour, British Reviewers, pp. 622–625; cited in Blanchard, p. 342.

2. Lydia Maria Child, letter to Margaret Fuller, August 23, 1844; Houghton Library; cited in Chevigny, p. 233.

3. Fuller, *Memoirs*, vol. 2.

4. Margaret Fuller, letter to James Nathan, April 15, 1845; cited in Julia Ward Howe, *Love Letters of Margaret Fuller, 1845–46* (New York: D. Appleton, 1903; reprinted by Greenwood Press).

5. Fuller, letter dated March 3, 1846; Houghton Library; cited in Blanchard, p. 244.

6. Fuller, *Tribune* dispatch; cited in Deiss, p. 29.

7. Thomas Delf inscription; cited in Howe, *Love Letters of Margaret Fuller, 1845–46*.

8. Emerson, letter dated July 31, 1846, in *Correspondence of Thomas Carlyle and Ralph Waldo Emerson* (Boston: James R. Osgood & Co., 1883), vol. 2, pp. 115–116; cited in Chevigny, p. 309.

9. Thomas Carlyle, letter cited in Blanchard, p. 257.

10. Fuller; cited in Blanchard, p. 260.

11. Thomas Carlyle; cited in Emma Detti, *Margaret Fuller Ossoli e i suoi Correspondenti* (Firenze: Felice Le Monnier, 1942).

12. Fuller, *At Home and Abroad, or Things and Thoughts in America and Europe,* Arthur B. Fuller, ed., 1856 (reprinted by Kennikat Press, New York, 1971) [herein: *At Home and Abroad*]; cited in Deiss, p. 38.

13. Fuller, *Memoirs,* vol. 1, pp. 194–199; cited in Blanchard, p. 260.

14. Adam Mickiewicz; cited in Deiss, p. 43.

Chapter 6: Italian Romance

1. Dante, *Inferno.* (Author's translation) *Penguin Book of Italian Verse,* ed. George Kay (London: Penguin Books, 1966), p. 75.

2. Giuseppe Mazzini, letter to Fuller; cited in Deiss, p. 43.

3. Fuller, *Tribune* dispatch; cited in Blanchard, p. 264.

4. Fuller, journal entry; cited in Deiss, p. 66.

5. Mickiewicz, letter to Fuller; cited in Deiss, p. 43.

6. Mickiewicz, letter to Fuller; cited in Deiss, p. 66.

7. Fuller, letter to Ellen Fuller; cited in Chevigny, p. 372.

8. Fuller, journal entry; cited in Deiss, p. 71.

9. Fuller, letter to Emerson; cited in Deiss, p. 77.

10. Fuller, letter to Richard Fuller; cited in Deiss, p. 74.

11. Fuller, *Tribune* dispatch; cited in Deiss, p. 75.

12. Ibid.

13. Fuller, journal entry; cited in Deiss, p. 72.

14. Fuller, letter to Caroline Sturgis; cited in Deiss, p. 76.

15. Fuller, *Tribune* dispatch; cited in Blanchard, p. 274.

16. Ibid.

17. Fuller, journal entry; cited in Deiss, p. 78.

Chapter 7: Ossoli

1. Fuller, *Memoirs,* vol. 2, p. 223; cited in Deiss, p. 79.

2. Fuller, letter to Marcus Spring, *Memoirs,* vol. 2, p. 221.

3. Margarett Crane Fuller, letter to Margaret Fuller; cited in Deiss, p. 83.

4. Fuller, journal entry; cited in Deiss, p. 95.

5. Margaret Fuller, letter to Margarett Crane Fuller; cited in Deiss, p. 83.

6. Emelyn Story, in Margaret Fuller, *Memoirs;* Margaret Fuller papers in the Boston Public Library; cited in Chevigny, pp. 403–405.

7. Fuller, *Tribune* dispatch; cited in Perry Miller, *Margaret Fuller:*

American Romantic (New York: Doubleday, 1963; reprinted by Cornell University Press, 1970), p. 275.

8. Fuller, *Tribune* dispatch; cited in Deiss, p. 94.

9. Ibid.

10. Margaret Fuller, letter to Margarett Crane Fuller; cited in Deiss, p. 94.

11. Fuller, letter to Richard Fuller; cited in Blanchard, p. 279.

12. Fuller, letter to Emerson; cited in Deiss, p. 96.

13. Fuller, letter to Caroline Sturgis; cited in Deiss, p. 96.

Chapter 8: Political Tensions

1. Fuller, *At Home and Abroad*, pp. 242–243; cited in Deiss, p. 90.

2. Fuller, *Tribune* dispatch; cited in Deiss, p. 123.

3. Ibid.

4. Fuller, *Tribune* dispatch; cited in Blanchard, p. 280.

5. Costanza Arconati, letter to Fuller; cited in Deiss, p. 125.

6. Fuller, *Tribune* dispatch; cited in Chevigny, p. 445.

7. Fuller, journal entry; cited in Deiss, p. 129.

8. Fuller, *Tribune* dispatch; cited in Deiss, p. 127.

9. Fuller, letter to William Henry Channing, in *Memoirs*, vol. 2, p. 235; cited in Chevigny, p. 448.

10. Arconati, letter to Fuller; cited in Deiss, p. 138.

11. Emerson, letter to Fuller, in *The Letters of Ralph Waldo Emerson*, vol. 4, p. 28; Fuller, letter to Emerson, in *Memoirs*, vol. 2, p. 239; both cited in Chevigny, p. 453.

12. Fuller, letter to Mary Rotch; cited in Blanchard, p. 290.

13. Fuller, letter to Richard Fuller; cited in Deiss, p. 143.

14. Fuller, *Tribune* dispatch; cited in Deiss, p. 144.

Chapter 9: Motherhood and the Republic

1. Fuller, letter to Caroline Sturgis Tappan, in *Memoirs*, vol. 2, pp. 231–233; cited in Chevigny, p. 441.

2. Fuller, journal entry; cited in Deiss, p. 146.

3. Arconati, letter to Fuller; cited in Deiss, p. 146.

4. Emerson, letter to Fuller; cited in Deiss, p. 147.

5. Fuller, letter to Emerson; cited in Deiss, p. 149.

6. Giovanni Angelo Ossoli, letter to Fuller; cited in Deiss, p. 152.

7. Ossoli, letter to Fuller; cited in Deiss, p. 153.

8. Fuller, letter to Ossoli; cited in Deiss, p. 156.

9. Ossoli, letter to Fuller; cited in Deiss, p. 161.

10. Fuller, letter to Ossoli; cited in Deiss, p. 164.

11. Ossoli, letter to Fuller; cited in Deiss, p. 165.

12. Fuller, letter to Ellen Fuller Channing; cited in Deiss, pp. 166–167.

13. Ossoli, letter to Fuller; Fuller, letter to Ossoli; both cited in Deiss, p. 167.

14. Ossoli, letter to Fuller; cited in Deiss, p. 167.

15. Fuller, letter to Margarett Crane Fuller; cited in Diess, p. 183.

16. Fuller, *Tribune* dispatch; cited in Deiss, p. 186.

17. Fuller, letter to Caroline Sturgis Tappan; cited in Chevigny, p. 470.

Chapter 10: The Battle for Rome

1. Editorial in the *New York Tribune*, July 27, 1849.

2. Fuller, journal entry; cited in Deiss, p. 196.

3. Giuseppe Mazzini, *Memoirs;* cited in Christopher Hibbert, *Garibaldi and His Enemies: The Clash of Arms and Personalities in the Making of Italy* (London: Longmans, 1965; reprinted by Penguin, 1987), p. 41.

4. Fuller, journal entry; cited in Hibbert, p. 79.

5. James Russell Lowell, poem in *A Fable for Critics;* cited in Deiss, p. 204.

6. William Wetmore Story, letter to Lowell; cited in Blanchard, p. 303.

7. Fuller, letter to Caroline Sturgis Tappan; cited in Deiss, p. 205.

8. Ibid., p. 207.

9. Fuller, journal entry; cited in Detti, p. 343.

10. Lewis Cass, cited in Deiss, p. 265.

11. Ibid.

Chapter 11: Death and Remembrance

1. Fuller, letter to Emelyn Story; cited in Deiss, p. 290.

2. Emerson, journal entry; cited in Blanchard, p. 339.

3. Horace Greeley, letter to Fuller; cited in Deiss, p. 277.

4. Fuller, letter to Margarett Crane Fuller, in *Memoirs,* vol. 2, pp. 273–275; cited in Chevigny; pp. 485–486.

5. Margarett Crane Fuller, letter to Fuller; cited in Chevigny, p. 486.

6. Fuller, letter to Margarett Crane Fuller; cited in Chevigny, p. 485.

7. Fuller, letter to Caroline Sturgis Tappan; cited in Deiss, p. 297.

8. Fuller, letter to Samuel Gray Ward; cited in Blanchard, p. 327.

9. Fuller, letter to Arconati; cited in Blanchard, p. 329.

10. Emerson, letter to Fuller; cited in Deiss, p. 303.

11. Emerson, letter to Ward; cited in Chevigny, p. 415.

12. Fuller, journal entry; cited in *Memoirs,* vol. 2.

13. Memorial inscription; cited in Miller, p. 315.

Bibliography

WORKS CONSULTED

Anthony, Katherine. *Margaret Fuller: A Psychological Portrait.* Darby, Penn.: Darby Books, 1920.

Blanchard, Paula. *Margaret Fuller: From Transcendentalism to Revolution.* New York: Delacorte Press/Seymour Lawrence, 1978.

Bell, Margaret. *Margaret Fuller.* New York: Albert & Charles Boni, 1930.

Braun, Frederick Augustus. *Margaret Fuller and Goethe.* New York: Henry Holt, 1910.

Brown, Arthur W. *Margaret Fuller.* United States Authors Series. New York: Twayne Publishers, 1964.

Chipperfield, Faith. *In Quest of Love.* New York: Coward-McCann, 1957.

Detti, Emma. *Margaret Fuller Ossoli e i suoi Correspondenti.* Firenze: Felice Le Monnier, 1942.

Deiss, Joseph Jay. *The Roman Years of Margaret Fuller.* New York: Thomas Y. Crowell, 1969.

Fuller, Margaret. *Memoirs of Margaret Fuller Ossoli,* ed. Ralph Waldo Emerson, William Henry Channing, and James Freeman Clarke. Boston: Phillips, Sampson, 1852. Reprinted by Burt Franklin, 1972.

Fuller, Margaret. *Summer on the Lakes, in 1843*. Boston: Charles C. Little and James Brown; New York: Charles S. Francis, 1844.

Higginson, Thomas Wentworth. *Margaret Fuller Ossoli*. American Men of Letters Series. Boston: Houghton Mifflin, 1884. Reprinted by Haskell House, 1968.

Howe, Julia Ward. *Margaret Fuller*. Boston: Roberts Bros., 1883.

Stern, Madeleine B. *The Life of Margaret Fuller*. New York: E. P. Dutton, 1942.

Wade, Mason. *Margaret Fuller: Whetstone of Genius*. New York: The Viking Press, 1940. Reprinted by Augustus M. Kelley, 1973.

ANTHOLOGIES OF MARGARET FULLER'S WRITINGS CONSULTED

Chevigny, Bell Gale. *The Woman and the Myth: Margaret Fuller's Life and Writings*. New York: The Feminist Press, 1976.

Howe, Julia Ward. *Love Letters of Margaret Fuller, 1845–46*. New York: D. Appleton, 1903. Reprinted by Greenwood Press.

Miller, Perry. *Margaret Fuller: American Romantic*. New York: Doubleday, 1963. Reprinted by Cornell University Press, 1970.

Wade, Mason. *The Writings of Margaret Fuller*. New York: The Viking Press, 1941.

ADDITIONAL READING

Flexner, Eleanor. *Century of Struggle: The Woman's Rights Movement in the United States*. Cambridge: Harvard University Press, 1959.

Hibbert, Christopher. *Garibaldi and His Enemies: The Clash of Arms and Personalities in the Making of Italy*. London: Longmans, 1965. Reprinted London: Penguin, 1987.

Marraro, Howard R. *American Opinion on the Unification of Italy. 1846–1861*. New York: Columbia University Press, 1932.

Myerson, Joel. *Critical Essays on Margaret Fuller*. Boston: G.K. Hall, 1980.

Myerson, Joel. *Margaret Fuller: An Annotated Secondary Bibliography*. New York: Burt Franklin & Co., 1977.

Myerson, Joel. *Margaret Fuller: An Exhibition from the Collection of Joel Myerson*. Department of English, University of South Carolina Bibliographical Series #8, 1973.

Myerson, Joel. *Transcendentalists and the* Dial. New Jersey: Associated University Press, 1980.

Trevelyan, George M. *Garibaldi's Defence of the Roman Republic*. London: Longmans, Green, 1907.

Index

ABOUT THE AUTHOR

CAROLYN FELEPPA BALDUCCI is an award-winning author of books for young adults. She teaches creative writing at the Residential College at the University of Michigan. She lives with her family in Ann Arbor, Michigan.

ANNA QUINDLEN, a 1974 Barnard College graduate and English major, is one of America's most distinctive observers of contemporary life. She writes a syndicated column for *The New York Times* and is also a best-selling novelist.